**Building Human Relations Through Art**
Škart collective (Belgrade)
> from 1990 to present

Seda Yıldız

ONOMATOPEE 224

T0035556

# Contents

# Sharing and taking action through art
Seda Yıldız

The inspiration for this book came after a meeting with the art collective Škart (Belgrade). On the 2nd of September 2019, in response to a request to organise a studio visit, I was invited to the house of Škart's co-founder Dragan Protić's (Prota) in Belgrade. As I entered a beautiful space with a courtyard under the trees, Prota warmly welcomed and introduced me to long-time collaborators of Škart: Lenka, Mirko, Filip and Reza. Sitting in circle, Prota shared the flow of the night and we set off; the first act was a song performed by Mirko (Mirko Petrovic Mirkobend) a singer and writer performing songs about the struggles of mentally ill and disabled people. When appropriate, he screamed: "Everyone is necessary to the world!". The song was followed by Lenka Zelenović's performance in which poetry takes the form of embroidery. Lenka reads her poems aloud as she transforms her feelings and social criticism into manifestations of embroidery, taking the form beyond its traditional boundaries of "women's work". We continued the night with a one-minute puppet animation screening whose stories were developed by Reza, a calligrapher from Iran, currently a refugee in Belgrade. These animations are bitter, talking mainly about his everyday life experiences inside a refugee camp and yet, they are still humorous. The night ended with guitar tunes by Filip, who transformed poems written by elderly pension seekers into songs as a result of a workshop that Škart initiated. Filip plays one of these: "I do not want to eat chocolate anymore!". As I was leaving, Prota gave us souvenirs (artworks); their Coupons, one for 'Revolution' and one for 'Fear'. (A few days later I came across these Coupons at the collections of the Museum of Yugoslavia in Belgrade).

That night (which I personally refer to as a performance itself) was a remarkable encounter. Škart's art practice is fluid, open and relationship-based which might (or might not) take the form of a poem, poster, zine, performance, song, video animation, or street action. Dialogue as a form; Škart has developed this method over decades of collaborations with local individuals, groups or various hosts including cultural workers, NGOs and activist groups. Yet I wonder how could one tell the story of Škart, and these multilayered engagements, some of which haven't left behind physical traces. Prota's reply to my question was something like "but who would care?". I thought it was important to share (and I knew that Prota knows this too) as it is empowering to witness that art has an ability to bring people together, to form alliances

and meaningful social relations. If nothing else, it becomes a form of resistance against forms of oppression.

As an interdependent curator[1], what could my role be in mediating Škart's art practice to a broader audience? The group's work ethics triggered me to think about the questions on how to operate in the precarious art scene, and with whom and how to work with it. In line with their motto "Building human relations through art" this book is an intimate examination of Škart's socially-engaged practice; a form of thinking and dialoguing in depth. Bringing together some traces from the last three decades of practice, it portrays how art, as collective action, functions socially and politically. Selected works – numerous encounters, collaborations, tangible and intangible works including posters, zines, poems, embroideries, documented or non-documented workshops, events and gatherings – revolving mainly around collectivity, community, and collaboration. The material dates from the early 1990s to the present, and also gives hints of the changing social and political setting in the region, marked by war, nationalism, isolation and transition. It is striking to observe how these shifts have developed the means to reconsider and rethink artistic production. Škart didn't remain indifferent to this reality, and decided to reject the position of powerless observer; their practice is not marked by such darkness but optimism.

The first step of this project (in the absence of a fully developed archive)[2] was to gather material from Škart's activities which is spread around two cities: Belgrade and Ljubljana. Given the absence of supporting material (the 90s remain poorly documented and inadequately researched), an oral history method was applied to approach their 'unofficial' art practice. Hours long conversations were held between September 2020 and October 2021 together with the founding group members Prota and Žole (Đorđe Balmazović), while each of us were at different corners; Prota in Belgrade, Žole in Ljubiana, myself in Hamburg. During the COVID-19 pandemic all conversations had to be realized online, though they were initially planned to take place in a village in Belgrade, around boxes of archival material at Prota's family house. This hasn't happened yet. Instead, there were many 5 o'clock online chat sessions. It has been our challenge, almost ironically, that Škart has spent the last three decades finding ways to bring people together physically. As togetherness takes other forms except that physicality, this shift has added a new dimension to the group's practice. One teaching of Škart is that once a structure is created, it reproduces itself in different ways. An example of such adaptability becomes visible examining their practice during the pandemic restrictions as they took different forms, such as a poetry writing workshop with the elderly

1
Interdependent curator, editor and writer Nataša Petrešin-Bachelez refers to the impossibility of being an 'independent' curator. Emphasizing the interdependence of our labor relations she points out the multilayered relations curatorial practice requires.

This is mainly due to social, political and ideological reasons. The break-up of Yugoslavia and dismantlement of the socialist regime in the early 90s caused art and culture institutions to maintain themselves in "minimal function"* operating on scarce budgets and under increasing nationalism. The failure of institutions to document and archive the art of the 1990s in Serbia is portrayed as "decadent" while the strict control of the official cultural institutions became visible leaving no room for figures of the "alternative" scene including Škart.** Even though some of the alternative institutions from the 1970s, such as SKC (Student Cultural Center Belgrade) continued to operate, their practice tended to be marginal. From the mid 90s till 2000 the need for alternative funding sources for culture was supported by the Soros Foundation providing a substitute or parallel system of non governmental, non-profit organizations. Also important to highlight is that the most important institution in the sphere of contemporary art in Serbia, Museum of Contemporary Art in Belgrade, remained closed between 2007 to 2017.

*Naomi Hennig, "Reviewing the network of the Soros Centers of Contemporary Art in the region of former Yugoslavia", 2011.

** Branislava Anđelković / Branislav Dimitrijević "The Finale Decade: Art, Society, Trauma and Normality", 2005.

in social isolation via sms, or through online "only good news" writing workshops with children, which then took them to the streets as a marching band.

The order I decided to navigate through the material was structured by chronology. This decision, despite being the first thing that came to my mind, also proved to be the most helpful. For Škart's practice reveals to be a chronicler of the times; ten years of Yugoslav wars in the 90s, the fall of the socialist regime followed by the transition to a neoliberal economy and the replacement of collective interest with an individual one. This historical and local setting formed the background of the group's socially and politically engaged practice which can not be grasped fully outside of this geopolitical frame. Therefore the book is divided into three chapters, the 1990s, 2000-2010, and from 2010 to the present.

Though creating such chronological divisions might feel like a rather didactic model, beyond tracing a linear perception of time it provides a capacity to understand and evaluate their art practice in the context of great social and political changes. The first chapter focuses on works from the 1990s which mainly take the form of street actions and the self-distribution of printed material (visual poetry). These works could be best understood as a reflection on the rise of nationalism and social isolation that was strongly present in the early 1990s. Consequently, Škart went into streets to react to a society that was falling apart with poetry, to make their message legible and connect with fellow citizens. The second chapter, covering the decade of 2000-2010, emphasizes the collaborative projects that are both organized inside and outside of the region. When the Yugoslav Wars ended in 2001, Škart decided to embrace collectivity as an official stance. In this decade we see a move from distributing art to the people, but giving them opportunity to become creators themselves; their projects became social gatherings, forming embroidery groups, choirs, poetry performances and workshops. The last chapter, presenting works from 2010 to the present, questioning ways of exhibition making (what is an exhibition? who is it for?) as well as the future of working as a collective. In this decade Škart intervenes in 'actual' institutions (museums, biennials etc) and operates in/around them by challenging their capacities and operational rules.

This linear structure further gives hints to many overlapping repetitions taking place across time, and how things are intertwined in Škart's practice. Over decades certain friendships turn into collaborations, and collaborations develop long-term friendships. Some of the groups Škart formed in the early 2000s, such as choirs, extended and

blossomed into others, some of which still operate today. Certain strategies and tools which had been applied in different occasions in the past become useful in recent years too. This continuity is particularly remarkable, for the region is defined by instability, disrupted histories and discontinuity, which also affected the artistic scene and cultural structures. Hence oral history, as a non-hegemonic tool of research and knowledge production, becomes essential in mapping missing local narratives. 'Dialogue as a form' is reappropriated in the editorial structure too, providing a deeper understanding of the group's practice.

This book is not a retrospective, or a monographic survey[3] (this terminology would not fit Škart who has been working with rather marginalised formats as zines, embroideries, choirs anyways), but an attempt to present Škart's work through the "continuity of discontinuities."[4] Beyond the fact that the projects included are all of personal importance to me (and my consideration of them as 'good' projects in terms of social usefulness and stimulating artistic imagination) the importance is also connected with their relevance today. They pose an essential question; how could art contribute to developing a better and more equitable society? And what could be the tools for imagination and action? Škart proposes; self-organization, community building, collaboration, solidarity and subversion. The book is further structured around these strategies, as they are woven through each chapter.

      Škart's practice stretches out to a greater variation; from street level to established art and culture institutions, forming children's choirs in foster care homes to embroidery groups with refugee single mothers, from street actions to representing Serbia in 2010s Venice Biennale of Architecture. Regardless of their form and duration, what they have in common is a strong social commitment. To examine how they operate on different levels, the projects which take place on the local, regional and international scale have been included. A special effort is given to cover less visible activities which took place in collaboration with local communities, associations, or NGOs that are not necessarily from the art circle. Also some relatively well-known landmark projects from the 1990s such as *Sadness* and *Coupons* are once again addressed. This is because they tell us about the beginnings of the group's formation, and how they helped to form 'the other line' in the region, keeping out conventional ways of production and display. Also some rather controversial workshops are included to discuss the challenges of socially engaged practice from an operational perspective. Particularly 'failed' examples create an opportunity to reflect on what worked, or what did not, and give a glimpse of how to work in the future.

3
I would like to thank Jelena Vesić for pointing out that not having a monograph of Škart's work is indeed in line with their operational practice.

4
Zdenka Badovinac & Ida Hiršenfelder, *Glossary of Common Knowledge*, Moderna galerija, 2018

What is remarkable in Škart's practice, on a more human level, is its sincerity, openness (everyone can make art and can become a 'member' of Škart) and simplicity. It is a diverse practice (both in terms of its operation and multidisciplinarity) and has a direct impact on its immediate surroundings. While doing this, they promote a manner of working with joy.

On a more practical level, there is a lot to learn from Škart's self-organization skills. They have been operating within limited material and financial sources from the 1990s till today, presenting a solid example that art (once leaving the institution) as an everyday part of life, could be a tool to fight back against inequalities and create forms of coexistence. The various groups Škart initiated in the early 2000s are an example of this. Take for instance NONpractical Women (*NEpraktične žeNE*) which was formed through a workshop in 2000. Today some of the participants still use the traditional medium of embroidery as a manifestation, raising their voice against violence, for equality and solidarity. Beyond creating an alternative economy, these embroidery pieces have become a self-empowerment tool for women whose voice is not valued in a patriarchal society. Or the choir *Horkeškart*, a working model of self-management, which has been operating in streets, villages, schools, and refugee camps singing songs of resistance since 2000. Introducing a self-management strategy to the group, as of 2008 Škart is no longer affiliated with the choir. Yet today under the name *HORKESTAR* the choir still operates, and such is a successful project as the community became autonomous from Škart.

The urgency of revisiting Škart's practice today from another perspective could be explored through Zdenka Badovinac's line of thinking. Badovinac points out the necessity of bringing on artistic practices that would otherwise stay invisible. In her essay, titled "Parallel Histories", along with other differences between the concerns of the East and the West, she remarks on the reality of how in the former East artists were (and still are) required to self-historicize their practice, and be their own historians and archivists while lacking well-functioning institutional structures. And histories as such, like that of Škart, are important to put alongside master ones to create plural narratives, as well as for non-Western art to enter the global process of exchange as Badovinac puts it.[5]

I further take on this curatorial responsibility for it is crucial and urgent to act upon the question of visibility, representation and the art historical canon (which is Western art history). Along this path another seminal essay, Maura Reilly's "Curatorial Activism" has accompanied me too. Reilly draws attention to the unfortunate reality of the art world that remains a stronghold of straight, white males whose

5
Zdenka Badovinac:
*Comradeship: Curating,
Art, and Politics in
Post-Socialist Europe*,
ICI, 2019.

patronage, curation, and art making result in a hierarchy that extends its dominance into museum collections and exhibitions.[6] Yet curating, as she points out, offers a possibility to "challenge dominant discourses and advocate a different art world by reconfiguring cultural representations and raising visibility for those who have been excluded from it."[7] Indeed, in the case of Škart one could mention double elimination; that being an artist from the former East, Škart has less visibility, and second, socially engaged practice has been seen as something secondary, as having a low status in the art world (disaccording with conventional operation rules of the art market). With this, as socially conscious art and culture workers, how could we engage in building counter-hegemonic narratives? Could this book create an intimate form of visibility to promote Škart's values as well as its creative resistance tools, opening up artistic possibilities?

Dialogues form relationships and this book is a station within that relationship. The parts of the conversation which did not make their way to this book yet remain to be shared some other time, shaped in different ways. For the dialogue continues.

A book is a collaborative medium par excellence. My warmest gratitude to Prota and Žole, as well as friends of Škart I have met; Lenka, Mirko and Filip.

I want to thank Zdenka Badovinac, Branislav Dimitrijević and Milica Pekić for their insightful essay contributions. While mapping the specificities of its locality, Dimitrijević positions Škart within the communicative patterns of contemporary art in the 1990s and argues how and why their practice needs to be considered as a self-determining activity. Badovinac discusses the return of art to common use through Škart's terms as she maps through notions as "common interest", "economy of modesty", "the not-yet-existing", "care" and "play". The plurivocality of Škart's invisible practice is revisited through a field research by Milica Pekić, visiting village schools and foster homes, talking to individuals or groups Škart had collaborated with including members of NONpractical Women, Group 484 and the Pesničenje poetry festival.

I would also like to thank Merve Ünsal and Matt Hanson for their dedicated copyediting & proofreading work, to Rob van Leijsen for graphic design, to Astrid Mania and Valentina Karga for encouraging my work at an early stage.

6
Maura Reilly: *Curatorial Activism: Towards an Ethics of Curating*, Thames & Hudson, 2018.

7
Ibid.

# PART 1:
# 1990s

# Error as a trace of humanity

In a city on the brink of war, Škart came to life in an abandoned print workshop in 1990, founded by two students at the Faculty of Architecture in Belgrade — Dragan Protić and Đorđe Balmazović, also known as Prota and Žole. The duo decided to name themselves Škart, meaning "scrap", "despised", or "left over" in Serbo-Croatian. Škart's understanding of the word has positive connotations — such as a "refusal" to remain silent in times of political unrest and rising nationalism, and an active "rejection" of passivity in confrontation with a lack of well-functioning institutions, with the aim of potentially expanding our understanding of artistic possibilities.

    The name sums up much of what the group has done over the last three decades: using creativity and minimal resources to reach out to the vulnerable and marginalised in society including the elderly, single mothers, refugees, the unemployed, and orphaned children. "How to make people participate in art projects?" was the starting point for the duo, which remains

the core of their practice today. This question has been revisited through numerous collaborations with individuals, groups who are not necessarily from an art circle. The 1990s shaped Škart's mode of production and communication, as well as their strong aesthetic values based on self-sufficiency. In ten years of wars and isolation in Yugoslavia between 1991-2001, the transition to a neoliberal economy, followed by the fall of Yugoslavia and its socialism, the lack of financial sources, as well as the deprivation of cultural infrastructures all resulted in building Škart's modus operandi: self-organization, self-production, and self-distribution. Upon these constraints Škart has built its core values: collaboration, care, and solidarity.

# ŠKART
......*Vam želi*........
# LEP DAN

**Seda**    To start at the very beginning, how did you two meet and how was Škart formed?

**Žole**    We met each other in Finland. Prota was a 3rd-year student and I was in my 2nd year. There was a union of architecture students meeting in Finland and 50 students from Belgrade joined, so this was the first time we met. After we returned to Belgrade, we became friends. Prota discovered a studio for etching on the rooftop of the academy, which nobody was using. He was the brave one: he proposed that we go and learn classical etching. The atelier was full of dust; it took 2-3 days to clean it. Later the etching professor started teaching us the basics; how to cut the plates, how to use the acid, and gave us the keys of their atelier. It was like our nest. We started practicing as a typical apprentice, learning craftsmanship. The idea was to produce identical copies, 20-50 copies... But for us it was difficult to achieve. They were not the same. We were making lots of printing mistakes, and one day Prota said, "but these mistakes are also beautiful!". So we started to experiment and make poetry with these mistakes. Because mistakes are very human, nothing is perfect. These mistake-graphics are called Škart in Serbian ('ausschuss' in German, or 'scarto', in Italian) so we called ourselves Škart. Our initial idea was to create a bigger collective with our friends from other departments in sculpture, drawing, industrial design; we wanted to have a big group with different skills, to be more colorful. But they were more individualistic and wanted to focus on their work so the two of us stuck together.

**Seda**    How did you decide to leave your "nest" and present your posters on the streets of Belgrade?

**Žole**    It was very organic. Our ideology and politics towards art was shared by the circumstances of the times. When we were at the atelier, we realised that if you want to exhibit in an art gallery, you have to know someone, be part of the scene, or climb the stairs of its hierarchy. We were not willing to do that. We were also in the faculty of architecture (studying in the department of urbanism) which was not popular back then. But we had experience researching the city, so we decided to treat the city as our exhibition space. We knew the technique of reproduction, so we produced our work in addition to 20-30-50 copies, as much as we could afford. We started with screen printing posters and made visual poetry out of Prota's poems. After, we went into the streets distributing and gluing them in different spots.

Fig. 2    Škart members during the action of distributing posters "Accused" around the city. Poster is dedicated to Mirjana Bokšan (in the photo), who was accused of selling oppositional newspapers on the street. Winter 1994/1995

**Prota**    Just to add here, to take part in a predictable art context you also need to adapt your products, to be useful for these exhibitions. We didn't belong to that circle, and also we did not have something useful for them, something they could treat as artworks. We didn't care about this. For us the message was important, not the product. That's why we produced posters, it was a kind of noise in the media sphere, instead of taking part in the art circle. These messages were visual poetry, abstract, self-sufficient messages. Sometimes they had weird meanings or maybe no meaning at all. It was a surreal message in the streets that didn't try to tell or sell something like the others. It was a new, open space for itself, a space of imagination. For us, it was very important just to open this sphere of experimentation and treat the city as a free ground to spread our message.

**Seda**   It is true that those posters were not carrying any clear, or direct political messages, but were very abstract and poetic. They were carrying highly political statements in regards to the chaotic atmosphere in Belgrade at that time. In a way they were subtle, activist interventions.

**Prota**   We decided to have an endless, continuous process of production and distribution. The very first one was "Škart wishes you a nice day". Complete nonsense... Who is Škart? Because nobody knew who we were back then. Who cares about a nice day? It was slightly childish... After it went even more abstract like "R for the letter R". Pure nonsense... Or another one, "Q a rare letter". In another poster there was just a small, tiny dot and underneath we wrote: "Important". We didn't give them a title, nor did we number them but insisted on doing this action every week, even though nobody mentioned it or documented it.

Fig. 3   *R FOR THE LETTER W*. Poster, 50 × 35, screen print, 1991

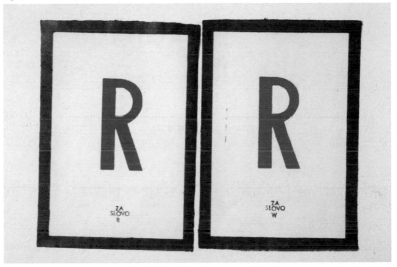

**Seda**   Some posters have Škart stamps, and some don't. Was this a conscious choice?

**Žole**   I was against it from the beginning. For me it was too big, too obvious and I didn't feel this need to mark them like a product of a company. But Prota came up with this idea to add some originality, and also gain visibility. I was not at ease with it; I even wanted to change our name from year to year, to put the focus on the work rather than who did it. I was impressed by Fluxus's attitude of the corporation of the art work, changing names and not being identified etc. For me the work is

really the most important thing and authorship should not be attached
to the work. The artist's name, the originality, fetishization of the art-
work... Sometimes we used the stamp, and for those posters that were
commissioned, like works for Radio B92, or cinema Rex, we didn't. This
stamp was maybe only used for the first year of our work. Then Prota
also agreed that it was too obvious.

Seda        I understand your stance against this fetishization
            of the figure of the artist, but of course creating vis-
            ibility for the collective is important too, and this is

different than branding. I feel that for Prota it was also important to be known as Škart. He was the one sending these posters to various people or newsrooms that were of interest to you, which was crucial to create consciousness, further visibility for your work. Honestly Žole, for you it wasn't of any importance to be known as Škart?

Žole        I didn't find being visible that important at that time. But thanks to Prota's efforts it worked, I have to say. He is very good at marketing, pushing the work. He is very skillful when talking about our work, as long as we're not talking about money... Then he gets totally silent! When we were working as graphic designers he was brilliant in marketing, discussing the work with clients, but the moment the client would agree and ask okay, how much does it cost, Prota would just become silent, turn to me and say, "Žole knows"! So I was always in charge of saying that.

Seda        Talking about these posters and promoting yourself, I wanted to ask you about one very early poster of yours that says, "Škart is again in the museum". What was this about?

Žole        We did it for our very first exhibition at the gallery in the village, our hometowns: Novi Bečej and Zrenjanin. The first action was in 1990. We were a group of four friends, one called himself a punk theoretician, who wrote a text introducing the show, and the other composer friend composed music for the show, based on one of Prota's poems. So there was sound, posters and poetry reading. We made a poster saying, "Škart is in the Gallery Imago". And the second poster was about the yearly exhibition of architecture students which took place at The Museum of Applied Arts Belgrade, and our work was also included. So we made a poster which said, "Škart is in the museum". Now I must say it is not my favorite...

Figs. 7-8        *Škart exhibition in a high white room.* Poster + Audio recordings from the 1st Škart solo show in Gallery Imago, Zrenjanin, Serbia, 1990

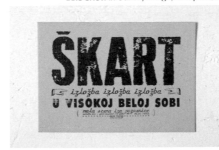

**Seda**     And there was also another one, which directly promotes Škart: it was an announcement in the newspaper?

**Žole**     Yes, a friend of ours was an Alpinist and in 1990 he was in the Pamir Mountains, including the highest peak in the Soviet Union, between the Turkish, Armenian, and Georgian borders. We asked him to bring our flag to put it there, along with the other nations' flags. Then, we published it in the political newspaper; "Škart goes to Pamir". There was this yellow pages section of people selling really weird stuff, like snake skin, or asking for bizarre leather objects... So we wrote an announcement, an announcement of nothing in that sense.

Fig. 9     Nebojša Vasović and Škart on Pamir. Škart public announcement, published in *Politika* newspaper 15.07- 20.08.1990

**Seda**     A unique self-promotion strategy, and it reminds me of your bizarre jingles on the radio.

**Žole**     Yes, sort of, this was the first official announcement of Škart. And then the radio jingle started around 1992.

**Seda**     For how long have you continued working with posters and distributing them around the city?

**Prota**     It was for the whole year of 1991, or a bit longer maybe. We made a new poster and put it in the streets almost every week, only with some gaps. Continuity gives you the responsibility to develop a skill, or a responsibility to the city itself; as it was our strategy to spread our messages around the city. And parallel to these street actions and mail art we used radio to reach a wider audience. Radio was very present at the time. In 1991, together with **Darka Radosavljević Vasiljević**[1],

1
**Darka Radosavljević Vasiljević**, one of the founding directors of Remont Gallery, was hosting a cultural program at Radio B92, Sketch Book, and broadcasting Škart's news regularly. Starting from the early date of Škart's foundation, Darka has been one of the individuals who supported Škart.

2
**Radio B92**, which later became a long-term collaborator of Škart, was the main oppositional radio in Belgrade founded in 1989.

3
**LED ART** group was founded by painter N. Dzafo in 1993, during socio-political turmoil that shoved Yugoslavia into a war and complete international isolation during the 90s. All the realized projects of LED ART (including the ones only sketched) bear the epithet of engaged art that intensely resisted the regime of Slobodan Milošević. LED ART has gathered more than 300 individuals in close to fifty projects during the ten-year activity period: artists, sociologists, art historians, journalists, scientists.

**4**
**Women in Black** is a world-wide network of women committed to peace with justice and actively opposed to injustice, war, militarism and other forms of violence. In 1991, they began a public non-violent protest against the war; the Serbian regime's policy; nationalism; militarism and all forms of hatred, discrimination and violence. Till today they have organized more than 500 protests, most of which took place in Belgrade streets and squares, but also in other cities of Serbia and Montenegro, throughout the former Yugoslavia, many cities of Europe, and around the world.

**5**
**Cultural Center Rex,** founded in 1994, is a place for contemporary, socially engaged art and analytical cultural practice. Rex offers a wide variety of programs; concerts, exhibitions, theatrical performances, presentations, showings of video works, discussions and organized meetings of local non-governmental organizations.

**6**
**Studentski kulturni centar (SKC) Beograd** was founded in 1971 and opened in May 1974 as an example of what the student protests of 1968 ultimately achieved. The founders of the Center were the University of Belgrade and the University Board of the Yugoslav Student Association. SKC was the most influential institution during the 70s and 80s in Belgrade, hosting important figures such as Joseph Beuys etc.

we created a program on **Radio B92** [2]. It was called Škart News; once a week on Tuesday mornings — weird news was on air.

**Žole**        No, it was Monday morning. First we were going out in the streets at 4-5 in the morning to distribute posters and after that Darka was playing our weekly message on her radio show, Sketch Book.

**Prota**        It was also a kind of attack on your mind with something you don't know. One old lady; actually the Serbian actress Rahela Ferai who survived the Holocaust, read: "And now something important: Škart News!" followed by a jingle, with a very bombastic orchestra playing. And the news is, for example: "R for the letter W", then again the orchestra plays... We were making nonsense out of the media, building up a free territory which was not contaminated with hate speech. Parallel to poster productions the radio program lasted for one and a half years. Also to reach a distant audience we used mail art; we sent posters anonymously to various people around the world; one-way, without an address.

**Seda**        I'm also curious to hear more about the art and culture scene in Belgrade back then. We were talking about institutions and hierarchies, and I wonder were there any other art & culture institutions with whom you had a common stance and considered collaborating with? And if not institutions, what about other like-minded artists or collectives in the region? For example, during the same time, in the early 90s, **LED ART** [3] collective was very active especially in Novi Sad, making highly controversial street actions; a genius example of subversive art practices. I could find many commonalities with your practice, too.

**Prota**        In that time maybe we didn't need collaborators outside of our close circle. By mail art we wanted to communicate at a distance, but for street actions or any kind of social political engagements it needed to be a group structure, which is reachable. We wanted communication, not necessarily collaboration. But for example we collaborated with **Women in Black** [4], and this was different. Once we felt collaboration was possible we directly communicated with them for a long time, and it was not only a short term project; it became ongoing. Also, not many independent art or culture institutions existed at that time. **Rex** [5], or **Remont** came later in 1999. **The Student Cultural Center (SKC)** [6] had a gallery in the basement and we used to put our posters in the window of the gallery. For them it was a useless window space, but for us it was a slightly protected space. Maybe on the streets our

other posters were not under guard, but there it was a protected space — completely selfishly bizarre.

Seda   I'd like to talk about your collaboration with Women in Black, as this was your first collaboration with an NGO, and as you said you managed to work together until recently. The results of this collaboration are slightly different from your rather surreal, Dadaist posters, which I will come back to later on. Apparently this was in relation to your strong activist stance, and it is maybe important to say here that you never draw a line between your art practice and activism, which has sometimes been criticised too. Prota, when I first met you in Belgrade in 2019, I remember that you introduced yourself first as "a communist, a poet, a member of the Škart collective and an artist". What about your personas, Žole?

Žole   I never describe myself as an artist as I do believe everyone could be an artist, so it is senseless to me. I describe myself according to the thing I am making my living from, which is graphic design mainly. And I also share the communist ideology; it seems the best ideology of all the others to me, but I wouldn't describe myself sharply as a 'communist' either. But I'd still say that the communist ideology is the closest to my way of thinking, and seems to be the fairest one; especially after living for 25 years in socialist Yugoslavia and 25 year in capitalist — or whatever it is at the moment — Serbia.

Seda   Have you ever been affiliated to a political party?

Prota   Never.

Žole   I was, because I'm from a little town with 30.000 habitants and every pupil in high school was nominated to become a member of the communist party. When I was 15-16 they nominated me, and to refuse it would be such a scandalous thing in a small town. So I started joining meetings 1-2 times a year. When I came to Belgrade to study at the university, I also joined the communist party at first, but then I stopped. I was disappointed as there was no discussion at all. "We have 5 topics to discuss today, lalalala lalala, who is for, who is against; okay everyone is for!" there were no different opinions, including mine, as I was still so young, 17-18, and shy to speak up. In the first years of studying, 1986-87, I was not politically conscious to be honest. Later during the 90s, I became more conscious because of the rise of nationalism during the **Milošević** [7] period. In 1991 I started reading and also selling

7
**Slobodan Milošević** served as the President of Serbia from 1989 to 1992 and within the Federal Republic of Yugoslavia from 1992 to 1997, and President of the Federal Republic of Yugoslavia from 1997 to 2000. In the period between 1991 and 1999 Serbia was involved in the Yugoslav Wars – the war in Slovenia, the war in Croatia, the war in Bosnia and the war in Kosovo.

the oppositional weekly magazine *Vreme* on the streets after the breakup of Yugoslavia to support myself, my brother, my girlfriend and Prota; so three of us were living on this income.

Prota  No, I was independent.

Seda  And how did you earn your living? Through graphic design mainly?

Žole  For the last 30 years my main income has been coming from graphic design. We only had a few exceptional years, 2004-2005, when we also made set designs for theatre in collaborations with The National Theatre of Belgrade and Brussels. Maybe another exception was the year 2018 for me personally, when I sold 10 of the migrant maps to the National Maritime Museum of England. And right now Prota does some workshops, also some designs for NGOs but he is obscuring his income while I am writing everything in this black book, all the jobs I did.

Seda  Where does the funding of these workshops mainly come from?

Žole  Most of the time from NGOs or non-profit associations in Serbia. Or sometimes from EU-supported platforms like CORNERS, who we collaborated with on some projects too.

Fig. 10  Metal plate designs for Radio B92, Cinema Rex, Škart and the festival "Lust for life-Wilhelm Reich" at OZKD, 1007

Fig. 11  Book design for the literary festival "Na pola puta" (*On the half-way*) in Užice, Serbia, 2013

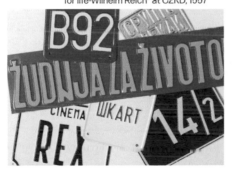
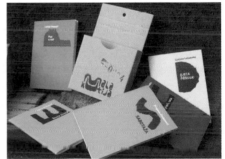

# Freebies: Same to everyone, or nothing for all

During the early 90s, Škart appeared in the streets of Belgrade with the motivation to "build human relations through art." This marked the entry of critical artistic practice in public spaces in Serbia, resisting the political and social environment. Leaving the studio and going to the streets was not only a conscious choice driven by an urge to communicate with fellow citizens, to overcome polarisation and social isolation; but also to question the places of art in society, and its accessibility. Instead of exhibiting at museums or galleries Škart created a scene for themselves, "treating the city as their own exhibition space". Not interested in the idea of producing 'objects' of art, but encounters in public space, Škart intended to remind their fellow residents about feelings of empathy and solidarity. Numerous self-produced, self-distributed projects and street actions took place between 1990-96; including distributing poems to passersby as a public declaration of personal sadness (*Sadness*, 1992-93), or survival coupons

of 'revolution', 'tolerance', or 'orgasm' that are printed and handed out to random addresses also by post (*Coupons*, 1997-2000). These freebies which were mainly self-financed (together with contributions of friends or acquaintances too) and occasionally by foreign sources, became a gesture of resistance.

8
Vesna Pavlović collabo-
rated with Škart between
1992-1994 and photo-
graphed *Sadness* street
actions in Belgrade and
Volvadina. In the 1990s,
Pavlović also worked
closely with the feminist
pacifist group Women
in Black.

Seda The Sadness project took place in 1992-93, and you created 23 poems in total, which were printed on cardboard as a direct commentary on the hostile social environment. *Sadness of Potential Vegetables*, *Sadness of Potential Landscapes*, *Sadness of Potential Travellers*... And you started to collaborate with other people who often joined your street actions too. **Vesna Pavlović**[8] joined and became a 'member' of Škart, helping to photograph these actions, and distribute Sadness cards in the streets, too. You wanted to encourage individuals to motivate and to reflect on social fragmentation, which was really present in Belgrade at that time. For *Sadness* you self-distributed both in Serbia and abroad, right?

Figs. 12-15 *Sadness*, 32 poetry-cards, 24 × 21 cm, 1992-93

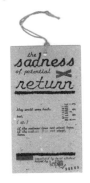 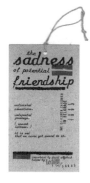  

Prota Yes, through street actions and mail art again. We were sending *Sadness* poems to people important to us, both in the local and international scene. We had quite an open mailing list of individuals from different scenes.

Žole This initiative came from Prota. He was making a list of people who were important to him, or to us, and we were sending posts, all of which were anonymous, one-way mails.

Seda And who was on this list?

Prota Musicians, architects, literature magazines, film directors, writers... Some of them later became our collaborators; Padja Vraneševlć, Slobodan Tišma, or our former professors, architect Bogdan Bogdanović for example. Also plenty of friends. We were not interested in the classic art scene, or the media; but it was important for us to appear, here or there, and still protect our invisibility. This was our strategy. People slowly started to hear about Škart, but they didn't know who we were exactly.

**Žole**     Whenever we printed a *Sadness* poem we used to go out to distribute it on the street in editions of 100-200 depending on our budget. It was very expensive at that time to afford screen printing. And again we used the radio for distribution, to reach a broader audience. Monday morning we would distribute them on the street; maybe the same day, or the following, we had the poem of the week broadcast on the radio.

**Prota**     Printed media is somehow frozen, it is on the paper; but the radio is very open so we wanted to use it to spread our message. Something important to add is that these poems were conceptualised; for example *Sadness of Potential Travelers* were distributed around railway stations; *Sadness of Potential Consumers* in front of the department store which had completely empty shelves. The *Sadness of Vegetables* in front of the farmer's market. For *Sadness of Pregnancy*, a pregnant friend was coming with us to distribute. *Sadness of Potential Landscapes* were distributed in Kalemegdan Park, and *Sadness of Potential Guns* was placed within humanitarian aid for Bosnia. We wanted to provoke people to think, why are the trains empty, why are the shops empty, and why had the country ended up under such austerity.

Fig. 16     Distribution of *Sadness of Potential Traveller*, at the railway station in Belgrade, 1992. Photo by Vesna Pavlović

Fig. 17     Photo is taken in 1992 or 1993, during the worst economical crisis in Serbia, when the country experienced the highest inflation rates. Photo by Draško Gagović

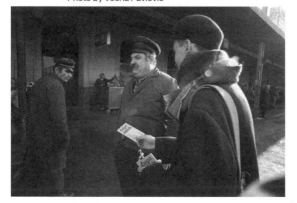
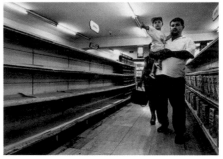

**Seda**     What were the reactions to these street actions? I have seen some drawings; I think Žole it is you who drew Prota giving away your printed works to the passersby as they hesitate to take it.

**Žole**     Yes, reactions were exactly like those drawings. And it was quite frustrating for me actually. Prota was the brave one, who approached everyone on the street. I was the shy one – it is hell for me to approach someone I don't know. So it was a challenge Prota took on,

giving away something for free to someone, which they hadn't asked for. More than half of them were not interested. Most of the time, a few steps later they were throwing these poetry cards into the bin.

Fig. 18    Drawing by Žole, Prota distributing Sadness cards on the street

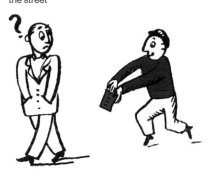

Seda    But you did not give up and continued these street actions and distributions for more than a year, on a regular basis.

Žole    It was Prota who was pushing us to continue. It was a big lesson for me, to realize how people are reluctant or don't care about art.

Prota    During the beginning phase of the *Sadness* project I was also disappointed, but after the second week people started to come and ask Žole for free *Sadness* prints and started to collect them. This was a sudden illumination for us, that someone needs it, even if it is sadness... which is also necessary because it is a comment on your weekly, political, emotional agenda.

Žole    But, unfortunately, they were mostly well-educated people who had been acquainted with art already; mostly professors, or students...

Prota    They were the ones who knew, or heard about the project. It was not covered in the main media, or announced. It was a pure subversive action for those who had the chance to get it.

Seda    And now I want to go back to discussing your collaboration with the Women in Black association and the refugee women from Bosnia, as this came right after in 1994. This was your first experience working with a closed group, and together with them you produced a zine, titled, *I remember*, covering the experiences of women escaping from the war. So the booklet is a collection of their personal stories with drawings based on memories of war. I wonder how you reached

out to these women, and what the collaboration process was like. How did you work on building trust?

Prota    Thanks to Radio B92, the Women in Black association heard about us. Actually this radio station later became a very important collaborator of ours; they invited us to design the books they were producing and we became their designers for the next 10 years. It was our main job indeed. One day somebody knocked on my door; and I was surprised because I was changing places so often… There was this woman and she said, "I'm from Women in Black, we wanted to invite you to make our logo". So we made a logo for them which they liked a lot, and it was the starting point for us; we started to design their books, posters. Also Vesna started to be their photographer, as these women were organising street actions and silent protests each Wednesday on the streets since 1992. For 30 years now! Then the refugee crisis started to emerge in Belgrade and they thought we had to make something urgent. It was this beautiful source of trust that they believed in our way of working, thinking and asked for help again. So we created the *I remember* action for them. We prepared the structure and encouraged Women in Black to apply this idea, directly speaking, to the refugee women. They brought paper and ink to the refugee camp and asked migrants to tell their personal stories, not only to talk about the trauma of war but about positive memories before the breakup of Yugoslavia too. Rather than in the name of a victim we asked them to speak about the period before the war; some talked about just the moment before they left their home. Our idea was to build their consciousness and self-empowerment in those miserable conditions in camps, encouraging them to speak up. And this was actually the first time someone asked these women to leave behind traces of their personal memories. *I remember* was a revelation against this passivity – that they are only the receivers of human aid, staying there silently and waiting for the next aid box.

Seda    And meanwhile you continued working on street actions, self-production and self-distribution methodologies. One of your longest-lasting projects, *Coupons*, first took place in Belgrade, in 1995. You produced coupons, 13 of them, which referenced the survival coupons distributed during shortages of basic needs, which was also the case in Belgrade, like coupons for food and similar necessities. In relation to the current socio-political context you were experiencing, you also pointed out that nonmaterial basic

Fig. 19    Logo design for Women in Black, 1992

Fig. 20    Women in Black anti-war performance in Novi Sad, Serbia. Photo by Vesna Pavlović

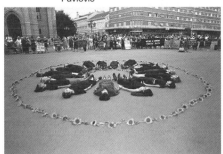

Fig. 22    Printed and promotional materials designed for Radio B92 Belgrade, 1997

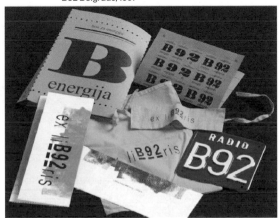

needs include human feelings and desires, such as coupons for miracles, power, relaxation, revolution, and orgasms. After Belgrade, *Coupons* travelled to different cities including New York, Stockholm, Graz and many others. What I find interesting is how you managed to adapt and adjust this project, which was highly local and site-specific, into different contexts and localities. For example, in New York, together with students from Parsons School of Design you made an action on the New York subway, distributing coupons to the passengers. How did you end up taking the project to New York, and what was your experience applying this work to another context?

Prota    In 1996, we were invited to the Olympic Art Festival in Atlanta to display the *Sadness* project. After Atlanta, we went to New York, from one contact to another, and during 3 weeks of hundreds of meetings we ended up knowing many people in New York.

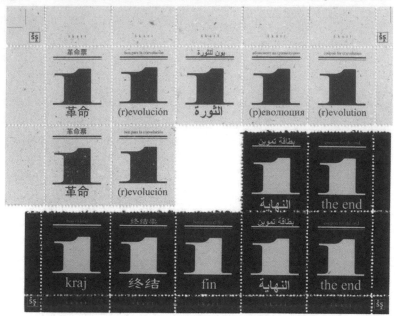

**Žole**    We came with big pieces of luggage full of artworks and distributed them every meeting.

**Prota**    And it was always free distribution, we were giving small *Sadness* books away.

**Žole**    Then we applied to ArtsLink funding in 1998. We got it and we were in NY on a partner's scholarship at the Dieu Donné Papermill. There we met Martha Wilson from **Franklin Furnace** [9] who invited us to collaborate with students from Parsons School of Design. So everything always goes by recommendation, connection, recommendation.

**Seda**    And for this New York subway action you printed multilingual *Coupons*. I saw the video documentation of the action, in which Prota stands up and says: "Ladies and gentlemen, I'm an artist and I would like to give my artwork to you, as a present, for free".

**Prota**    Yes, we were secretly recording the action. Together with the students we decided to ride the subway once a week and distribute *Coupons*, because everyone was trying to sell something on the New York subway. It was crazy, full of advertisements. Instead, we decided to give something away. Each person was asked to give *Coupons* to the person sitting next to them and to explain that this is an artwork and a gift from us.

9
**Franklin Furnace** is a New York based organization that serves to preserve and encourage the production of avant-garde art, particularly forms such as performance art that are under-represented by arts institutions due to their ephemeral nature or politically unpopular content.

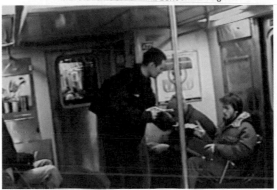

Fig. 24     Škart distributing *Coupons* for survival in the NYC metro, November/December 2000, in collaboration with students of Parsons School of Design NY

**Žole**     And people were telling us why they are not interested in them, for me that was the most important thing that happened there. One guy said, "Okay you tell me these coupons are artworks, but if they are artworks they should be in the museum, not given away for free here". Then I asked him if he goes to the museums, to which he replied "Of course not!"

**Prota**     People think, it is not my world, I don't belong there.

**Žole**     Exactly, but I find this answer very interesting! I asked this question for years, why don't people want to go to museums? Why do they feel art is so far away from them? Maybe it is not understandable, or is it too difficult to understand? There's something that keeps people from going to museums. However, some things are reachable for anyone; for example a mobile cellphone is a great invention; everyone has it, because it is useful and helpful. But it seems that art does not have such a capacity to convince people that it is useful.

**Prota**     But this is the fight, this is your battle. For me it was always a continuation; poster actions were somehow meaningless, nonsense. But with the *Sadness* poems we created quite a raw, political agenda, a certain criticism. Even if people throw these poems away, or put them lazily in their pockets. So, even this delayed reaction was important to me. It was important to think maybe they will look later in their home, maybe another person will see it as well, so the echo of revelation can continue.

**Seda**     Yes, maybe even though you were not able to transform an audience only through one project, it was quite a revolutionary and refreshing gesture to distribute an artwork on the street for free. I find even the confusion it creates for people alone is quite

meaningful. This gentle force, approaching people to encounter an artwork directly, sitting next to them and giving them a piece.

Žole    I have to tell you when we were in New York in 1998 we met one of the greatest designers, Tibor Kalman, by chance. After a public talk, we approached him and gave him our *Coupons* and we exchanged telephone numbers. Prota called him a few days later and we were invited to his studio; a huge studio with many employees. He was very interested in what we showed him and then said, "Giving something for free in these times is such a refreshing idea indeed!" I remember his excitement very well, but I was not able to understand back then, since for us it would not be normal to do the opposite, to sell them on streets for example!

Fig. 25    Distribution of *Sadness* in Belgrade, 1992. Photo by Vesna Pavlović

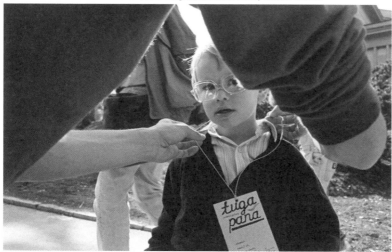

Seda    Well, today, distributing something for free on the streets has an almost a negative connotation; a foreigner approaching and offering you something unwanted... It creates an uncanny feeling. But I really liked this twisted approach, how you play with people's expectations and mindsets. And after 20 years we can still say that it is such a refreshing and radical idea in today's neoliberal reality in which nothing exists for free... Maybe it is also interesting to add here that, after many years, *Coupons* were also displayed in museums, and became part of the Museum of Yugoslavia's collection too. But still, when we met

Prota in Belgrade, he was giving away these coupons to us as souvenirs. It was a generous gesture to give an artwork as a gift, which further made me think over the idea of artistic autonomy and ownership in your work.

Prota     This comes from our belief in communism, that art and education should be accessible to anyone. As Škart we decided from the very beginning that all we produce will be distributed for free; because distribution is endless.

Seda     Another note to add about the endless distribution of *Coupons* is that you were indeed invited by various art & culture institutions or festivals as artists to present this project. How did you display them, always through street actions? In Belgrade, for example, you were also traveling to small villages and simply getting in direct contact with people, distributing them on the streets. And once invited outside of the region, you developed a strategy to adapt multiple languages to every host country.

Fig. 26     Still from video documentation distributing coupons in Beli Potok, village near Belgrade, August 1998. Shot by Miloš Tomić

Žole     *Coupons* were originally in Serbian and English. After, we introduced them in German when we were invited to Graz by Steirische Herbst in 1998.

Prota     In Graz we even built a fake machine to distribute coupons on the streets again; it was a wooden box and our friend hid inside. We

were walking around the street and our invisible friend was distributing these coupons to passersby.

Fig. 27    Delivering additional survival *Coupons* in Stockholm, 1998

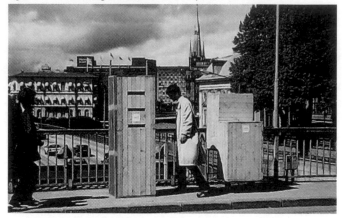

Žole    Then we were invited to Sweden, so we introduced Swedish coupons. In New York we choose the five most common languages in the city; English, Spanish, Chinese, Russian, and Arabic.

Prota    It costs to publish, and thanks to these invitations we covered the costs of production, then we distributed them locally and internationally wherever we went. We also continued to send them around by post mail, worldwide, to some people, or the magazines that interested us.

Seda    By the way, was this more or less the period when you first had a chance to cross borders and travel outside of Yugoslavia, to show your work at the end of the 90s?

Prota    The first time we were abroad was actually in 1995.

Žole    Actually performance artist Marc Hawker invited us to join a contemporary dance show, together with ballet dancers. I don't know why he invited us, maybe because of Prota? Prota invited him to *ARMATURA* and they became friends. So together with Mark and the famous ballet dancer Sonja Vukićević, we danced for an hour; it was part of the Mayfest festival and nobody understood what was going on...

Prota    In 1993 we organised a performance at the faculty of arts in Belgrade, and so we met Marc Hawker there. Together with a choir and orchestra we composed an anthem to architecture, which was called *ARMATURA* [10]. I wrote the lyrics, which were very simple:

"Armature, armature, this is the thing that connects us"
(Armatura, armatura, to je ono što nas spaja)

10
*ARMATURA*
architectural anthem
(love-technical poem)
premiere: Faculty of
Architecture, Belgrade,
Kabinet 301,
November 8th, 1993
lyrics: Škart
music: Ana Kara Pešić
performers: Choir
of Music school Josip
Slavenski Belgrade,
Conductor: Lambra
Dimitrijević, trumpet
quartet, french horn
quartet, URGH! band,
Marc Hawker, Mikrob
collaborators: Branko
Pavić, Katarina Živanović,
Nenad Jovanovic (video),
Zoran Jerković (sound),
Vesna Pavlović,
Nikola Majdak (photo).

Fig. 28  Invitation card for *Armatura* performance at the
Faculty of Architecture In Belgrade, November 1993

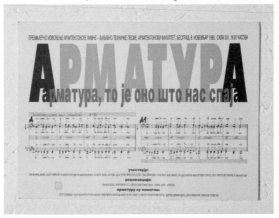

Prota    It was a very noisy, surprising night. There was a big mass of
students and we repeated the performance five times. It takes maybe
just ten minutes, but for us it was quite an encouraging event. We actu-
ally sent this as a proposal to the Venice Biennale of Architecture in
1994, and we received a letter saying something like: please do not
send us such nonsense ideas, we are a biennale of architecture and
have nothing to do with music or performance art. Good luck and good-
bye... But then in 2010 we joined the Venice Biennale of Architecture, to-
gether with two choirs who also performed *ARMATURA* at the opening!

Seda    I'm surprised to hear that you tried reaching out to
the biennale, which is maybe at the top of that hierar-
chical ladder, one that you would not be interested in.
What was your motivation when applying back then?

Prota    It was a kind of subversion. *ARMATURA* is an anti-war song, a
pacifistic song which was created in wartime Serbia. It was an idea to
make this anti-war song as a potential anthem to architecture so that
it would maybe provoke. It was a kind of politicisation of the holy-glory
neutralisation of the biennale through self-importance, a slight subver-
sion to think, "let's implement the idea of an anti-war song for the biennale".

Žole    I was not following the biennale. I have never visited it except
for the one we were part of, so I have no idea if it was political or not. But
the song has a very nice rhyme; "Armature armature, this is the thing
that connects us", and a positive message, not clearly a political one:
"Let's be connected". It could also mean like 'let's connect through the
Internet, a Facebook group or so on... You have to have a great imagi-
nation to find the political message! Anyways we were refused as we
asked to bring the choir of 50 people from Belgrade to Venice for
the performance.

Prota      It had a political message too. *ARMATURA* was an example of how a classical choir, singing, was integrated into an anti-war song, yet in a slightly Dadaist context. We also had subtitles: "A low-technical song", so double-nonsense. You have technical instructions but why low? Everything is very mishmash, but why not? It was very important to me that Ana Hofman, a music theoretician from Slovenia, wrote a book about amateur choirs and she mentioned the *ARMATURA* performance, which was the main anti-war happening in the 90s from the perspective of musicology. But luckily, after almost 20 years, we performed together with the choir from Belgrade and Ljubljana at the Venice Biennial of Architecture. It was a beautiful Yugoslav happening, a victory of nonsense!

Seda      Indeed, we can say that working with choirs provided an organic transition from the 1990s to the 2000s, a shift from working mainly with printed materials and street actions to rather long-term collaborations with groups of people. As for the 2000s, you often use workshop as a method to connect with people who are mainly outside of the art circle to develop engagements in the long-term.

Žole      Yes, 2000 was a breaking point.

Prota      Something important to mention, in this transition from 1999 to 2000 we did another project; *Your Shit, Your Responsibility*. We started the project first in Belgium, together with the Ei-migrative Art Collective who works on art & activism against violence. It was an invitation from a friend in Belgium, who asked us to help by marking dog shit in the streets because he was very annoyed with it being everywhere. We came up with this idea of making small flags to mark shit and stickers, with the slogan: *Your Shit, Your Responsibility*.

Žole      And we were also invited to have a solo show in a gallery for graphic design which was organised by Ei-migrative Art Collective. We opened the exhibition on the 19th and the 24th of March when the war started in Yugoslavia; NATO invaded Yugoslavia. We were stuck in Brussels, working with a group of students in a workshop. And of course our work with the students was politically motivated and dedicated to the war as we were under the influence of that. For six months, we produced graphic designs, printed materials such as rubbish bags or traffic signs with bombs falling down. It was a very heavy process. We were homeless, moving from one place to another. It was also difficult to make money in the black market as we didn't have legal papers, etc. to work. We had to go every week to check ourselves with the police

and it was very boring. Then we started collaborating with Ei-migrative Art Collective, which lasted 15 years. We were making graphic designs for them and helping with their exhibitions.

Figs. 29-31    In collaboration with Ei-migrative art collective and students from universities in Brussels, 1999

**Prota**   But that work, which we initially created upon the request of a friend in Belgium, was also useful in another context; it worked as a political message in a totally different context here. We were distributing these pieces in Belgrade since that message is actually a question of political responsibility relating to each person. And it created a division; some people said it is not an artwork but a political campaign. Then it received the main prize in 2000 at **October Salon**[11], and after that the **Center for Cultural Decontamination (CZKD)**[12] invited us to present the work, which opened another chapter for us.

Fig. 32    *Your Shit, Your Responsibility*, posters, flags, stickers. 2000, in collaboration with Peter De Bruyne

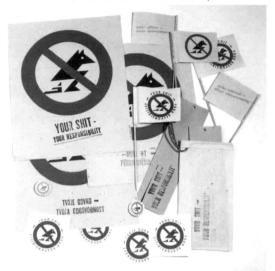

**Prota**   We did the action throughout the year in Belgrade, distributing these objects and stickers all around the city. People mostly didn't know it was Škart; they thought it was a new political party. Then we presented the whole process in CZKD, at the end of 2000.

**Seda**   In a way this was the first time you 'presented' a long-durational project and a street action within an institutional frame, as a sort of a 'closure event'.

**Prota**   Yes, it was the first time that we made such a compromise. We never presented another action, named or closed it. We accepted this invitation but still wanted to avoid a classical, boring presentation, so we decided to make a little show. We organised an audition for a choir and asked our friend who was working in Radio B92 to make an announcement, inviting people to join the choir and orchestra. 50 people came to that audition and we told all of them that they were selected.

11
October Salon is the biggest international exhibition of contemporary art in Serbia, established by the City of Belgrade in 1960. It started as an exhibition of the best works of fine arts, and went on to become, by 1967, an important review of current tendencies in applied arts, as well.

12
The Centre for Cultural Decontamination (*Centar za kulturnu dekontaminaciju*) is an independent cultural institution located in Belgrade. The centre was established in 1994, by Borka Pavićević, as a response to the political and cultural climate in Serbia. The centre works against "nationalism, xenophobia, intolerance, hatred and fear" and functions as a gallery, community and a professional forum.

Žole        The show lasted for about 20 minutes. First, a VJ friend
screened an animation. It was a video showing different ties combined
with different suits, a symbol of politicians, changing over and over
again. And then the choir of 50 people sang the song, *Holy cows* (Svete
krave) by the famous Yugoslav chanson singer Arsen Dedić. The song
was about those politicians in power who never leave their positions,
and that in every system there exists some protected 'holy cows', and it
is the working class who usually pay the price.

Prota       Also we showed the interviews we conducted with people
from the movement of resistance asking what they thought about their
personal responsibilities in the 90s.

Žole        We also arranged a conductor from the music school to work
with the orchestra. That night was packed and there was a long queue.
Maybe 500-700 people were waiting outside to get in. We had to repeat
the performance a few times. At the end of the night a member from the
choir said, "Would you like to continue working with us?" It was a perfect
idea! We already wanted to work with people long-term, and this was
how it developed naturally. The offer arrived at the perfect time.

Prota       Yes, thanks to *Your Shit, Your Responsibility* the choir was
born, and it was a new huge starting point for us to work with a big group.

Žole        Our practice is somehow divided into decades, the same
year we also decided to initiate two choir projects and a female embroi-
dery group. Both groups started in 2000; the choir lasted for six years
(which still operates under the name of Horkestar, formerly known as
**Horkeškart**[13]) and some of the members of the embroidery group are
still continuing their practice under the name of **NONpractical Women**[14]
(*NEpraktične žeNE*).

13
Horkeškart (choir +
orchestra + Škart) was
founded with the par-
ticipation of 50 people
(all the participants
were accepted with no
music testing) in 2000
through Škart's invitation
to perform at CZKD.
Since then, the choir
continues to perform at
provincial elementary
schools, refugee camps,
street markets, as well
as museums, festivals,
galleries both in the
region, and outside.

14
NONpractical Women
(*NEpraktične žeNE*)
work with embroidery to
express their thoughts,
feelings, and social criti-
cism, taking the art form
beyond its traditional
boundaries of "craft"
or "women's work.". The
community unites the
embroidered towels
from many women, men
and everyone else, since
2000. Members include
Lenka Zelenović, Brigita
Međo, Sanja Stamenk-
ović, Pava Martinović,
Vesna Nenadov, Škart,
Vladan Nikolić, and many
other women and men.

Fig. 33        Women embroidery group workshop, Belgrade, 2000

*TV commercials are longer,*
*news filled with more and more sins,*
*They are using our heads for garbage bins.*

Brigita Međo, NONpractical Women (*NEpraktične žeNE*), 2021

*While worker works*
*Filthy rich jerks.*

Lenka Zelenović, NONpractical Women (*NEpraktične žeNE*)

# Poetry as promising territory

If there is anything Škart never gave up on over the course of thirty years, it would be poetry. To Škart, poetry is a new language, one that is not yet invented. It is an "unspoiled, promising territory; a promising place". Škart understands poetry as a situation to be experienced and shared, an opportunity to raise one's voice. During the early 90s, Škart joined poetry festivals throughout Yugoslavia introducing the idea of 'applied poetry'. Dissatisfied with the ways things are, they would take over "the poetry refrigerator to make into a poetry garden". Žole would perform the poems written by Prota in a rather extravagant manner onstage because of a need to create what wasn't there, to challenge and play around the conservative structure of the festivals, and reclaim a new form of poetry.

In 2008, the group founded the monthly festival Pesničenje (Poetrying), welcoming anyone to the stage, and particularly those whose poems were rejected by competitions. The festival, as an organizational model, is an example of how to characterize Škart; it runs on a self-sufficient economic model and

self-publishing strategy. Through a symbolic fee of 1 Euro, a pocketbook of poetry compiled by the participant's poems was sold as an entrance ticket. This income would allow them to continue publishing upcoming editions. Between 2008 to 2013 more than 60 poetry pocketbooks were published.

Emphasizing the necessity of speaking out, Pesničenje proved that poetry could give us the courage to speak, to feel and to cherish each other. This shared place encouraged those who needed to say things they couldn't otherwise say. Mirko (Mirko Petrovič Mirkobend), a singer and writer, performing songs about the struggles of the mentally ill and disabled people became a frequent visitor (later a member of Škart too); screaming when necessary: "Everyone is necessary to the world!". Or a former collaborator Lenka (Lenka Zelenović) started to perform her embroidery pieces — often associated with the domestic figure of women, the household and leisure: "There is no time for conversation, the lunch needs to be made!". By this way poetry becomes an anarchist act that speaks of inequality, patriarchy and violence in today's world.

Fig. 34    Poetry pocketbooks published by Pesničenje

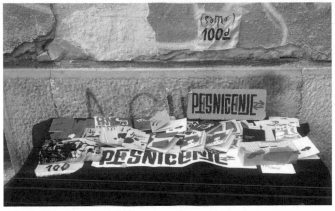

Seda     I was quite surprised to hear about your rather outra-
geous performances that took place in the early 90s
in Yugoslavia; as they seemed to be the opposite of
your subtle artworks. I'm specifically referring to the
festival you joined in 1991 and 1992 MAJSKA RUK-
OVANJA in Titograd, Podgorica in Montenegro now,
where you literally attacked the audience, going to
the extremes onstage. You transformed poetry into
a performance. Where does this radical approach
come from? Do you feel safer in poetry?

Prota     Žole has always been interested in continuity, but I'm more
into improvisation, a kind of freewheeling. Somehow we are total oppo-
sites. To me, things can continue or not. But for poetry, if someone will
ask me at the end of life, who I am, I might say I'm a poet. I started to
write poetry from an early age and composed these poems. I was also
playing harmonium and guitar in music school and writing music too in
the second grade of elementary school. I knew how to score and how
to compose basically, so my very early works were scores for instru-
ments, sometimes for two instruments, with poems, but very tradition-
ally composed songs... Later in 1976, punk came out. I was 11 and quit all
those previous scoring things—I started to jump and scream and com-
pose loud songs. I still continued to write poems. At school I was not the
football player or the handsome guy who attracts girls or boys. I was
mostly alone, and had plenty of time. I continued to write as I felt safe,
and I knew how to play with it. This is also how we started with making
posters with visual poetry in the early 90s. I really like our beginnings
because we were like kids who start learning letter by letter. We started
the same: "R for letter R" or "Q a rare letter". It was at first nonsense but

with time, and in other projects, our message became clearer, it flourished. With *Sadness*, for example, it is an easily accessible, very direct language. At that time the media was full of hate speech, which tried to shape reality as political propaganda. I wanted to distance myself from this approach and implement personal responsibility, and also express my feelings about this reality. I was a political idiot who didn't follow the news; but even as a political idiot and an uninformed, undeveloped political person I tried to speak up. Because why not? As a small citizen, who is in the middle of a war, I was just trying to speak up in the name of myself, and also others who were speechless at that time.

Seda     As opposed to your previous subtle subversions, was this extravagant performative approach – with costumes, screams, breaking the vases, throwing flowers to the audience – a strategy to attract more attention, and make your voice heard through poetry?

Prota     It was a very organic continuation of the things we did in the early 90s. If you start with visual poetry you can't continue reading very academic poetry onstage. Because visual poetry is already a step forward. For us performing poetry and also subverting the poetry festival is a meaningful continuation; of course we could not let the poetry festival be as it was, because we were not satisfied with it. It was so traditional, conservative... It was like a poetry refrigerator instead of a poetry garden. This is why we decided to organise our own poetry festival, to make this garden of poetry happen.

Fig. 35          From the poetry festival Pesničenje

| | |
|---|---|
| Seda | And Žole, what was your relation to poetry like? You were also performing Prota's poems onstage at those poetry-reading competitions. |
| Žole | I did not have any relation to poetry. I was a draftsman and as Prota said I was not into improvisation, I'm quite a boring person. I was into sports and basketball so I knew from an early age how to work hours upon hours and how to practice to achieve something. Before this I was drawing. Why I'm more into discipline is because I believe in hard work. Things need to be continuous and systematic otherwise it is impossible to make improvements. When we started working with Prota, he brought his poetry and I brought my drawing skills. And Prota was much more into poetry festivals in Yugoslavia; he was sending poems during the 80s but was never selected. Then, in 1991, he asked, "May I send my poems under your name?", I said yes. Then we were both accepted to the festival in Montenegro with Prota's poems! Prota said it is a very traditional and conservative festival and we have to do something outrageous. He proposed to perform in an unusual way and we started to rehearse; they were very short poems, only a few lines long, so we appeared onstage for less than a minute, with a costume on. We broke two vases full of flowers, threw confetti at the audience, broke a wooden stick – unusual for everyone. For me it was very fun, why not be a sort of clown or puppet to play a bit? The first night in Podgorica they invited us to a bar, and it was all so hilarious! The invited poets who drank just a few sips of Rakia and pretended to be drunk, telling about the golden days of old Yugoslav traditional, famous poetry, those very old lines... We just couldn't believe how fake and decadent it was; we were laughing so hard. |
| Prota | You know they were playing this cliche role of 'bohemian poet'; the poet gets drunk and quotes other poems. |
| Žole | That night I decided not to talk about poetry so as not to be discovered as the "fake poet". On the second day of the festival the ten finalists were announced in the newspapers. There were 30 people waiting, and I was the one selected among them! It was crazy, winning by cheating... |
| Prota | Yes, Žole was the only one among the group who was selected to go to a more famous, bigger festival. |
| Žole | What was even more paradoxical was that I was there, alone without Prota. And again the festival was the same, eating, drinking, reading other people's poems and so on. The competition was broadcast on TV and I was the last to perform. So I stood onstage, and did what I performed previously. People got so excited; some were even crying! Friends, neighbours who saw me performing on TV were calling |

my family to congratulate me; "Oh we didn't know Žole was a poet, we saw him on TV!". But next year, 1992, it became even more crazy because Prota sent poetry to the festival committee under seven of our friends' names, and we were all selected! We went to Podgorica altogether with only one real poet among us, Prota! And there I got the third prize; this was the real show.

Seda     And what kind of poems were they, Prota?

Prota     It was full manipulation, if I sent a poem under the name of a girlfriend; it was like a seductive, sexual love poem, for example... For each piece of mail I switched papers, envelopes, sometimes adopting my old poems for the name of the person I was sending, or wrote new poems in their name. It was actually really interesting, applied poetry, to fake the festival and bring our friends to the seacoast! We traveled to the seaside, stayed at hotels for 3-4 nights, had meals, joined performances; they treated us like special stars. That poetry festival in 1992 was the very last Yugoslavian poetry festival. After that Yugoslavia didn't exist anymore. So, for us, symbolically, it was also very important and I'm really proud that we joined the last edition.

Fig. 36     Poetry book "traNSporteri" published by Dark Chamber + Forum Novi Sad, designed by Škart, prepress by čavka / Nebojša Čović (permanent collaborator for 30 years)

PLATNO!!!

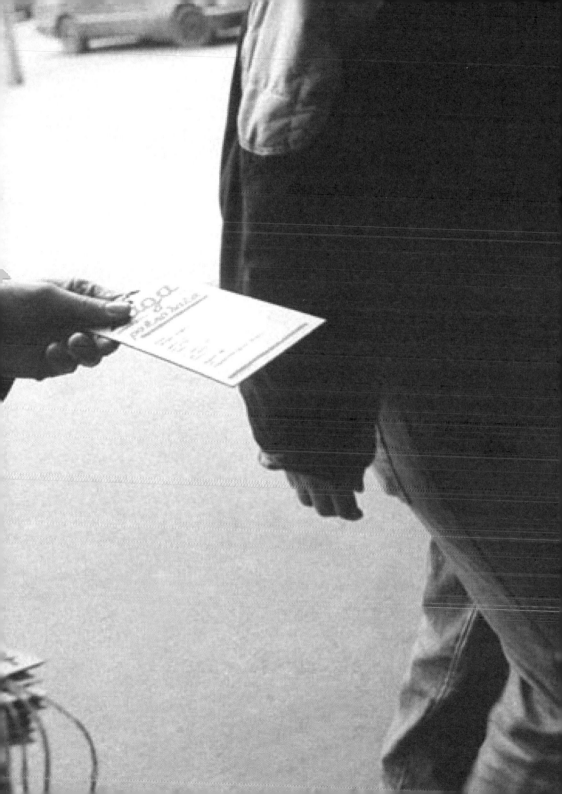

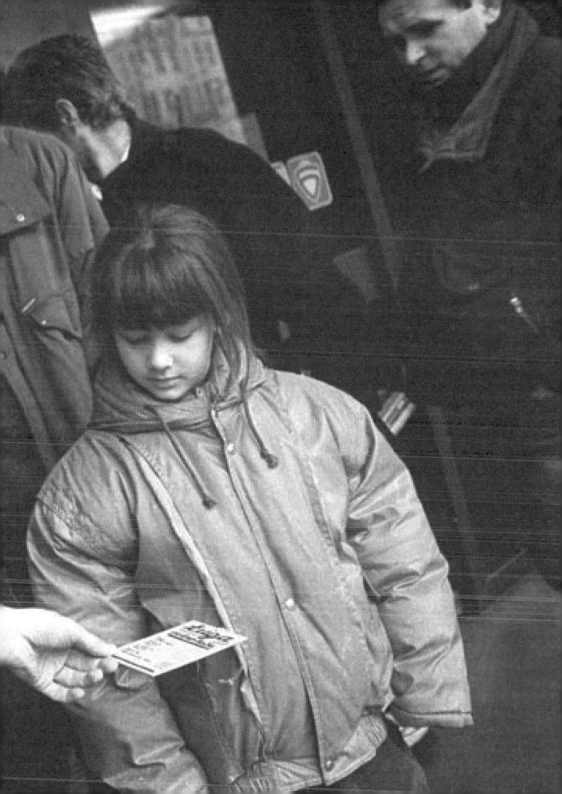

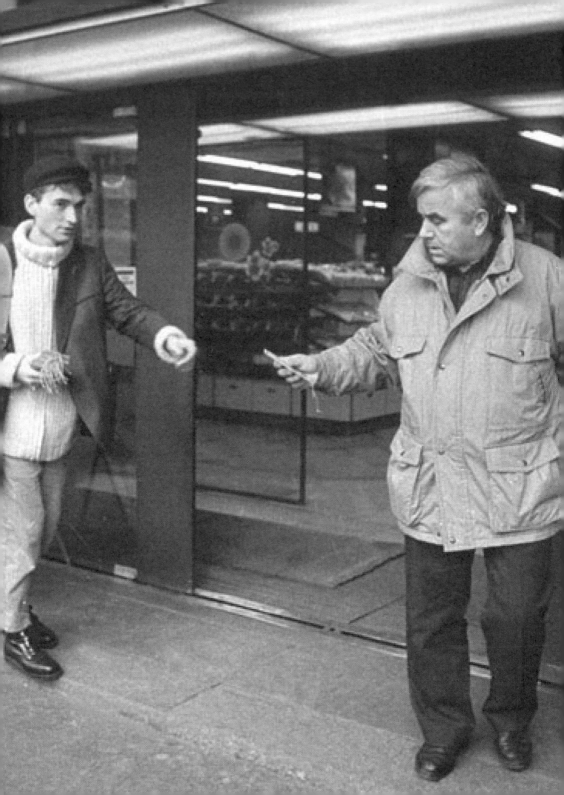

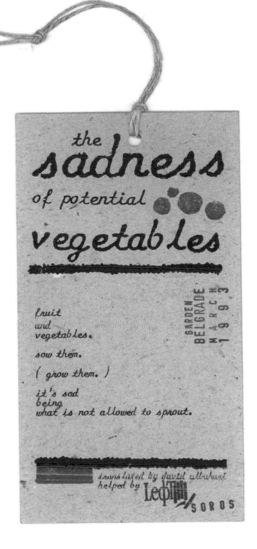

the
**sadness**
of potential
**vegetables**

GARDEN
BELGRADE
MARCH
1993

fruit
and
vegetables.

sow them.

( grow them. )

it's sad
being
what is not allowed to sprout.

translated by david albahari
helped by Leo / SOROS

65

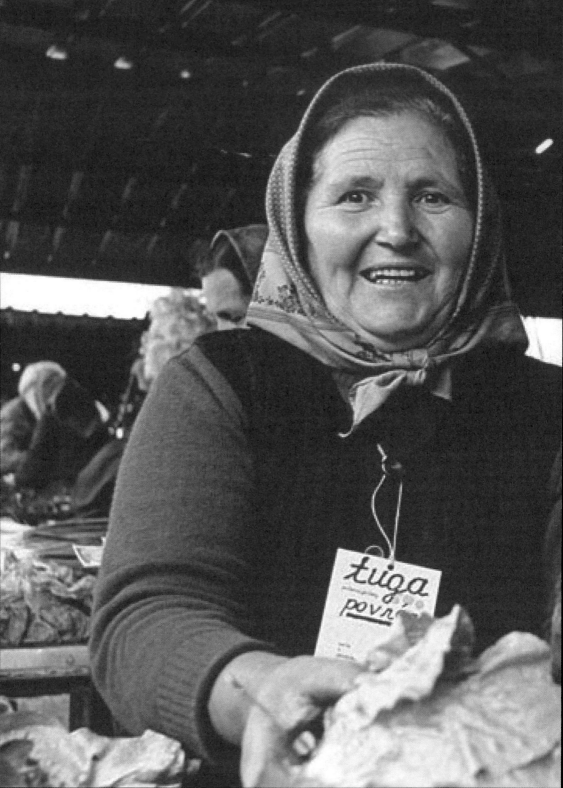

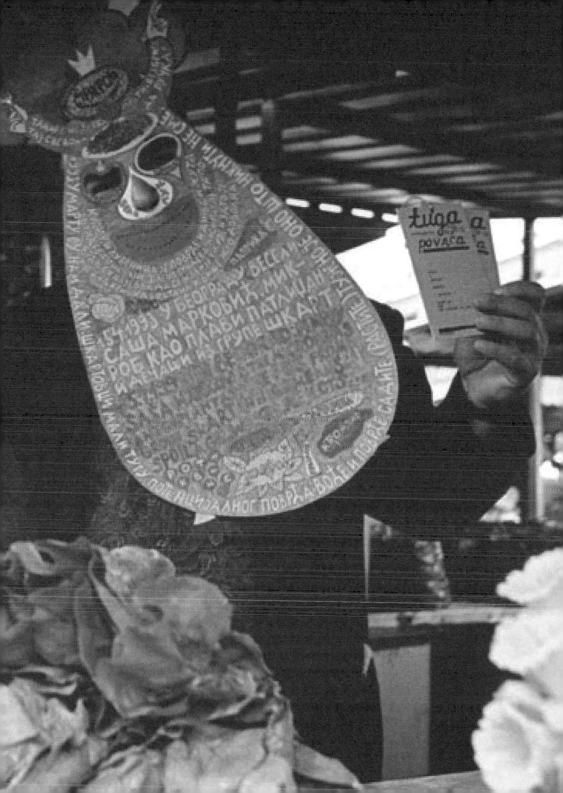

# PART 2: 2000-2010

# The beauty of working together

When the Yugoslav Wars ended in 2001, the fighting may have ceased but the fallout it created — trauma, social fragmentation, and isolation, as well as the lack of institutional infrastructure — continued to rumble on throughout Serbia in the 2000s. For Škart, collective work was a way to overcome narrow individualist interests during a turbulent time, offering new configurations regarding the relationship between art practice, collective desire, activism, and solidarity. The first principle was unity, joining forces to build more just worlds. From the early 2000s onward, Škart's practice started to evolve more collectively, bringing together numerous collaborators through social gatherings — choirs, embroidery groups, poetry writing workshops — which are free and open to anyone. The desire to be in a group, act collectively, to share life and create work that overshadows authorship became part of the shared ideology of the collective.

Škart has been a supporter of individuals and groups. They have collaborated not only on

social terms (inclusivity and publicity), but also by creating economic opportunity. They defend an art economy that is based on cooperative networks in which anyone can find themselves in the role of an artist, being creators themselves. These engagements are not always a set of intangible social relations; they sometimes take the form of physical objects (without being conditioned by products at all). Considering Škart's reluctant relationships with art and culture institutions it might sound contradictory that some of the tangible results, later on, like embroidery pieces, are sold as art objects; and that collectors or museums buy them. This marked the group's initial engagement in the art market, though it is a very rare exception. Yet with respect to the moral economy of participatory art, the question that has to be asked is: who benefits from this? It is important to note that Škart did not only take advantage of the situation themselves. In the case of sales, the income would belong to the participants, as in the case of embroidery pieces. And such is the twist of instrumentalizing circuits of art through means of benefiting from institutional sources on practical terms.

Seda    Since the early 2000s you started to collaborate with single mothers and organised various embroidery groups. How was the embroidery group NONpractical Women formed?

Prota    We got funding from Akademie Schloss Solitude in Germany for three months between May-July 2010. As a trial, we formed an embroidery group working with Yugoslav immigrants in Stuttgart, since Yugoslavia was still at war and there were many migrants there. After our return to Belgrade we initiated another embroidery group together with refugee single mothers. And this was how it started.

Fig. 37    NONpractical Women *(NEpraktične žeNE)* embroidery group, performing at the main square in Belgrade, September 2001

Seda    You often talk about the necessity to establish a flat-hierarchy while working with groups. How does this work exactly? I can imagine approaching a group – who may have no familiarity with art, or who suffered from a traumatic experience – with an idea to develop a collaborative work could be problematic since this could lead to a toxic climate of over-expectation. When you first approached these women did they show any interest in collaborating with you, particularly considering their circumstances? How did you build trust with them? Was it a process?

Prota    It developed from our collaborations since the 90s; thanks to the Women in Black association we were first introduced to. At first we just went there to see what they were doing in their everyday lives. In all of these groups of minorities, which are fragile and endangered, the system tries to make them passive them as much as possible because "only a perfect victim is a good victim". Try to imagine; all of these ladies

with their children are collectively mourning their husbands and brothers who were killed in war. And they were making flower motifs on embroideries; a traditional repetition. A mute repetition. When we arrived they were not eager to do anything at all; we just started to talk to them and made notes from our conversations. We didn't anyhow glossily present ourselves as artists. The first week we only talked without a proposition, and after we reshaped their quotations into rhymes for embroidery pieces. I knew if we directly asked them to write or draw something for embroidery they would be blocked—it is a challenging process. So we just introduced the idea. We wrote down and shaped lyrics which were their products, it was only a bit more skillfully prepared. One day the woman who initiated the association said: "You know our friends Prota and Žole who used to come here, they wrote something" and then started reading these lines. Then each woman recognized their stories. "Okay, choose a story and make an illustration if you want", she said. So this was our slight entry into the group. In a couple of weeks they came back with embroideries and suddenly there were 25 beautiful presentations from their personal positions, thoughts about war, different aspects of family life, or emotional statements. They were very proud to see how their personal statements can be equally important in this extremely political society; and sharing them while using a traditional, common skill they already knew from village life. And till that moment they have been making embroideries of flowers, but they were not encouraged to use it another way. So we introduced this idea that they could use embroidery to raise their own voice.

Seda    This was also how you met Lenka [15] for the first time?
Prota   Yes, it was September 2000. Lenka was in the same group; she was also a single mother who lost her family. Her husband, three brothers, their wives and children were killed in the basement of their house in Kosovo by the Serbian army.

Seda    I remember very well the night she appeared onstage to perform her embroidery statements out loud. It was such an empowering encounter to see the way she is attached to these embroideries, and that she has been producing them for 20 years; to speak up, to share her thoughts, emotions, everyday life experiences in a very brave manner. Maybe we can also talk about the alternative economy these embroidery pieces created for these women. And this was your first introduction to the art market, as you also

[15]
Lenka Zelenović is one of the members of the NONpractical Women (NEpraktične žeNE) embroidery group that Škart initiated in 2000. Members work with embroidery to express their thoughts, feelings, and social criticism, taking the art form beyond its traditional boundaries of "craft" or "women's work. After many years of collaboration, Lenka organically became a member of Škart collective, as Prota and Žole call her today. Some of Lenka's pieces, besides being shown at poetry festivals, exhibitions and protests, are among museum collections.

encouraged and motivated the women to exhibit their pieces in an art context, and to sell them as well. Also, today Lenka's embroidery pieces are among private collections, as you helped her to sell some of these pieces, which provided a small income to support herself and her daughter. And you also invited her to your exhibitions; at October Salon you exhibited a series of these embroidery pieces too.

*There is no time for conversation*
*The lunch needs to be prepared*

Lenka Zelenović, NONpractical Women (*NEpraktične žeNE*)

Fig. 38          Lenka Zelenović performing her embroidery pieces,
                 Belgrade, 2019

**Prota**     That workshop with the single mothers association only lasted over the summer actually. Somehow after the first opening none of them were ready to continue making embroideries; maybe they felt it was an obligation to the association, or maybe they did not consider it as a personal fight. Only Lenka from the group took it as a personal tool for fighting and freedom. We also paid a small contribution for each of the embroideries she made, and now she has almost 300 pieces after 20 years. It was maybe not a lot of money, but it was enough, for example, to renovate her kitchen, or to buy another piece of furniture. But this income that came from embroidery-making made her proud. We also met with her weekly, it was a friendly catch up with hot chocolate or coffee drinking, sharing stories, money and embroideries. Nowadays she rarely does embroidery pieces.

**Žole**     In 2001-2002 we did an exhibition in Novi Sad and we put these embroideries in the vitrines of the city library. We asked interested passersby how much they were willing to pay. Imagine that each piece is 2-3 days of handwork, but nobody was willing to pay more than 5-10 EUR, simply because people didn't have money. The only possible way to sell them was through our connections; sometimes a foreign curator was visiting and asked to buy them as a gift. Between 2008 and 2010, I exhibited them in London a few times, and sold a few of them, each for 100 GBP. Prota also did an exhibition in Leipzig, so that was the first time we deliberately entered the art market, but we are not brilliant managers I have to say... Maybe our biggest sale was 15 pieces to FRAC, a French-state funded collection.

**Prota**     Another important thing, she was fired from her work and still needed 3 years of work to be able to retire. And thanks to these embroideries she was able to join the association of applied artists in Belgrade, and this is how she managed to get papers and make it to her pension period. So now she is an official artist and she gets a pension! This was the biggest success for her.

**Seda**     You also initiated a men's embroidery group; again in the early 2000s? And how did that go?

**Prota**     Žole started it in Albania in 2003.

**Žole**     We were invited to exhibit embroideries at the biennale in Albania, and it was very strange. So we were going to the museum to install the show and asking people on the streets where the museum is, and I realised that nobody knew where the museum was... I said okay, I don't want to go to the museum; I will exhibit embroideries right here in the center, in front of the opera building with thousands of people passing by. And it was the best way to reach people instead of displaying

them in a museum that nobody knows how to get to. So I stood 5-6 hours each day, guarding them. While waiting, I thought, why not start making embroideries myself? Because there were no men embroidering, so why not? Because the Balkans is very male-dominated and embroidery is considered a 'women's thing'. So I collected some friends from the choir and we started doing actions in Belgrade; in the streets, cafes, or restaurants, making embroideries with a group of men. Prota also did one action in Macedonia, and we did another one in Korea when we were invited by the biennale. It was also interesting to see that actually men did not feel the need, or urge to express themselves, like Lenka, or Brigeta did. It didn't work that way with men.

Figs. 39-40    Exhibiting women's embroidery in the main square, Tirana, Albania, as part of Tirana Biennial, 2003

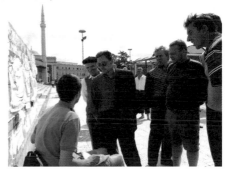

Prota    However it worked another way; maybe not as a continuous production based on the necessity to express themselves but as an anti-patriarchal performance. Most people were shocked to see these actions on the streets. I remember we had one action in Gdansk, Poland; a man was staring at 4-5 of us and said, "This is the end of the world, men are doing embroidery!"

Seda    True, it was very powerful to attract attention, even though it did not last longer.

Prota    It lasted 2 years, here and there... At first we were teaching men how to do it, then we were going on the streets. Maybe some other artists would call it a project, but for us when something doesn't last 10 or 20 years we don't call it a project...

Seda    Let's maybe talk about choirs in more detail. Parallel to these embroidery groups, you initiated a few amateur choirs which lasted for years, with different

groups including pensioners, or orphaned children. The first choir you formed in the early 2000s, *Horke-škart*, is still running for example. By the time some of these choirs faded, or gave birth to others, some people who left *Horkeškart* later formed another choir, *Proba*, which also joined various exhibitions together with you, traveling to Venice Biennial of Architecture in 2010, representing the Serbian pavilion. But I want to start with the first one, which was in a way organically formed after your performance at Center for Cultural Decontamination in 2000. How did the choir function, and what was the repertoire like?

Žole     At the beginning we were singing songs from the Socialist period; songs of rebuilding the country. After the first performance at the Center for Cultural Decontamination we decided to continue, according to the suggestions of the choir members. We practiced in schools, Rex, libraries, and arranged everything on our own. You know it is not an easy job to gather 50 people. It was at first me and Prota who did all of the organization. But from the beginning it was my idea not to serve the group all of the time but instead to form something that can last after us, on its own.

Maybe embroidery was more of Prota's section, and choir was mine; which I'm mostly proud of because we succeeded to work with 50 people for six years, and ended up introducing the idea of self-management to them. You know it is very typical that political party leaders, and founders stay in power till the end... We initiated *Horkeškart* in 2000 and separated in 2006, but they are still running under the name *Horkestar*, which is beautiful.

Seda     What was maybe unique about the choir was that you were mainly performing on the streets, at farmer's markets, schools, refugee camps in Serbia. And also traveling not only through Yugoslavia but to other countries, too.

Žole     We wanted to perform at unusual places where the choir normally doesn't go, and it was our habit from the 90s. We continued to perform in the streets, which was possible at that time. Nowadays if you want to do the same you need permission. Then we had a friend who had a connection to the refugee camp, which hosts Romani people from Kosovo. So, we went there and organized a concert. It was absolutely beautiful, they immediately started accompanying us, singing and dancing.

Fig. 41 Choir *Horkeškart* performing in Skopje, North Macedonia, 2003

Fig. 42 Choir *Horkeškart* performing in Ljubljana, within the frame of Mladi Levi Festival, 2006

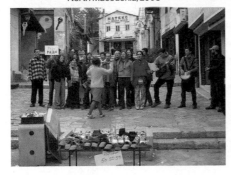 

Seda     Also in 2005, you travelled altogether to Stuttgart's Akademie Schloss Solitude, and to Kassel to join the exhibition *Collective Creativity*, which was curated by What, How & for Whom (WHW) at Kunsthalle Fridericianum. How did you manage to convince the institutions to invite you as a big group? In terms of logistics it must have been very difficult to organise?

Figs. 43-44 Choir *Horkeškart* in the refugee camp Kraljevo, Serbia, 2001

 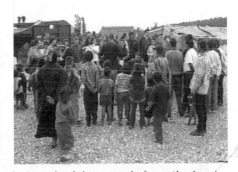

Žolo     It was! But with the choir we had three goals from the beginning; first to perform music from the socialist period – because the government in Serbia changed in 2000, Milošević fell from power so we thought it was a breaking point. We wanted to offer an optimist repertoire by choosing songs from the 50s and 60s which are about rebuilding the country. The revision of history was introduced rapidly and people who got power wanted to erase the past; the first thing was to remove the communist idea, which was believed to have broken Yugoslavia; to present communists as bad guys, and nationalists as good guys... Now they are achieving this in Serbia, reversing history. But with the choir we wanted to keep the memory of that socialist past, and also

tell our version of the truth. And lastly, the choir members were mostly young people in their twenties who never traveled outside of Serbia, so it was important to provide them with a chance to travel abroad.

Prota     Because of ten years of isolation; they were 10-15 years old when the war broke out and after the isolation period followed; so they were never outside of Serbia.

*Backwards*

*backwards to dark*
*they signal to us*
*backwards to flaws*
*for ancient cause*
*backwards to mud*
*dip your calloused hand*
*backwards to battle*
*for your motherland*
*backwards to calamity*
*both village and city*
*both olds and youngs*
*let's all go backwards*

*backwards!*

(performed by *Horkeškart* and *Proba* choirs first in front of Serbian Academy of Science and Arts, Belgrade University, Serbian Orthodox Church, Supreme Court of Serbia and Serbian Government, first in 2006. Translated by Milan Marković)

Fig. 45     Choir *Horkeškart* performing during the exhibition "Collective Creativity", Kassel, 2005

Žole  The idea was to share our privilege, or opportunities with them; so whenever somebody invited Škart we wanted to bring the choir with us too.

Seda  **But how did this work on a practical level? I also remember the Venice Biennale rejecting your idea maybe also because you wanted to host a choir of 50 people singing at the opening...**

Žole  It was extremely hard but we succeeded. In 2001 we went on tour to Croatia, Zagreb and Istria, on 2002 to Montenegro to join Cetinje Biennale, and we had a mini-tour of concerts traveling to remote villages, elementary schools around the city. In 2003 we made a tour around North Macedonia. In 2006 we joined the festival "Moje, tvoje, naše" in Rijeka, Croatia, and later in the year in Slovenia and Slovakia. First they would invite us and then we were looking for sponsors. It was difficult of course; in summertime we were staying in tents, sleeping on floors but we still managed to do it. In Montenegro we found very poor accommodation for three days; we rented a bus from Belgrade with a private sponsor's help and yet it was the most brilliant tour ever. The bus was the biggest expense. We were paying 1 Deutsche mark per km.

Seda  **Who finally supported these tours? Mainly private foundations? Were you also able to get financial support from the state too?**

Prota  They were all private foundations; Rex and the Center of Cultural Decontamination for example. And we were also thinking of asking our friends to contribute.

Žole  I remember that Pro Helvetia supported the tour to Croatia; and also to Germany, together with another German foundation. In Macedonia the Swiss Embassy supported for example.

Seda  **And during this trip to Germany something surprising happened; you found a label – which is actually based in Japan – and recorded the album, *Live in Solitude*, at Akademie Schloss Solitude in 2006. This is maybe one of the rare traces of your years-long work with the choir.**

Žole  It was our second album actually. The first one was recorded in Belgrade, in a church. Then I met this Japanese guy – again a friend of a friend – who liked our music. After we recorded the second album with the choir at Akademie Schloss Solitude. Yoshio Machida proposed to release it through his label in Japan, *Amorfon*.

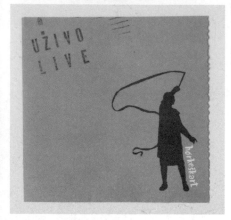

Seda    And that same year, after six years of collaboration, you decided to separate from *Horkeškart*. What happened? And right after the break up, some of its members formed *Proba* in 2007, with whom you also collaborated.

Žole    People involved in *Proba* were the ones who left *Horkeškart* as they wanted to be more socially engaged. After some time, *Horkeškart* wanted to semi-professionalize and work with a professional conductor too, so it went in another direction. And the majority of the group also wanted to play with rock pop stars on stages rather than on the streets. Now they are really well trained and have proper concerts. Some people gave up also because there was a hierarchy in the group. They realized the conductor and the musicians put themselves prior to others and some people didn't like it and left. Then they formed *Proba*, which means rehearsal, with ten people, in 2008. We continued performing in unexpected places, and this time the repertoire consisted exclusively of our songs. Also, we introduced another method; instead of having a concert in front of an audience we went to the stage, rehearsed one song then left the lyrics to the audience, and came back 1-1,5 hour later to rehearse together with them. After 90 minutes of rehearsing together with the audience, we would sing the songs altogether. So the concert was a public rehearsal, and it functioned very well for me, since it was not patronising and we put ourselves at the same level as the audience. Until 2014 we continued collaborating together.

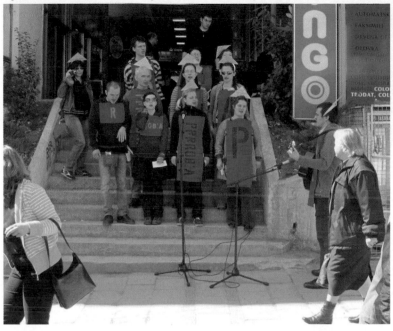

**Seda**    I also want to ask about the other small, rather short term choir projects you initiated during the same period; Prota, you especially were working with children and pensioners?

**Prota**    A children's choir started in 2008 at Bela Crkva, a small town on the border with Romania. There was an orphanage where we did a project together with **Group 484 *(Grupa 484)*** [16]; and the choir was also formed through our continuation of previous visits with Grupa 484. It was called *Moon Children (Deca Sa Meseca)*. And after, we formed another children's choir in Belgrade, *April Dragon June (Aprilzmajjun)*. The method was similar; we wrote and composed new songs for kids rather than repeating classic children's songs. We composed songs out of their everyday experiences, speaking with them. We created poetry on them and together with them. So the repertoire is almost like their CV; songs about how one girl broke her arm, how one guy likes to take a shower in his socks as he feels safe with them on... Such small, bizarre and beautiful things. We also traveled together; because it was very important for these children just to leave their gated community and go somewhere else. We visited villages, schools, different festivals and they have been very proud to sing songs themselves. Also for the audience it was a beautiful experience as the repertoire was unique.

16
Group 484 *(Grupa 484)* is a structured organisation with a systemic approach to forced migration and migration in general, in direct contact with migrants and refugees in our country and with a developed educational programme that places migration issues in a broader social context.

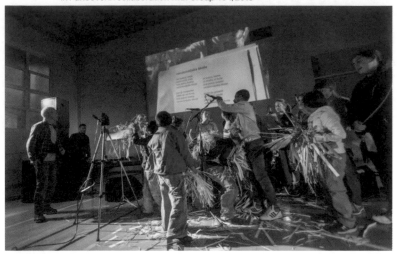

## WHAT DO THE RICH DO WHEN THEY DON'T DO ANYTHING?

*I'd ask the rich*
*If they have to work,*
*And what they do*
*If nothing's what they do.*

*I'd ask the rich*
*While they sleep and yawn*
*Why not share their money*
*With those who have none.*

*I'd ask the rich*
*If they have any friends*
*Or they just collect*
*Interest and someone's debts.*

*I wouldn't ask anything.*
*But you should hear my voice.*
*I don't know anyone rich.*
*All I know is us, us.*

(From Vera Radivojević foster care house in Bela Crkva, Belgrade, 2021)

17
**Ana Hofman** is an ethnomusicologist and anthropologist who is interested in music, sound and politics in socialist and post-socialist societies, with an emphasis on gender, memory and activism. Her research practice is focused on activist choirs in the area of former Yugoslavia and the sensorial politics of sound in relation to the current crisis of neoliberalism.

**Žole**     Then we started another choir with pensioners in Belgrade. What was really important for us about these choirs was that we were indeed forming communities; people were becoming friends, new collaborations were appearing. Even a few people who met in these choirs got married. We were also going to their weddings together... It was beautiful to see these side events come through just from hanging out together. We made a community.

**Prota**     Also, I think when we founded the choir *Horkeškart* in 2000, it was the first independent alternative choir that came out after the war. Later on, each former Yugoslavian country started to form their own choirs. Ethnomusicologist **Ana Hofman**[17] talks about these activist choirs in detail. Today there are many alternative / amateur choirs in Croatia, Serbia and Slovenia, but *Horkeškart* was the first.

**Žole**     As far as I know, after *Horkeškart*, Volkspopoli was formed in Belgrade, in 2005. Then Kombinat from Ljubiana, in 2006 and then Le zbor, cipkice, ck3 from Zagreb, Raspeani from Skopje, etc.

Fig. 50     *Better Bitter than Sweeter*, Poetry circle of The Zrenjanin Center of Gerontology performing at the Belgrade Cultural Center, 2015

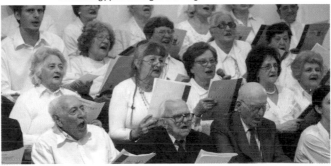

# Rethinking workshopping

Škart has been using the workshop as a tool for active empowerment, creating a situation to be experienced, to interact with anyone involved. Workshops create a common space for learning with and alongside others, deconstructing authorship from the outset. During the first decade of the 2000s, they initiated mostly local, long-term and community-based engagements with orphaned children, pensioners, single-mothers and immigrants, sharing knowledge and techniques of poetry-writing, embroidery-making, and storytelling. These gatherings mainly focus on giving participants the opportunity to let their voices be heard. In this methodology, Škart acts as a mediator; setting up an infrastructure and providing the necessary tools, and leaves the rest to the makers. Participants are involved in the whole production process which allows them to share their reflections and stories. Thus, a workshop becomes a tool for self-connection, as one becomes evidently proud of their skills and their knowledge. Facilitating the narratives

of the group, fostering their imaginations and sharing their desires; Škart opens a road for social, psychological and individual empowerment. In these examples — of which only a few have developed into a tangible product like a zine, video animation, or an embroidery — here it is not possible to refer to an artist-figure who creates a "landmark" work in terms of collaboration. On the contrary, the work is, as it were, the sole and exclusive creation of these very people.

Such community works are mainly realized locally and as long-term engagements. Another example of a workshop which took place outside of the region was in 2009; Škart moved into Peppie Close in Hackney, London (outfitted to house and care for the African Caribbean elderly) for two-months. The group worked with the elderly on poster making, using participants' personal stories as source material. However, a few trials which were rather short-term, took place outside of the region and were marked as failures too, creating a difference of opinions within the duo about the idea of work-shopping. Workshopping; is it learning by doing, or does it create fast-food art?

Figs. 51-52    Škart together with the residents of Pappie Close Elderly Care House, Hackney, London, 2009
               Realized within the frame of the residency program of SPACE.

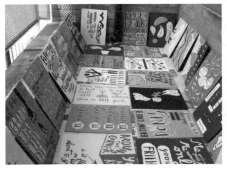
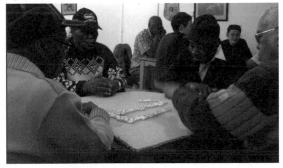

Figs. 53-54    Škart together with NONpractical Women (*NEpraktične žeNskE*), Mladi levi Festival, 2021

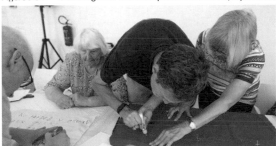
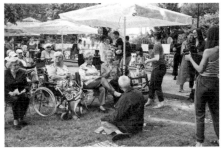

Seda    After 2010, you started working with the workshop format often, mostly collaborating with children from minority communities, and migrant or diaspora backgrounds on collective storytelling. An example of this is *Paper Puppet Poetry* (2019) in which children share their everyday experiences by crafting paper puppets, and performing their stories onstage. I'm interested in how this format evolved over time, because you later applied this same workshop when working with different target groups too, including the pensioners for example.

Prota    Through puppet theatre performances, children create stories, and speak about their relationships with their grandparents, or, for example, their bad meals which they hate in their *menza*. So, very simple, everyday life stories. And they also got the chance to travel around a bit. Together with Žole we did the same workshop later on with pensioners in Slovenia. It is very interesting to see how a tool for kids later could become a tool for pensioners. Afterwards we applied it to a collaboration with migrants and we performed in some places, also outside the region. We once worked with a group of children in Sweden too.

Figs. 55-56　*Paper Puppet Poetry*, in collaboration with Reza, at Belgrade Asylum Center, 2019

Fig. 57　*Paper Puppet Poetry*, developed at Borderline Offensive artistic residency in Košice, Slovakia in 2018

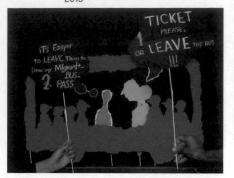

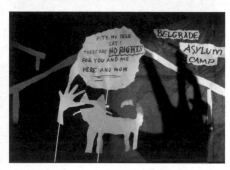

**Seda**　I want to discuss this idea of using workshops as a tool to reach different groups, as you just mentioned that it can be used anywhere and applied to other contexts. I wonder, what could be the limitations, if there are any? Maybe language? Or a short amount of time spent together? What were the challenges especially when you organized these workshops abroad?

**Prota**　Language is not a limitation at all actually; if you have a good translator and local collaborators, it works perfectly. Because everything depends on the kids; they create stories, they animate and act. You know, we are actually almost outside of the content creation aspect. I am maybe filming these animations but they are the authors, and this tool makes them the real author.

*Pilnot*

*when asked*
*by a stranger*
*what to become when*
*get*
*grooooo*
*wnnnnnnnn all my friends seveners-kids*
*one-voice-screamed pilot!*
*and I said*
*squirrel*
*— what?*
*squirrellll llllllllllllllllllllllllllllllllllllll*

(From Nordic CORNERS expedition, poetrying based on a story heard in Lapland, summer of 2011)

**Seda**    I also find it beautiful how working on the same methodology which you developed locally could then be applied to the global level. However, I remember that Žole had some concerns regarding these workshops taking place abroad, mostly because they are realized as short-term projects. Žole, what didn't work for you? Or what could be a better methodology, what do you think?

**Žole**    I am not sure how these workshops could work on a global level. You know, workshops first became popular in the 1990s and more and more from the beginning of the 2000s. It was very popular for people to meet and exchange ideas, and soon it became the idea to get funds too. But I was not sure what people really learn from it. When meeting new people, I need time to create a closer intimate connection, but Prota could just jump in a group and initiate conversation easily. My idea was that people must learn something from a workshop, or got inspired by something. If you achieve one of these things, then I would call it successful. It often happens that participants are not makers themselves. It is also difficult to do this in a short, limited time, as some people need more time, like me. From 2011 to 2016, we joined the project *CORNERS*, which had the idea to unite artists from remote places, including the Balkans, Georgia, Turkey and some villages from the north of Sweden, to develop an artistic project that could be applicable in different parts of the world. The organizer's idea was basically to bring these artists to Sweden, Turkey, or Serbia, like parachuters, and put them in a place

to enlighten the whole society in one week. I told the organiser, "So you want to make McDonald's art, which can travel anywhere!" And why am I skeptical? Art, especially in our case, as in the Škart case, relates to our context, Yugoslavia. Our workshops and choirs worked far better in the former Yugoslav countries when there was no language barrier for instance. Once we tried one in Poland, and another in Sweden, but the moment you get a translator you lose a bit of Prota's charm, language, or convincing skills. In Sweden, some children came to the workshop, but they had no idea about us. I remember they were not interested at all, and we almost created the work by force. We tried to improvise but it was not natural, not fluid. And it was just two days. So without local collaboration it doesn't make sense to me. It could function another way, like I work with my local team in Serbia, develop a work and then maybe we invite another team from another place to share knowledge and experience in exchange, careful not to force participants to do something reluctantly.

Figs. 58-59    From the workshop series *CORNERS*, 2011-2016

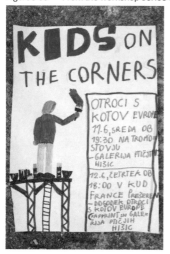

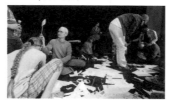

Fig. 60    *CORNERS*, Papyrint workshop with children in Ersboda, Sweden, 2014

Seda    I understand your concerns, but it does not necessarily mean that the format would not work at all. Maybe there is a language barrier, cultural differences, or time limitation; yet despite the many differences in all these peripheries, I believe people have more or less similar experiences. Maybe it doesn't matter to a great extent if you are an abandoned child, or a pensioner in Turkey, Georgia, or Serbia, because how society classifies these fragile individuals is very

similar. And interestingly, the everyday stories of these individuals, complaints or wishes are similar as well, like complaining about food, the feeling of being oppressed, or not being important to someone. The secondary feeling is maybe the commonality, so if there is an approach, a methodology that could trace these human gestures, commonalities, I wouldn't call it McDonald's art. It is true that once applied to another context, this workshop format could require certain adjustments; but this is also part of our job, to explore and provide meaningful conditions, no? I also believe that instead of saying no to McDonald's art directly, as you do Žole, one should take lessons from such failures to come up with certain adjustments. I'm very aware that this is a slippery ground and one must be aware of its challenges to initiate a meaningful encounter, and still be aware of one's own position and stance.

Prota     I totally agree.

Žole     The participants have to be willing or interested, otherwise you can't force them to come and produce something together. It doesn't work like this. You have to prove yourself in front of them with a skill, or somehow seduce or impress them with a brilliant idea so that they can trust you and become interested in joining and realizing something together. Otherwise if you just appear and give some free materials, children would ask, why am I doing this? Maybe the only advantage for them would be to skip their class, and this was my feeling in Sweden. In that sense, the best artist for me is a street musician: a street musician offers something to passersby, something that no one expects or asks for; the music could surprise them and the viewer is free to decide whether to listen or not.

Prota     At the same time, your investment is zero; you can ignore the musician, or just observe the musician from this class-driven position, as if the musician is a clown and you are privileged to observe them.

Žole     But if that workshop was not obligatory, none of the children would have come.

Prota     In Sweden it was a three-day workshop and on the fourth day you are asked to have a result. And yes it was imposed; you have families, organizers and all these "if" questions... It is very stressful and does not work. I understand that, for Žole, working under stressful conditions brings double stress. But as Seda mentioned it can be used as a tool. For example, children in school could use it, a teacher could use it...

**Žole**    Remember the last conversation with this guy; I said it feels like we are landing with a parachute to educate the people there and he said: "Yes, this is our idea, to bring a brilliant artist!" No, not at all... It was a bit patronising, people didn't ask for us to be there and it is kind of like intervening in their lives.

**Prota**    True, it is colonizing in a way.

**Žole**    I believe in finding other ways to work. But we also continued working with workshops that focus more on practical skills. We did political poster workshops in Graz, Rijeka, or at the Athens Biennale in 2013 with Cactus Studio from London, inviting other graphic designers and activists too. We developed this idea for the workshop that lasts 5-6 days, and then applied it in Rijeka, Novi Sad, Graz, and later at the Athens Biennale in 2013. The idea was to produce political posters with students and also to teach them the skill of screen printing. Then the team worked on expressing their ideas themselves. For me this kind of workshop, which is a combination of sharing skills and knowledge, works well.

Fig. 61    From the printing workshop *Developing a Visual Voice*. Realized within the frame of 4th Athens Biennale AGORA, 2013. Together with Cactus Network and Tzortzis Rallis, 2010

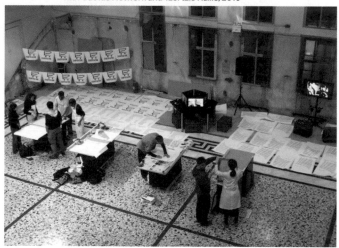

Fig. 62     From the *Community Poster Workshop*
hosted by < rotor > association for
contemporary art, with Cactus Network
(Tony Credland and Glenn Orton), 2010

Figs. 63-64     From the Radical Poster Workshop, Rijeka, 2016

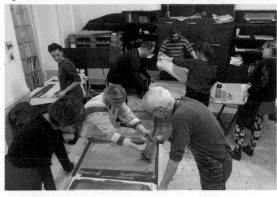

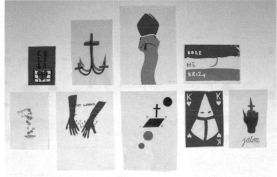

1

2

3

На машини прошина
у фабрици тишина

4

Ako kažem da je mrak, zato veze pojesti me

5

mak, poješće me

lepo cveće,

niko

neće

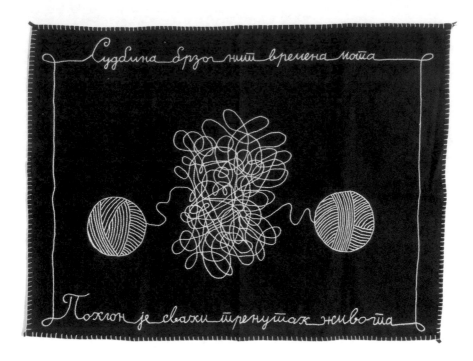

Судбина брзо нит времена мота

Поклон је сваки тренутак живота

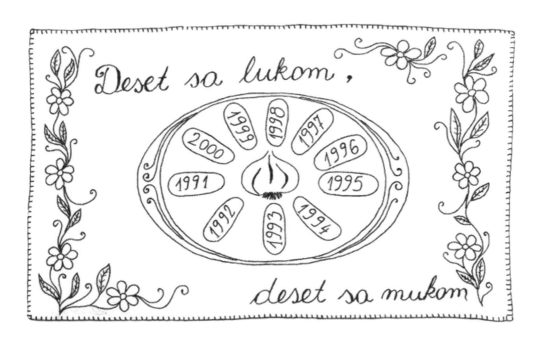

Deset sa lukom,

2000 1999 1998 1997 1996 1991 1995 1992 1993 1994

deset sa mukom

8

9

**1**

*please tell me to whom*
*war will bring the spring-bloom?*
by Lenka Zelenović, NONpractical Women, 2000

**2**

*the banks are awakening false hope*
*their loans push us to the end of our rope*
by Brigita Medjo, NONpractical Women, 2005

**3**

*smiling faces in my town*
*billboards and obituaries are all around*
text and embroidery: Brigita Međo,
drawing: Vladan Nikolić, 2014

**4**

*on machine is dust*
*in factory is rust*
by Lenka Zelenović, NONpractical Women, 2005

**5**

*if i say it is darkness*
*the darkness will eat me away*
*so i'm making pretty flowers*
*forever safe i will stay*
by Milka B, member of Single Refugee Mothers
Association ZENA, Zemun, 2000

**6**

*rolling up strings of time is swift*
*every passing moment of life is a gift*
text and embroidery: Brigita Međo,
drawing: Vladan Nikolić, 2012

**7**

*10 with onions*
*10 with sickness*
collective work by Single Refugee Mothers Association
ZENA, Zemun, drawing: Dusica Tomić,
embroidery: Lenka Zelenović, 2000

**8**

*up until recently I was getting my pay*
*holding this placard is all I can do today*
by Pava Martinović, NONpractical Women, 2016

**9**

*first goes seeds*
*then goes harvest*
*then goes village fair*
*then back to seeds nest*
by Kovačica Embroidery group, 2000

**10**

*lie currents through kitsch veins*
*absence of idea, emptiness remains*
text and embroidery: Brigita Međo, drawing: Vladan
Nikolić, 2020

# Exhibition as a living thing

Škart chose to take action outside of conventional museum spaces in order to reach a wider audience, leading art into everyday life. The collective has never been interested in "exhibition making" as it is known conventionally, unless the exhibition becomes a space of encounter that offers a real exchange. Despite largely operating outside of art and culture institutions, Škart is not completely isolated from the "art world." They don't totally reject the system, but the conventional rules of being in the system, or rather, the market economy. How to participate in this system is a matter of choice, and their answer is through creating alternative forms of art community — making art through participation. The group held a series of lectures and activities, organized concerts and workshops internationally and took part in various biennales mostly through collaborative and participatory work. In 2010, they represented Serbia in the Venice Biennale of Architecture, which was followed by their first solo shows in museums, however paradoxical that may sound.

Yet, exhibitions, for Škart, are also opportunities to gather the Škart family. As of 2010, Prota and Žole started to focus on their individual artistic practice besides, but still when Škart was invited for an exhibition, they would invite other members of the group, friends, or old collaborators to occupy the space together. It is through coming together that Škart creates an exhibition ritual, which is beyond the artwork's object-matter, investigating the ways we can "use" the museum and transform it into a social, active, open, and inclusive space.

Seda      I would like to talk about the period from 2010 to the present as you mentioned that you both started to focus on your individual practice, along with continuing to work as a collective, though maybe not as often as you used to? I'm particularly curious to hear more about your practice in the last decade, mainly your socially-engaged practice which took place, not in the streets, but mostly in collaboration with associations, as we don't have many traces from this period. What have you been focusing on?

Žole      Between 2013-2017, I was working in asylum centers in Serbia, making interviews with migrants, *Migrant Maps*. We started together, but then Prota did not want to continue with this work. And I made 16 large maps out of these interviews. Apart from this workshop, I was mainly working on my 160-page comic book-graphic novel from 2008 to 2018. And after ten years of work, it was published.

Fig. 65     *Migrant Maps*. Đorđe Balmazovic (Škart collective) in collaboration with asylum seekers in Bogovadja camp in Serbia, NN, Damascus, Syria (2015). Courtesy of the artist and Group 484

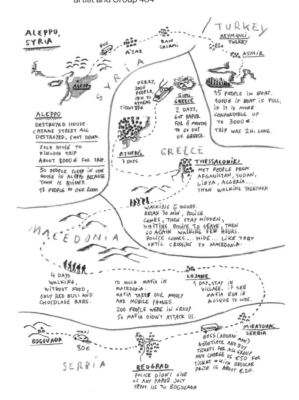

**Seda**     Why didn't it work for you Prota? Why did you decide to leave the project?

**Prota**     I never left it. We just had two different approaches; Žole was making maps and I was doing poems and embroidery with them and it was again a collaboration with Group 484. Žole continued on with the migrant groups and I continued working with orphan care centers. But it was also related. With some of the migrants I made paper poetry animations, for example. These things are quite connected even though we didn't do them together.

**Žole**     I moved to Ljubljana in 2016. At that time Prota started to work on his movie, which is still ongoing. I have never seen him so motivated and concentrated on something before! And since 2019, I have been working on the exhibition for MAXXI in Rome, drawing 365 calendar portraits of heroes.

Fig. 66     Đorđe Balmazović, *Calendar*, 01.03.2019 – 31.08.2020. Installation view, Bigger than Myself. Heroic Voices from ex-Yugoslavia, Maxxi, 2021

Figs. 67-68     Still from the movie *DUGA RESA* (Fringe Infringe), 2021

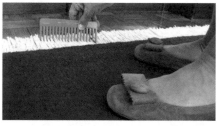

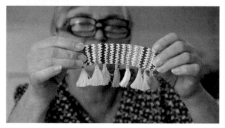

**Prota**     Before these, Žole was away for some period. He went to the UK and we started to do the poetry festival Pesničenje for a few years, from 2008 until 2013. And it was a big meal to prepare, a monthly event. We also toured a lot with this festival all around the former Yugoslavia. This was a new context for us too, and it also came from the choir experience. The choir members who wrote poetry were the first invited poets, and similar to no-audition choirs it was also a no-filter poetry festival; we didn't have any selection process, it was open to different approaches from pioneer punk bands to gerontology center choirs, or people who write in their small corners. So this really helped us to continue with these self-published book productions. In the meantime the things we

started early in 2010, like with NONpractical Women continued. We still work with them today; we meet weekly and tour together. Another thing that continues is the workshops at orphanage centers, but this year because of the pandemic nothing happened. Last year until April we succeeded in continuing to work with them. Some other opportunities began to emerge—we started to be invited as designers of exhibitions, and this is also an interesting process of using our design skills and architectural skills for somebody else, not only for us, but as makers for somebody else's ideas.

Seda     So the poetry festival started in 2008 when you were already in the UK, Žole?

Žole     Yes, Prota initiated it.

Prota     We were a group and they were the ones from the *Proba* choir. So all these groups brought others, that *Proba* came out of *Horkeškart*, and then Pesničenje came out of *Proba*.

Seda     To me the festival bears strong characteristics of your work; for many years it ran through self-organization and self-publishing strategies, which helped you to develop the sustainable structure of the festival. Would you like to talk a little about this, what the organization process was like?

Prota     The festival team was around ten people. At first we were invisible. We just invited the people we knew to come and perform and this is how it started. Each last Friday of the month, at 20:00, we met at Rex. Then month by month it became crowded. It was beautiful how each time you think that nobody will come because it is raining, or it is boring, or too many things are happening in the city on the same day... But each time it was packed and beautifully supported. Later it became so popular that we needed to limit the number of participants. The duration of the show was 1,5 hours or sometimes it lasted 3,5 hours... So we needed to limit it with 10-20 participants each night, which was a challenge for us, fighting with the structure that you need to keep practical through order.

Seda     And how did it fade out?

Žole     After 3-4 years less and less people joined. In 2010-2011 Rex was sometimes fully packed with three hundred people, but then in 2013-2014 it was less, like around fifty people came, so we decided to stop it. But over the years we never made an exception, only July-August was a holiday, otherwise we organized it ten times a year. And as

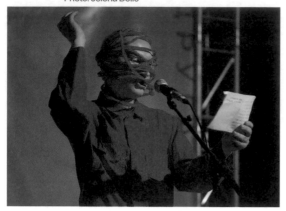

of 2015 we decided not to do it on a monthly basis. But for a while it was a place to perform poetry, and also to combine poetry with film, music, pop culture and performance. It was a hybrid event; when you came you really didn't know what you would see.

Prota    We also did side events around different villages, outside of Rex, travelling around Yugoslavia too.

Žole    They were also inviting us from Sarajevo, Mostar, Rijeka or Ljubljana to organise the same event in collaboration with locals.

Prota    Also in small cities like Vranje, Novi Sad, and village schools. Once you create the structure, the content then needs to have a chance to develop itself. Instead of having big shows in Belgrade monthly, I felt more intrigued and inspired to have small events at the village elementary schools or in the gerontology center, or any kind of place which is not predictable. That's how it continued. We published books for village kids too, and the pensioners. It became a new challenge to decentralise and dislocate the main event, to unpack it and make it also useful for small-scale events. And actually the poetry festival became again connected with NONpractical Women they had some shows by themselves, sharing their embroidery in the form of poetry. Luckily some other collaborators joined too. Now after 15 years of Pesničenje still some people I know or don't know talk about it, because sadly there is no longer a poetry festival in the city. I am glad that it also left some kind of invisible traces, this abandoned poetry club.

Seda    Was it also how you met **Mirko**[18], through the festival?

Prota    Yes, he was a regular. We traveled to villages together with Mirko, and the schoolchildren loved him! You know this huge guy screaming, performing poetry in a high-pitched voice.

18
Mirko (Mirko Petrovič Mirkobend), singer and writer, performing songs on struggles of mentally ill and disabled people became a frequent visitor at Pesnicenje, and later became a member Škart too, as Prota calls him.

Fig. 70     Mirko performing poetry, Belgrade, 2019

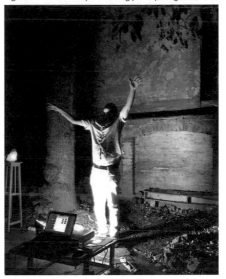

Seda     Let's try to overview your practice over the decades, as you also say that it is almost divided by the decade: between 1990-2000 you mostly worked with printed matter and street actions. The 2000s were marked by collective engagements, like choirs and embroidery groups. And afterwards, there was a focus on your individual practice, particularly after 2010. Prota already mentioned you still collaborate, but I guess the two of you don't have a chance to work together as much as you used to, also now that you live in different cities?

Žole     One reason is that I was absent for three years when I left for London. Actually now the place where Prota lives was our former studio, then Prota moved into that place, so it became his apartment. This, and also what I find also destructive to the group, honestly speaking, was the digital communication; internet, mailing, networking... It took a lot of time and also created distractions. So we did not have a common space, our studio, and it was slowing us down. I really think to exchange ideas we really need a physical space, not calls, mail... It was around 2015-2016 when we lost the studio. Pera, who is the 3rd member of Škart, also started to participate less and less. I still really miss working together as a group in that space, but maybe it was specific to that period and I have to accept it.

**Seda**  What about Pera? You call him a member of Škart, but I thought you only collaborated for the project in the Venice Biennial of Architecture?

**Žole**  Pera (Goran Petrović) was the technical mind in the group. He was extremely helpful when producing the seesaws in Venice. And also another work which was not that visible, but important for me, the poetry machine we built together for the Biennale of Contemporary Art ARK Underground in Konjic. A small city near Mostar. And the place is crazy, it is a military shelter, and was one of the largest underground facilities ever built in Yugoslavia, which was made to host 200-300 people. It was also made to host Tito and his wife in the case of atomic war. In Bosnia they discovered this shelter and some people succeeded in organizing the biennale. For the first edition in 2011, we visited the space. It is crazy that everything, even the furniture, is preserved and left as if it was still the 70s... So we proposed to produce this box, a poetry machine, which looks similar to the original wooden furniture there. It looks like a typing machine made of wood but inside we placed a computer, there is a button and it says you have one minute to recite a poem you remember. I think we collected hundreds of entries.

Fig. 71    Sketch for the poetry machine

Fig. 72    Installation view at the Biennale of Contemporary Art ARK Underground in Konjic, 2011

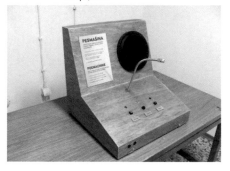

**Prota**  Also you could listen to the previous ones, the machine was randomly playing recorded entries. So anyone could become a member of this invisible poetry community. And Pera designed the machine; he is an architect too. We also studied together and he became our technical support. In the beginning, we worked as a graphic design duo and Pera helped us to learn all of these computer skills. He is the one who doesn't like openings or unnecessary social gatherings; he hates choirs, he is not part of that social Škart way of working. He is with us, as a member and friend working on a small scale.

Žole     When it comes to design he is a genius, an extremely talented industrial designer.

Seda     **So you were collaborating much earlier than the Venice project?**

Žole     Yes, he has been with us since 1997. He was helping us to do the prepress of the designs in the studio. And yes, he is extremely shy and doesn't go to concerts, or exhibitions so he is sort of invisible in our work. He only came with us to Venice.

Seda     **Maybe now is good timing to talk about your partici-pation in the Venice Biennale of Architecture. You rep-resented the Serbian Pavilion in 2010, and the case was like this; Žole didn't want to join, Pera wanted to go because he needed the money and Prota wanted to give it a try. Could you talk about the participation process, how did it happen?**

Žole     The Serbian Association of Architects was responsible for the selection and they made an open call for projects. Actually, we heard about it through a friend, who was a professor at the architecture fac-ulty, and a jury member too. He said the theme relates to our practice and that we should apply. So we did. There were 34 proposals, mostly from architecture offices. I guess we were maybe the only ones without an architecture background; somehow we won the competition.

Seda     **Prota, I read somewhere you mentioned that you did it because it was a biennale of architecture and oth-erwise it wouldn't be possible. What do you mean by that?**

Prota     I really liked the context of that biennale; it was titled, "People meet in Architecture." Actually we are architects, even though we never deal with architecture itself. It was still a kind of step away from the art biennale, which I liked. We were not treated as artists, but that's a dif-ferent matter...This outsider's position for me was the perfect place to take part in the architecture biennale. I never went to that biennale before, and it doesn't mean as much to me except to experiment on another scale, because that was an interesting challenge. I thought why not combine Žole's imagination with Pera's skills? Let's combine poetry, machines, choirs, and create a space as a playground, which we also did with the poetry festival too, treating it as a playground for different poets. So this was the challenge and also a chance to invite

the choir to sing *Armatura*, the rejected anthem we created in 1993. I thought let's fight for it and use our skills to create something together. Žole was just back from London, so it was also a good chance to work together again. It was beautiful timing and it really shows that we can still do things collectively for the same goal.

Žole      My main concern was why we would represent a state. I was not sure if I wanted to represent Serbia. There are lots of political games around that because of this revival of nationalism. Although the government we had at that time was moderate and not as nationalist as the one we have now, we were afraid that when we were there the ambassadors or politicians would abuse the situation, using the opening to promote their political ideas. When we applied to the competition after the first meeting I said no. Prota said yes; he is always the most optimistic of all of us, and Pera too. So the decision was yes, by a large majority. Then we created a proposal in two weeks. After they chose us, we only had six months to finish the project.

Seda      What about that story where you didn't want to put the Serbian flag in the opening ceremony?

Prota      We were afraid that they would want to fly the Serbian flag, and say we are the Serbian Pavilion, we are the Serbians... We were against it. Yugoslavia was written for the pavilion. We didn't want to have a Serbian flag there so we had this argument about not flying the flag beforehand. The experience with the commissioner was amazing; he dealt with the situation quite well. Also we had a meeting at the ministry of culture one month before the exhibition. They asked us, "What do you expect us to say in the opening speech?" and I took the opportunity to say, "Please don't speak longer than a minute". I remember he said "Hmm very interesting, I will try". To be honest, he took exactly 60 seconds!

Seda      It is a beautiful speech actually, not nationalist at all.

Prota      Not at all, it was beautiful.

Seda      And the title of the show is *Seesaw Play-Grow* [19], an installation with wooden seesaws, traveling plants, *Plant-o-biles*, as you name them, and poetry, which was applied as a wall-text. Could you talk a little about how you developed the idea?

Žole      We came up with this idea to make a playground, because a playground is an example of a space where people meet. It is a relaxed, open space. I suggested building a seesaw whose players are on an

19
*Seesaw Play-Grow*
Serbian Pavilion at the 12th Venice Architecture Biennale.
curator: Jovan Mitrović
inventions: Goran Petrović Pera
production: Skills Division (production assistants: Vaso Lukić, Filip Zarić, Goran Marinić), Ban Drvo
collaborators: Choir PROBA (guest choir KOMBINAT, Ljubljana), Snežana Skoko, Sanja Stamenković (textile), Saša Djukičin (web design), Vladimir Brašanac, Čedomir Kovačev (web design, translation), Dušica Parezanović (documentation), Branko Pavic (plants).

equal plane; they need each other's existence, otherwise they can not play. So we made this crazy seesaw with multiple seats. Pera started working on the engineering part, and as usual Prota brought poetry. He suggested using a poem of one of the biggest poets in Yugoslavia Vasko Popa, which mentioned that his wife once told him she wished for a tree that "would run after her down the street". Inspired by this metaphor, Prota suggested building traveling plants, *Plant-o-biles*, so that one could walk together and take them wherever they went. So, we combined poetry, machines, plants, and the pavilion became a playground. Also the choir, *Proba*, joined us. 10-12 of the members came to Venice. And they invited another choir from Ljubiana, the *Kombinat* women's choir. So, we sang songs all together. It was very spectacular. *Kombinat* were wearing these red t-shirts that looked like uniforms, because you know, to maintain the seesaws we needed three technical workers from Serbia. But to invite someone outside of Europe, non-European citizens was quite difficult, we needed papers etc. So it was advised to hire Italian local workers, and of course their fees needed to be paid by our pavilion. But that was expensive, so we came up with this idea to show three workers as official Škart members so they could travel with us. And that's how we managed to have them with us. When *Kombinat* heard this story, to show a gesture of solidarity with the workers they made these red t-shirts which looked like worker clothes. WORKER/ARTIST was written on them.

Fig. 73    Sketch for the Serbian Pavilion at the Venice Architecture Biennale, 2010

Figs. 74-75    *Seesaw Play-Grow*, installation view, Venice Architecture Biennale, 2010

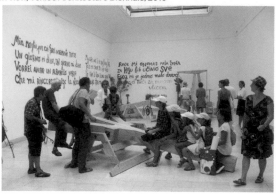

Fig. 76    Choir *Proba* performing at the Venice Architecture
Biennale, 2010

Seda    And how was the collaboration with the team? Did
you have any conflicts during the production, as you
had many doubts before participating?

Žole    Not much, only when we were asked to make an exhibition
catalogue. Normally we are against this, instead of exhibition catalogues
we produce empty notebooks to distribute to people for free, so they
could use them as they wish. Again we wanted to do the same, the team
didn't like it at first but we managed to finally convince them.

Seda    I also wonder what kind of feedback you received.
And besides criticism, did your selection/winning
the competition create a conflict among the local
scene in Belgrade? Honestly, I'm surprised that
you were chosen as the only non-architects who
applied. Of course these distinctions don't mean
much, but I also remember Prota talking about this,

that you made it happen only because it was not maybe that big of a prestigious event as the Venice Biennale is itself. But I also find it ironic that even though you have been practicing as artists for many years – maybe some people do not consider you as artists, but still – you never worked as architects. Just because you had been trained at the school of architecture they agreed to choose you? Because what you presented was highly conceptual, it was not architecture in a classic sense right? Indeed it is very similar to the rejected proposal you submitted to the biennale in 1994. Back then your ideas of combining poetry and choir were not found to be related to the architectural biennale frame at all. It is also interesting to see this changing perspective in the biennial itself.

Žole      But back then we were also an unknown group, maybe except in Serbia. Now 16 years later, we are still not super famous, but more people know about us. Maybe this also helped represent the state. And of course for a while you became the center of attention. Local newspapers are asking for interviews etc. but there was nothing much written about the work. Maybe only two critics said the work is bullshit. They wrote how we represented Serbia with these strange objects that had nothing to do with Serbia, or with our culture and traditions. You know things like this... And another journalist said something like, "But this could be a pavilion of every country, it does not represent Serbia in a unique, specific way." I said, "But what do you expect us to present? Something like Cevabcici?" I am not a fan of this biennale because of this national division. Art should be more open and each country should only present good ideas, not represent nations. But again, the government back then was not as nationalistic as this one, I would not consider representing Serbia today.

Seda      Yet I think it was really important that you did it, because this is your battleground, and you can be the game changer maybe, even for only one exhibition. So, why not! Transforming the pavilion into a "crazy Yugoslav carnival" as Prota calls it. Also, how you deal with the exhibition catalogue situation plays with traditional ways of exhibition-making. But still having lots of doubts since the beginning, what was the overall experience like, especially for you Žole?

**Žole**    I think it worked very well. You know I agreed to the majority rule, so we made it happen. But we made it quite well without many conflicts. As you said we managed to bring all of the Škart characteristics; poetry, playfulness, humour... When I saw people coming out of the pavilion in a good mood, playing, using the objects, and having fun, I was very happy about this.

**Seda**    I was only able to find one tiny piece published in English about the work. I guess she was an American cultural journalist who mentioned something like, out of all these shining super clean, precise pavilions I was impressed by the Serbian pavilion and its simplicity, and how it became a real meeting room with positive vibes, not with overly imposed intellectual input. By the way, what happened to the seesaw afterwards?

**Žole**    Yes! There were lots of negotiations, promises that after the biennale it would be placed in a central park in Belgrade. Empty promises... After the opening everyone forgot, but for us it was really important to propose a work which could stay behind after the biennial. So after the biennale it made a stop in Ljubljana and was exhibited in a festival there for 3-4 weeks. Then we managed to get it back to Serbia, back to a tiny village where it was built. It stayed there for months, and next year we got an invitation from London, 100 Union Street. They have a huge garden and the seesaws were exhibited for three months. Later they came back to the village Novi Bečej, near Belgrade in 2013. But after the government changed, nobody took care of it. It was destroyed over time. We don't have this culture of sustainability, or maintenance here.

Seda     And probably participation at the biennale created visibility for you, because right after the biennale you received the first invitation to exhibit at the Museum of Applied Arts, Belgrade. So the half-retrospective exhibition *škart: halftime* took place in 2012. And a few months later you were invited to organize HOMEMUSEUM (ŠKART: DOMUZEJ 1/homuseum 1 (provisional dwelling place) at The Museum of Contemporary Art Belgrade. And this was followed by another retrospective-like exhibition at the AICHI Triennale in Japan, in 2013. Despite the fact that you were focusing more on your individual practice during that time, you always travelled together and used the exhibition format as an opportunity to work together.

Žole     Yes as always, whenever someone invited Škart, we traveled together. And later, we also joined a monthlong residency at NTU CCA Singapore together in 2017.

Seda     I want to talk about the *škart: halftime* [20] exhibition in a little more detail, because I think it was a crucial attempt to locate your work within an institution and you started to explore ways of transforming the exhibition into a living thing together with the participation of your long-term collaborators. Also you led guided tours almost every night during the exhibition timespan, organised poetry reading events on the museum's balcony. Prota, I read in an interview that you said, "To me the exhibition was unimportant, but what I found beautiful was getting things out of the box". I'm curious to hear more of your thoughts about the show.

Prota     Again it was a chance to unite our Škart family; choirs, the Pesničenje team, Pesna, other friends. They all helped shape it. When we arrived there, even though it was a museum of applied arts, we were not allowed to hang or write anything on the walls... Normally our main way of working is to put all the things we created on the wall, and to write poetry on the wall. They said they had no money to print on the walls either.

Žole     It is not allowed because the building was undergoing a conservation effort.

Prota     But it was not the same for every exhibition, anyways... So we needed to cover all the walls with recycled advertisements. A friend was working in a company, and we collected used advertisement

20
*škart: halftime* took place between 9-26 October 2012, and features an overview of the multiple engagements of the group. In addition, Škart organized workshops and invited, every single day, other groups to come join them in the museum including "Elektrana" (Pančevo), "AKTO" (Bitolj, Macedonia), "Radionica 301", "Karkatag", "Iglene uši" (Belgrade).

boards, cut them, covered the walls and hung all the objects with ropes. It was an endless process and we wrote the poetry on them. It was almost like a family living in the museum doing work for a week, beautiful.

Žole    We were working very intensely and it is also strange that no one was helping us at the museum. They were coming at 11:00 then leaving at 16:00, and we only had 4-5 days to install the work. So we had to do things with more than 10 friends. It was also strange that at 20:00 we had to leave the space. Museums should be more flexible... I wouldn't accept working like this anymore. I like to work with pleasure.

Seda    Still you managed to find a way to make the show happen.

Prota    Yes, and this was also an opportunity for us to unpack our boxes. For two decades we moved from place to place, without knowing what is where... It was a good opportunity to see what we had. Actually it was Žole's beautiful idea, maybe too radical. I still love it but I am sad that we didn't do it, or I didn't listen to him. He said, "Okay, let's unpack all the boxes and leave them on the floor, like that, and each day let's take one work out, and speak about it". Somehow it felt a bit unfair to the museum, having everything on the floor, messy like garbage, but now I find it radically beautiful. But we can do it next time! Then, I took something out of his idea, and decided to have a public tour each evening to talk about the works. We also invited other groups we collaborated with, such as Women in Black. Embroidery ladies also came and talked about their work too. And at 7pm, after the tour, we had balcony wars. Each night we invited friends to come to the balcony of the museum and read poetry with megaphones, calling out to other balconies in the city.

Figs. 78-79    *škart: halftime.* Exhibition view at the Museum of Applied Art, Belgrade, 2012

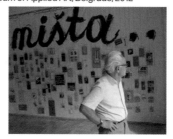

**Seda**    And what did you show in the exhibition?

**Prota**    Almost all the printed matter we created. We focused on our design practice, mostly graphic design. And also the poetry machine was there, the one we built for the biennale in Kosnic, and it created its own public space. Some objects we did for the Venice Biennale, like the walking bush and trees. And embroideries too. So there were machines and poetry.

Figs. 80-83    Graphic design by Škart, 1996-2000

**Seda**    Except for the graphic design works you mainly showed some traces of your practice, like embroideries. I actually refer to them as traces. To me your work is the shared moment. And once you exhibit it, your socially engaged practice, you only exhibit some traces out of this engagement.

**Prota**    True.

**Seda**    I wonder what you feel about these traces? I know that you are really not fetishizing them, or that they are not sacred for you. What is your relationship to them? You also don't want to exhibit them at all, but you still keep them though you don't know what you have and where they are.

**Prota**    They are also tools for communicating. I hate this kind of frozen, art graveyard way of showing things.

**Seda**     Art graveyard, beautiful way to name it.

**Prota**     I prefer to use them as a tool for other meeting points too. Through these objects we communicate with potential audiences, collaborators. Also we distribute them. We are mostly giving away whatever we can, to create new dialogues with them.

**Seda**     Also, I wonder as you often work a lot with poetry and words, how do you communicate them with a foreign audience, especially when you exhibit them outside of the region? For example, you showed the embroidery pieces in Japan. How do you communicate text-based work?

**Prota**     In this case these tools always need to improve themselves, by themselves. Like in Japan we brought our walking plants with us, and it is another rather direct way of communication. People walked with the plants, so it is another way of thinking about your surroundings and communicating with others. For the embroideries, we had a brilliant translator who worked on the translations. But anyways, these poems still function on their own, as they are really nicely written; honest, simple yet critical poems. It doesn't need a strict political context to be understood. Poetry stands for itself.

Figs. 84     Exhibition view, Aichi Triennale 2013

# If you want to go fast, go alone; if you want to get far, go with a group

*We never say: "I made this, I did this!"*
*We always sign as "Škart". Prota writes poems,*
*but he signs them as "Škart". I make drawings,*
*but it is always "Škart".*

Over three decades Škart has worked extensively on reappropriating available material and financial sources and finding ways to navigate in times of upheaval — war, post-war period, the transition from socialism to capitalism, social trauma and isolation, or recent Covid-pandemic days. It was the struggle that gave Škart the resources necessary to build a better and more equitable society. It became clear that one needs to take action and build tools to change the things one is dissatisfied with. To achieve this, joining of forces would be needed; collective work, solidarity and social responsibility. In Škart's terminology 'collective' is considered primarily as a practice. A good illustration of the division of labor and collaboration between

members of Škart is that each bring their exper-
tise to the table. Žole's visual skills are enriched
by Prota's poetic touch, which is often supported
by collaborators' inputs.

Revisiting Škart's practice, beyond the endeav-
ours of Prota and Žole, is to thus witness the
stories of many other individuals. These stories
demonstrate that "survival is not an academic
skill", it is about learning how to stand alone
and make common cause with those who are
identified as outside of these structures.[19] And
what could we learn from this way of thinking,
working and living together as socially-engaged
practitioners, conscious citizens and sensitive
individuals? How could we repurpose these
tools and methodologies for our own ends?
Perhaps it is by coming together, sharing exper-
tise and realizing the power of self-organisation
where we could learn from the experiences that
might be helpful for us, in the present and for
the future.

19
Audre Lorde, *Your silence
will not protect you.* Silver
Press, 2017

**Seda** What I'm most inspired by from Škart is your methodology: how you re-purpose tactics, or tools and apply them to different circumstances, contexts. And your understanding that the collective is bigger than the self, and that in Škart's terminology this is considered primarily as a practice rather than mere dry theory. A good illustration of this could be the division of labor and collaboration between the members of Škart; as everyone brings expertise to the table and the group operates within a horizontal hierarchy. In your cooperation mostly Žole's visual skills are enriched by Prota's poetic touch, which was then supported by other collaborators, such as Pera's technical knowledge. And another thing is how you succeed in navigating your artistic production under difficult conditions. Prota, your recent work, poetry writing workshop with pensioners during Covid confinement days, Defiant Pensioners, is a beautiful example of this. I think it is impressive how you managed to communicate with the elderly through SMS and kept writing poetry as they were going through months-long isolations. What is also striking here is that, you added an institutional level to collaborating, as Kunsthalle Wien became your partner. I find this project to be a working example of a collaboration between the institution and socially-engaged practice, which does not always go well together. But this one was not a compromise from your side, you still produce the work on your own Škart terms, and then you profit from their financial and maybe technical infrastructures, using their channels of communication to gain further visibility. Honestly, I think we should work more on this and search for ways to use institutional sources to create meaningful collaborations. Maybe we can talk about this in more detail?

*Today in a Retirement Home*

*I chat up grannies, banter with greybeards*
*Everyone's fiercely glaring at me*
*Corona is the word of the day*
*About it I have nothing to say*

*I read books, compose rhymes and then*
*Often resort to things forbidden*
*On YouTube I watch all sorts of clips*
*The teeth I've left are but three odd chips*

*All my books I have read,*
*My old worries I have shed.*
*What a joy, oh, poor me*
*Just junk remains eventually.*

*Now I'll be sour awhile*
*And once again I will compile*
*Some Coronavirus hearsay,*
*So that I keep them at bay!!!*

Dušan Todić, defiant pensioner in quarantine, Gerontology Centre, Zrenjanin,
April 2020

*Sharing*

*It is nice*
*to share*
*if we have something*
*to share*
*the little something*
*that we did*
*not share*
*has remained*
*somewhere*
*to be shared*

Mira Vasić, defiant pensioner in quarantine, Zrenjanin Centre of Gerontology, Serbia, March 2020

Žole    There is also one similar work we did in collaboration with The Museum of Contemporary Art in Belgrade, which I believe is relevant to this question, and also how we imagine working in the future too. I think these examples could bring a lot of capacity for the future. In 2011, we did a conference for graphic design *(Graphic) Designer: Author or Universal Soldier*. It started in Belgrade and the aim was to gather graphic designers every year from all around the world for 3-4 days of talks, lectures, exhibitions. In 2011, the main topic was activism in design. So that year we took over and organised the event at this gallery, legacy of Milica Zorić & Rodoljub Čolaković. It is a very special, beautiful villa in a forest. The museum gave us this villa with three floors, and we had the idea to occupy the museum together with invited students and graphic designers, sleeping, working, and living together there. At first the curator found the idea too radical, but in the end they gave us the green light for five days. The ground floor was a big eating table. We also made a kitchen. The second floor was a big workshop & working space. The third floor was the sleeping place where we also used the presentation room, getting over the sleeping bags. So we were having breakfasts, working all day, and between 8-10 attending lectures and screenings. After 10 pm, we put the sleeping bags back. To me that was like a dream, dozens of us living in the museum, using it as a home, and exchanging with each other. And this is how I imagine the museum, an active place where people share ideas and work together. And this is how I see the future of museums too, as a place to gather. I still believe in the importance of sharing space, and being much more close to each other physically rather than hiding behind computers.

Figs. 86-87    From the exhibition HOMEMUSEUM (ŠKART: DOMUZEJ / homuseum (provisional dwelling place) at The Museum of Contemporary Art Belgrade, 2012

Fig. 88    Poster for the conference (Graphic) Designer: Author or Universal Soldier, 2012

**Seda**    And what about your recent work? Even though you focus on your individual practice too, this does not mean an end to collaboration, right? Or a break? How would you imagine working together from now on?

**Prota**    At this moment I feel it is also important to finish this big experience, the movie, for myself. Then I am ready to restart working together, and I've been thinking maybe we can start slightly with these picture books, or children's books, to combine our skills and unite our languages, combining poetry with Žole's drawings. This is also something we started years ago; we made these picture books for different people and different places, in collaboration. And I still find them really interesting, they are poetic and sensitive. Now maybe we can continue working on them for kids.

**Seda**    These books were mainly the result of workshops realized in collaboration with local institutions and associations, right? I know that gathering physically to create things together is really essential to your practice, and particularly to Žole who still has doubts

about communication in the digital sphere. But during the last one and a half years as physical gatherings were quite limited, unfortunately there was no possibility to work as such. And this is another thing I wanted to discuss; that you were trying to find ways to still continue those engagements using different channels too, again as I mentioned the recent collaboration at Kunsthalle Wien. You moved your collaboration with pensioners to online realms, making video animations out of their poetry and screening online. How did you develop this idea?

Figs. 89-90   Selection of pocket books, 1998-2013

**Prota**   This is again about the importance of unpredictable visibility. Through Facebook they saw these poems and invited us. Since 2016 I have been persistently publishing pensioners' products, and embroidery pieces too. For Žole it is maybe a waste of time.

**Žole**   No Prota, it was also me who told you to share them. Because Prota has been doing these things with them for five years and we are really bad promoters. We never did anything with it. I told Prota to maybe share them on social media regularly because people have to know about this.

**Prota**   Yes, true and even in earlier Škart works it was also me who did the communication, mail etc. It looked like a waste of time but this was also the dirty part of the job that needed to be done. On the one hand direct communication and action with the group is important, but on the other hand if you want to continue echoing things you need to open doors to the outside, too. And social media was one of these doors. Maybe before we published posters we used radio that had a limited circle of users, but then social media opened us up to a bigger group.

Žole    But we also used these social media accounts only for pensioners. We still never use it to promote our work, or we never had these kinds of newsletters saying Škart is exhibiting here and there. I think we would never do that.

Seda    But there is nothing wrong in doing that too. Why not do that? Maybe you don't like it but at the end of the day it is also a tool to share your way of thinking and working to a wider audience, and that's the point. I don't find it wrong. Okay, maybe when you were isolated in the 90s you used mail art often, but that was the only possibility to reach a distant audience back then. Interestingly those methods are becoming more visible and popular today, like during Covid confinement days, artists started to address it again, to emphasize the physicality. And I was also lucky to receive a gift from you, a few of these poetry books. But then I thought, they are so beautiful and emotionally touching that I wanted to share them with others too, and in that sense using digital communication, or social media becomes really useful to continue this echo of sharing. At the end of the day you don't make the work only for yourselves, right? We want to create a space around the work; so why not share it with as many people as possible, using as many ways available?

Žole    Yes, maybe. I understand your point but I am still not the kind of person to send these newsletters, announce what I do. I think we are not into such self-promotion. I don't know, maybe I will change. For me, it was really important, this personal touch; when we were corresponding with people we were always sending multiple copies for them to give out to others if they liked too.

Seda    For me it is not self-promotion; it is also a form of solidarity to share things, learnings, experiences to help and support each other, if you like. I hope it doesn't sound too naive? At least this was my idea in writing extensively on your work recently. I remember very clearly the evening I met Prota in Belgrade back in 2019, after seeing all these massive amounts of work, whether documented or not, here and there, I asked Prota how you would imagine sharing all of

these. And Prota replied to me like no one is interested in the work, or why should anyone care about it? But today looking back at your practice for the last three decades, not only do we have an understanding of artistic practices from the region from the 90s till now. I find it particularly useful and inspiring to revisit your methodology, examining how you used self-organization and self-distribution tools; as these become relevant in our current conditions which obviously require a rather collaborative and inclusive way of working.

I also believe that this book could be another opening, not only between me and you, but also the Škart family as you call it, including past/recent collaborators; such as with Lenka and Mirko, as well as future ones. So I don't want this conversation, or the book to sound nostalgic. I think we are interested in talking about the past to examine ways of working and living together now, sharing experiences, knowledge and ideas that could be applied to the present and future.

Fig. 91        The first encounter with Škart, Belgrade, 2019

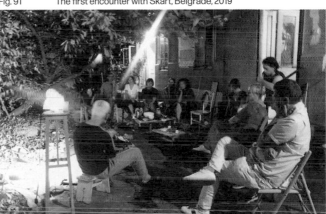

# How could (why should) one tell the story of Škart?

Today we only have traces of Škart's actions and engagements here and there as their work has rarely resolved into a tangible product, and it was not documented often. It was indeed not an intentional decision to reject the idea of documentation, but rather an organic one as the group valued the process of the creation in direct communication with others, more than the "work" itself. Works as such, which are highly conceptual and not object-based, are not only underrepresented as they are not of interest to the art market due their ephemerality, but it is also a challenge to exhibit them "in an art world that prefers to frame artists as commodity makers rather than change makers".[21] In the case of Škart, one could even consider a double marginalization: first, socially engaged art — as having a low status in the art circle (disaccording with conventional operation rules of the art market) — has less spectrums of visibility; and second, artists in the former East, who are largely outside the Western canon (apart from Western attempts to exoticize the

21
Nato Thompson,
Living as Form: Socially
Engaged Art from 1991-
2011, MIT Press, 2017

"other") still retain secondary positions. Similarly, nothing much has been written about Škart's practice after the 90s, as it moved from printed matter to a more socially engaged practice that takes place mainly outside of art and culture institutions, and thus remains less visible.

Why revisit Škart's multi-layered work, which deals with the relationship between the individual and society, the demand for art to take an active position in everyday life, using solidarity, collectivity, humour, and pleasure as a mode of critique today? Despite emerging from unique geopolitical conjunctions, while still being based on a humanizing instinct to stress what people have in common, Škart's practice is easily accessible for anyone. And this dichotomy makes the group's sustainable methodology timeless and groundless. Investing in human relations as their material, focusing on strategies of self-organization and active empowerment, Škart proposes possibilities of survival and endurance in terms of building interconnections and collaborations. This capacity further unsettles the "conflicts of thinking/action, individual/ collective, author/participator, as well as aesthetics/ethics"[22], and therein lies the strength of their work.

22
Claire Bishop, "Art of the Encounter: Antago-nism and Relational Aesthetics". No. 114 (Winter, 2005), published by: Circa.

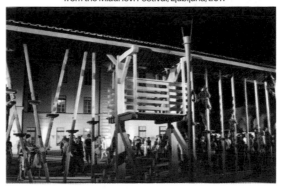

Fig. 92      *SINGEROLL, STOROLL, PENJALEC.* Installation view
from the Mladi levi Festival, Ljubljana, 2011

Seda

While searching for traces of your work, I found that nothing much was published on your practice after 2010, which was mainly rooted in a socially engaged art practice, often realized outside of art and culture institutions. Your work from this era includes choirs and embroidery groups. So there has been a lack of criticism about what you have been doing too. I was only able to find essays, articles that discuss your work from the early 90s, mostly street actions which are referred to by Darka Radosavljević or Branislav Dimitrijevic. These two figures were probably the first to write about your practice in detail, which again dates back to the late 90s, or the early 2000s. I found it interesting that even though, at some point, these socially engaged works have been embraced by art and culture institutions, and gained another layer of visibility – like embroidery pieces that received an award at the October Salon in 2007 – this did not change much in terms of its reception by critics. And as an outsider, I found it difficult to understand why there has been a lack of interest – here I'm referring to art critics, historians, writers, curators – to cover your work particularly from this period, the 2010s and onward. What could be the reasons, from your perspective?

Žole      Darka was indeed one of the first people who supported us since the beginning, but somehow she was pushed aside in the late 1990s and 2000s because of some difficulties with Rex and B92. In the 2000s we started to work with collectives, and let's say there was not

much material proof of our work; we did concerts, or embroidery work-shops mainly. It was years of work but it was not like usual artefacts; we didn't produce things to put them on a wall, they were objects artists usually create. As a result of the choir, we published an album of a choir, but again it is not a typical artistic product. And I guess that way we stay a little bit outside of the attention of the art critics.

Seda      But then you also for example showed the embroi-dery pieces in art institutions, and they were exhib-ited at the October Salon. So they were "valued" as artworks.

Žole      Yes, actually it got an award at the October Salon, the edition of 2007. It was curated by the French curator Lóránd Hegyi.

Seda      This means those works did not always stay invisible. I agree that from a curatorial perspective that it is challenging to talk about and share artistic prac-tices which are not tangible. How would one share, document and archive your socially-engaged prac-tice—this question was also a starting point for my research. I thought maybe one method could be to gather traces and use less commonly known shar-ing methods such as oral history interviews. And this has been my approach to your diverse material.

I think this book helps us to try to map your three-decades long practice, to know more about not only your work, but also the working conditions, and socio-political atmosphere in the region, too. As for the lack of criticism about your work, I was some-times struggling a lot to place your practice in the local scene. I also directed my questions to a few prominent art critics, writers, and independent cura-tors based in Belgrade. I received different answers, regarding the institutional and political perspective, as well as the nature of your work. The first is that it was not necessarily you who has been marginalised from the viewpoint of art criticism, since criticism is marginalised as a discipline to begin with. And that it has been the consequence of larger political processes, the rise of neoconservatives, populists who also took over art institutions.[23] And secondly, probably the scale of the material from the last

23
Mail correspondence with Jelena Vesić, 5 April 2021:

"I don't know if Škart has a monographic book of their work, if not – this is I guess in line with their practice, they are not operating as a gal-lery-artists and therefore perhaps a monographic survey of their work and all the glossy things would not fit their prac-tice, they are working with alternative small publications and – as far as I know – they have a plenty of different small publications realised within the corpus of exhibitions in Serbia and elsewhere. I don't con-sider them marginalised from the side of art criti-cism – unless everyone is marginalised, since the very criticism is mar-ginalised as a discipline, especially day-to-day reviewing of the art prac-tice. A lot of people wrote about Škart in various different catalogues or thematic essays, they are absolutely not out of the picture within the so-called critical/political art scene – au contraire. Now, it is true, the entire field is marginalised and quite out of focus for almost a decade, which is the conse-quence of larger political processes, the rise of neoconservatives, populists who also took over art institutions where nowadays neither Škart nor me, nor any of our friend-collaborators are welcome".

24
Video correspondence
with Branislav Dimitrije-
vić, 13 April 2021.

three decades created a constraint as one could not know how to approach and deal with such a massive amount of material, and that there are not enough people available to conduct such research.[24]

Žole     I'm very open to the idea of criticism. Also this was something I wanted to try out in our practice too, for example, when we were invited for a presentation to not only talk about the glossary things we did, but also things that didn't work, or things that failed. It is important to say, "I failed here", and to hear about how the work is received, to improve the work, and to see the missing points. Here, I need to say the harshest criticism was written by Miško Šuvaković, a critic from Belgrade, who is very conceptual and is interested in postmodernism. He wrote a text about our piece which was exhibited at Manifesta 3 in Ljubljana (2000). We were invited by the curator Kathrin Rhomberg, though we didn't meet the curator. The article he wrote couldn't be worse, he said things like Škart are not artists. And at the end he said something like, but poor guys, they are not guilty, the guiltiest person is the person who invited them—the curator Kathrin Rhomberg.

Seda     And what was he criticising so harshly?

Žole     We showed *Your Shit Your Responsibility* there. We were going around Ljubljana in the streets; glueing posters, putting up stickers and flags around the city; as we usually do. It was a street action. He said it was total bullshit. Actually, often we heard from friends, other critics that that work is our weakest work, and that it was maybe political action, political marketing rather than an artwork.

Figs. 93–94    *Your Shit, Your Responsibility* street action in collaboration with Peter De Bruyne at Manifesta 3, Ljubljana, 2000

**Seda**  I might agree that this specific work is more in the political realm than the artistic one, but also the period you made that work in is important to pay attention to as well. This was literally the moment when the war broke out, and you ended up stuck in Brussels.

I want to go back to the topic of failure and talk about things that did not work. Do you have other examples of failures, critical views about your work?

**Žole**  Yes, the biggest failure was the Sweden workshop in 2014. Maybe there are also things we should have done better, like the poster we did in 1993 with Mona Lisa. It was an anti-war poster series, and that one was saying something like, "Piece is so simple". We felt so ashamed afterwards! This is also one of the good things about working with Prota; that you raise the bar very high, thinking it should be aesthetically good enough every time. But Prota is very relaxed about it; he lets things go naturally. After some time you realise that these flowing things are much more interesting than the ones that you try to make perfect.

**Seda**  This also occurred to me, talking about doing workshops, that there is sometimes division between the desired way of working between you and Prota. Prota is really into the workshop format and also working with children in a more pedagogic, rather playful manner. And lately he has been occupied with making another workshop with them, writing only positive news and going out in the streets to manifest as a marching band, for instance. Whereas Žole you feel more comfortable applying craft skills in a rather organised, focused way, more towards the direction of using drawing, or working with visuals. Despite these differences, how do you imagine the future of collaborating?

**Žole**  There is a strange combination of personalities here, it is true. People are also telling us how our personalities are different, but we still manage to work together. Of course neither of us has an easy personality. But the main thing, if you want to be in a collective, is to be tolerant. It is a big part of it. And it is often that we have to make a compromise. So far, how we mostly collaborate is that Prota writes poems and I make illustrations for him. But I also wanted the other way around, that I draw something first and then maybe Prota writes poetry on them, but of course it never happened. I expect equality in the collaboration. And I also think that the future is in images. Together with Prota we also

Figs. 95-96   *Good News Drummers*, Prota in a workshop with children from Vranje and Bujanovac. Performance for the opening of the Art Weekend in Belgrade, 2021

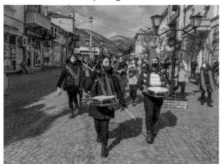 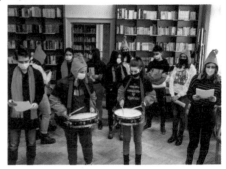

made some educational-mediation workshops on how to read images in different countries with different groups. One in Rijeka, another in Slovenia in a local small village museum and the other with pensioners in Zagreb. We were focusing on reading the visuals together with a wider audience. I also find it interesting that, for example, in Yugoslavia, we have a long tradition of literature, especially poetry, maybe a bit more filmmaking but almost no visual artists, and I think maybe it is also because painting is less accessible to people. So we choose a collection of paintings and then expose the group to them and ask people how they read them and have a conversation around them in a bit more of an engaging way. I am also interested in working with this idea of images, and reading the images.

Fig. 97   Workshop within the exhibition Performing the Museum, The Museum of Modern and Contemporary Art Koroška (KGLU), 2015

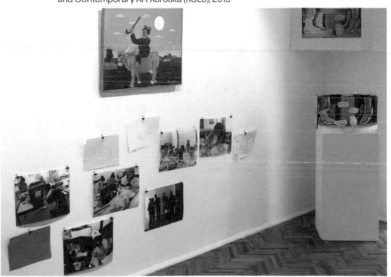

**Seda**    Would you prefer working more on a local or a global scale?

**Žole**    I am totally for the local level, so that I can understand it better, and this is the thing that makes me happy. Also another failure example is in 2006, when the curator of the Gwangju Biennale invited us to build a choir there. We travelled there with conductor Boris Mladenović, a well-known musician from Belgrade, probably the greatest poet on the music scene of the former Yugoslavia. What happened was that we announced an audition and only 7 people showed up. 3 were kids, below 6, and 4 pensioners over 70. Then you understand the reality of Korea, that kids go to public school from early in the morning till afternoon, and after they go to private school for a few more hours, 6 days a week! The parents think they'll get a better education, and end up in a better university, so a better future... So there were no other people except 6 and 70-year olds who were willing to make some free time to sing. There was only one guy in the group who used to be a singer playing in the clubs, a guy below the poverty line, and he was the only one that did not fit this typical Korean life story, work work work. Then after a week, the organizers sent us to a local female high school, and we met a group of students and they were very skilled so it was very easy to practice together. Together we had a concert, but then we did a video explaining why and how we failed. It is a perfect example of how the same way of working doesn't work in different localities. In Belgrade we called for an audition and 50 people showed up, but in Gwangju this didn't happen.

Figs. 98-99    Still from the making-of, forming a choir in Gwangju, S. Korea. Realized together with Boris Mladenović within the frame of the 6<sup>th</sup> Gwangju Biennale, 2006

 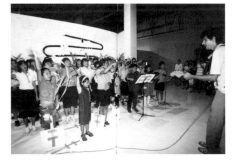

**Seda**    Your practice is focused on working together with people, gathering as a group physically, but lately it also became the case that you were not able to do so under pandemic conditions. Žole, you are in favour of working offline, and Prota is more progressive, trying to embrace digital communication tools

in practice. Are you also interested in exploring work in a digital sphere too? In the way that the 90s organically shaped your tools, in a pre-internet period you made use of mail art, distributing printed matter, the 2000s brought more mobility, so workshops came, and you were also able to travel outside of the region. And after 2010 you started to use video animations, playing with another medium, maybe for the first time? You managed to update your tools and ways of operation to keep up with the changing times, as required.

Žole     Well, I am not particularly proficient at this. But when I say I believe the future belongs to images, and yes that is also a part of the digital world. I have to be more into this somehow, and gain more knowledge.

Seda     And through all these experiences, what is a learning experience from Škart that you find particularly relevant today? What is one thing that you are proud of, something characteristic of Škart that can be applied to the present and future?

Žole     Working collectively, bringing people together and creating groups that can continue working together even without us. I'm very proud of this, and I don't see this quite often. When we formed the choir we wanted it to be self-sufficient and for it to function without us, independently. And we succeeded in this. The choir continued after us for years. An artist's ego is big and it doesn't often adapt to working collectively. It was crucial that when working with collectives we were never imposing our personalities, or leadership. We give people the freedom to develop things in equal ways, which is really difficult to achieve. And another thing is that the art world is obsessed with products, but in our case the products were not the point, it was never the main thing. It was about the process of working together. And for a better society, to live more equally, my opinion is that working collaboratively is a necessity. An equal basis, this is a Škart thing, which I hope could be applied to future modes of working, and I thought maybe this could be our contribution to the art world, something that is not well-recognized as I said, as the art world often depends on products.

Seda     What about collaborating with younger collectives, would that be of interest to you?

Žole     Absolutely! When you work with someone, first you have to carefully choose them, and then you have to be open and avoid

imposing opinions – that is the point in working together. And I'm open to that. But I also sometimes wish to work just with the two of us, me and Prota. I would also like to continue working in collaboration with him, making books of drawings and poems, similar to the small zines we have been producing.

# Škart

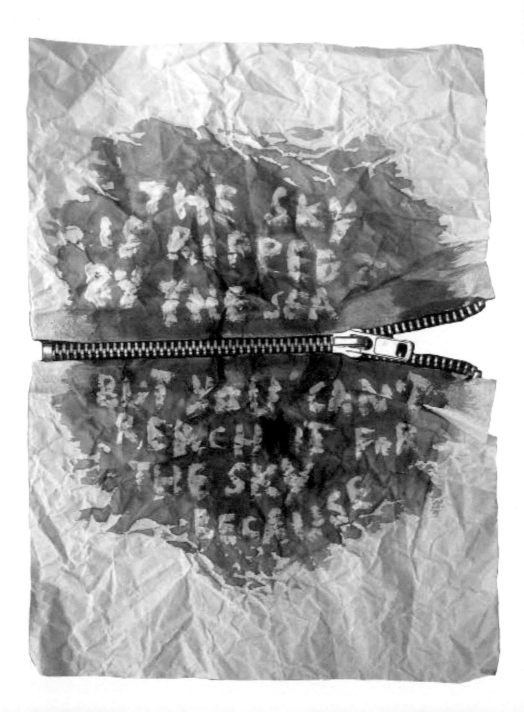

We thought it was impossible:
One of us a poet, the other a
draftsman. One a punker, the
other uncommitted. One a su-
prematist, the other a realist.
Totally impossible:
One sexually questioning, rela-
tionship-less, the other in casual
relationships.
No chance.
The one characteristic we had in
common was the brave leap our
parents had made – socialism
had enabled them to transcend
their social background and
leave behind their farmer-work-
er families for the big city, to
finish university and set off to
work in the field, raising the pop-
ulation's literacy, in education,
healthcare. They invested them-
selves and their education into
building a new world. So there at

least we had a past in common.
In all other respects – nothing.
From there, from the impossible,
we began to hang out and work
together.
From there, from the impossible,
came also this poem.

škart, Belgrade, June 2014

# about the sky and the sea

the sea is guarded by the sky
you can't reach it from
the sky because

the sky is ripped by the sea
but you can't reach it for
the sky because

(translation: Svetlana Rakočević, london 2014)

(pre-škart, first year of acquaintanceship, Belgrade, 1987)

## Celebration

(first) škart selfpublishing
Edition *No need for anything for the beginning,* 1990
Circulation: 15 (in Serbo-Croatian)
+ 5 (in Polish)
translation by Milan Marković

confetti
are imprinted in the snow
so, as if nothing
ever had been

everything´s still remembered
only by numbers

## The Runaway Poems

škart selfpublishing
Edition *No need for anything for the beginning*, 1991
Circulation: 7
   (selection 3/20)
                  translated by Milan Marković

THE POEM THAT RAN AWAY

because it could not stand these two
neighbouring poems

'

## A poem on poem

lyrics by škart, 2004
music by Boris Mladenović
arrangement by Marija Balubdžić
performed by HORKEŠKART and PROBA choirs
translation by Milan Marković

to make a poem you need
more letters than on the menu
more than you have here, indeed –
we need a poem brand new.

for a poem you need less
than the loud ones shout
in perpetually altered state –
we need clear verses out.

a poem requires exactly,
if anything needed at all
for this "piece of sky that's free"
but trivial and tearful.

for a poem you need nothing,
we're better off in it's absence –
our gale is certainly coming
with no consents or consonance.

## Substitution

(from the conversation with Goran M,
defender of occupied Sarajevo 1992—1994)
Mostar—Sarajevo 1996
I edition, FISSION, CZKD 1996
II edition, škart-samizdat,
    library *No need for anything for beginning*, 2006
translation by Ana Davičo

so
in war
in awe
I read more books
the'ever before

oh
I need
another war
so I could read
a bit more.

# The sadness of potential vegetables

škart selfpublishing-selfdistributing
(distribution: green market place)
13/23
translated by David Albahari

fruits
and
vegetables.

sow them.

(grow them)

it's sad
being
what is not allowed to sprout.

garden
Belgrade
march 1993

## Fashion '94

škart-radio-poem
programme *Words and Images*, Radio Studio B, Belgrade, 1994
(programme editor: Nada Petronijević Čović)
translation by Milan Marković

This season
Black is all the rage.

We've been persistantly
Planting the dead
all year long

now calmly waiting
for a big night
to sprout.

gagagagagagagagagagaga
gagagagagagagagagagaga
gagagagagagagagagagaga
gagagagagagagagagaga
gagagagagagagagagaga
gagagagagagagagagaga
gagagagagagagagagaga
gagagagagagagagaga
gagagagagagagaga
gagagagagagagaga
gagagagagagagaga
gagagagagagagaga
gagagagagagagaga
gagagagagagagaga
gagagagagagagaga
gagagagaga guujuugagaga
gagagagagagagagaga
gagagagagagagagaga

180 × ga

28/4/2020

# Critical framework

# Škart in the 1990s – The politics of small gestures in the time of war and privatisation
Branislav Dimitrijević

After more then 30 years of activity, the group ŠKART has become the longest lasting artistic group in Serbia. What makes this simple fact somewhat peculiar is that the very activity and the very name of the group have not aimed at achieving something fixed and durable. During these 30 years the label ŠKART was put on a series of seemingly ephemeral and transient activities at the crossover between the poetical and the political, between the artistic transformation and social intervention. Since their formation in 1990 ŠKART initiated, produced, organised and staged numerous public actions and events that, in their cogently modest manner, altered the meaning of the social engagement of art in the public space in Serbia. The list of their activities have included: writing, designing and printing books, notebooks, posters, flyers, boxes and other paper and cardboard products; street actions ranging from pasting the walls with their visual poetry posters to distributing their poems and other printed works to specific groups; broadcasting experimental radio programs, setting up conflicting and dissensual situations in-between the public and the private spheres; celebrating the "small heroes" of everyday life and participating in the activities of the organisations of civil society; founding and organising amateur choirs and initiating poetry festivals; collaborating and making embroideries with refugee women groups, and co-authoring musical and theatre performances with children without parental care. This list of activities is far from complete, and all their activities have a situated and site-specific scope, but what they all have in common is their persistent positioning on the borderline between what is considered to be belonging to the language of contemporary art and what is considered to be a form of community work, with an intention to use art, music and poetry to give a voice to various social groups, and to create new and different forms of social interaction.

All these activities were never intended to be regulated by the logic and the standards of the "exhibitionary complex" of contemporary art. Although their works have been displayed in museums and galleries, their reluctance to become fully *exhibitable* is an aspect of their localised and contextualised intentions, and both of their artistic and social priorities. For the sake of classification, their activity needs to be placed under the proposed art-historical labels of relational art and

participatory art. However, in this text I shall try to argue that regardless of this art-historical requirement, their practice needs to be considered primarily as a self-determining activity, developing and unraveling fully within specificities of its local context and habitus, even of its local "traditions". Therefore, it is a practice which was not instigated or much informed by the emerging artistic "trend" that simultaneously came into view in other places.[1] This is not to say that this simultaneity and similarity is insignificant, but to stress that their position has emerged exclusively from the local context, or rather, from an antagonism with the main cultural and social patterns of that context, and also the patterns of artistic work and artists' behaviour characteristic for Belgrade of the 1980s.[2] Although their work was significantly informed by some instances in the Serbian and Yugoslav avant-garde, it was not induced by any diachronic or synchronic cultural authority. They have been deeply involved with the immediate and the localised, with the sense of community – but not as something necessarily unproblematic and cohesive (rather as a site of *dissensus* [3]) and carrying the *sense of purpose* that does not follow any logic of the instrumental mind. A poetic purpose, a purpose of playfulness, always configuring in the public space the deeds and the values that are missing and missed in this space, due to its overwhelming authoritative and commercial appropriation.

The year 1990 could be considered a year of the final collapse of the Yugoslav socialist federation.[4] Serbia of the 1990 was an example of a bipolar state which had one foot rooted in the old state structures and the other stepping into a process of "transition" based ideologically on extreme nationalism and economically on clientelist privatisation controlled by the ruling party. With its war-mongering policy, and its role in organising and supporting paramilitary forces that conducted numerous war-crimes, the Serbian state became fully isolated from the international community and for more than 4 years under strict UN sanctions.[5] Needless to say, in the field of culture the situation became disastrous, cultural institutions were stormed by nationalist ideologists, artist and cultural workers mostly self-isolated themselves and decided to keep a "low profile" expecting the political change that will bring a long awaited "normality". This "normality" meant accomplishing a successful process of transition that was delayed by Milošević's dictatorship, a bit of a wishful thinking that created a condition of withdrawal and passivity.[6]

All this needs to be taken into consideration not only to outline the wider contextual framework in which to locate ŠKART, but also when

1
See: Claire Bishop, *Artificial Hells: Participatory Art and the Politics of Spectatorship*, London: Verso, 2012.

2
For an introduction to the artistic situation in the 1980s, see: Branislav Dimitrijević, "That's the look that's the look the look of death (briefly about the art scene in and around Belgrade in the 1980s), *Osamdeseta: Slovenija in Jugoslavija skozi prizmo dogodkov, razstav in diskurzov*, Moderna Galerija, Ljubljana, (pp. 122-129), 2018.

3
"A dissensus is not a quarrel over personal interests or opinions. It is a political process that resists juridical litigation and creates a fissure in the sensible order by confronting the established framework of perception, thought, and action with the inadmissible, i.e a political subject". Jacques Rancière, *The Politics of Aesthetics*, New York: Continuum, 2006, p. 85.

4
The war has not started yet, although it was just waiting to happen after some republics initiated the processes of secession and announced their independence (Slovenia, Croatia). Meanwhile in Serbia, the newly established Socialist Party appropriated all the mechanisms of power, assets and infrastructure of the ruling Communist Alliance after purging liberal opponents against Milošević.

5
This all generated the highest hyperinflation in

Europe that in January 1994 reached a crescendo when the dinar's monthly inflation peaked 5.578 quintillion percent. This all caused rapid social impoverishment with estimated 3 million people living under the poverty line, closing down of the remaining factories, massive unemployment, economic and technological underdevelopment, food and petrol shortages, wide-scale corruption and burgeoning organised crime.

6
See: Branislava Anđelković and Branislav Dimitrijević, "The final decade: Art, Society, Trauma and Normality" in *On Normality: Art in Serbia 1989-2001*, Museum of Contemporary Art, Belgrade, 2005.

7
Fleck also observes that "there is no fundamental difference between the work of young Western artists and that of their peers in Central and Eastern Europe", and they fully abandon what he identifies as "Eastern European aesthetics", i.e. the entire artistic traditions in their countries pre-1989. All quotations from: Robert Fleck, "Post-Communist Art", in M. Hlavayova, J. Winder, *Who if not we should at least try to imagine the future of all this?*, Amsterdam: Artimo, 2004, pp.231-246. An earlier version of this text was published in the catalogue of the second edition of Manifesta (1998), a major culturo-political initiative on the European level aimed at bringing the attention of the Western public to contemporary artists from Eastern Europe.

positioning them within the communicative patterns of contemporary art in the 1990s, patterns that in an almost celebratory manner observe the perceived attitude of "Eastern European artists" to finally be able to produce art that is "indistinguishable from Western art", to pursue "international aesthetics", "regardless of their origin" and the local circumstances of their practice, and to "keep in touch with Western critics and curators on a daily basis". This is how curator Robert Fleck describes the characteristics of what used to be called "post-communist art", art that breaks away from its immediate past and hurls towards the magnetism of Western hegemony.[7]

This observation could be partially correct, and particularly so from the position of a Western curator who is mostly approached by artists focused on their international careers in the global art system. However, the observation is inapt to comprehend specificities of alternate positions, those in which art is approachable only in a locality, and only with local means – and it was precisely this aspect of art that was to become singled out in writings on participatory and relationist art. So the very event of this form of art did not actually happen in the eyes of a Western curator (as s/he is interested primarily in the *exhibitable*), neither for a Western gallery and its regular audience, but rather in an environment "where you wake up, go to sleep, quarrel with the neighbours dog and wonder where your dear friends are after waiting over three hours for them in a cafe near the main railway station".[8] This is how Finnish theorist Mika Hannula describes a locality, an environment in which the localness of art is located, a physical and a discursive site that can be activated for the production of content within the public sphere. This attempt to activate a locality along with its circumstances and by proposing and trying specific situations, Hannula calls "the politics of small gestures":

"A small gesture generates opportunities to think, feel and hear alternatives – and then to learn how to implement and to maintain them. Not in a full-scale solution for the big gesture, but in a mundane, day to day act of trying to make everyday life a little more worthwhile. It is about the beauty of ordinary acts. A process that is filled with trials and errors, and with amazingly few successes. But a practice is what it is all about: the trust of an experience that is happening in your *situatedness*, the feeling of being thrown into the flames of conflict.[9] ... A small gesture is about how to manage to make a meaningful difference in our daily realities. A small gesture is

nothing if it is not anchored in and committed to the continuation of a context in which it tries to become what it wants to be."[10]

The very name they gave to the group, ŠKART, has aptly explained their position, their involvement with what is considered to be something of a wasted leftover in a production process, anything rejected as unusable or wrong, a meagre result of some failed attempt.[11] Or, lets try to put it more precisely: *something too unsuccessful to become a commodity*. This word had been used widely in a production process, so to label something as "škart" meant that this object, or a part of it, is already on its path to a bin. Funnily, this actually happened during one of their first participations ever at one large annual architecture and design exhibition in 1991. The keeper removed their printed work because it was stamped with stencilled letters saying "ŠKART". They started using this "logo" already in 1990 and have used to mark their work ever since.

This particular *anti-brand* accompanying their *anti-design* came to signify a position akin to everyone and everything that got lost, derailed, confused, outcasted, refused, rejected, or simply everyone and everything that was weak enough to be run over by the historical and political reality. It is most definitely the circumstances of war that accelerated and amassed this unwanted surplus of history – and the work of ŠKART has become recognised for their participation in anti-war movements – and especially for their collaboration with the Women in Black movement.[12] But the war was not only induced by nationalist euphoria – it was also a manifestation of another process, the process that was full-blown in all socialist countries: the process of *privatisation*.

Here, we shall repeat an argument that the Yugoslav war of the 1990s was in fact a violent form of privatisation. Privatisation is a violent affair as such: "it is a violent dismemberment and private appropriation of the dead body of the socialist state, both of which recall sacred feasts of the past in which members of a tribe would consume a totem animal together", as Boris Groys summed it up.[13] To put it bluntly, war in Yugoslavia was *a continuation of privatisation by other means* and this was not limited just to the world of objects and properties. Privatisation is not only as a socio-economic process but also as a way of thinking: it was happening in the hearts and the minds of citizens. Socialist production based on the model of self-managed factories lost their historical context and got gradually dismembered and practically eviscerated:

8
Mika Hannula, *The Politics of Small Gestures – Chance and Challenges for Contemporary Art*, Istanbul: Art-ist, 2006, p. 42.

9
Hannula, p. 16

10
Hannula, p. 38

11
The word *škart* comes from Italian *scarto*, i.e. from the Latin origin meaning *waste*, *scraps*.

12
The book *I remember* (1995) is a result of this collaboration, and also one of the first products of Škart that combined their anti-design and a procedure in which protagonists are invited to express themselves poetically and visually. The book consists of poems and drawings of women who escaped from the war zones of Bosnia and Croatia. The poems were about memories of small and poignant details from everyday life that was interrupted by war – about a bowl of soup that was left uneaten in a hurried flee, or about flowers left unwatered.

13
Boris Groys, "Privatization or the Artificial Paradises of PostCommunism", *Art Power*, Cambridge: The MIT Press, 2008, pp. 165–172.

14
Ibid.

15
Lets evoke an anecdote about ŠKART that may illustrate their position in regard to the visceral effects of privatisation. When they participated in an exhibition called

by Serbian artists in Ljubljana in 1994, they witnessed a phenomenon that artists whom they assumed to be working together on a joint project started marking and grabbing hold of space on the walls of the ŠKUC gallery for their individual works. Unwilling to participate in this, ŠKART decided to put up their prints on the doors of the lavatory. Interestingly, their work still stands pasted on these doors, as the ŠKUC gallery decided to leave them there.

16
See: https://novi.uciteljn-eznalica.org/index.php/arhiva-autora?id=683

17
See: Jelena Vesić et al, *Vesna Pavlović: Stagecraft*, Vanderbilt University Press, 2021.

18
KÔD was the first artistic collective in Serbia whose activities involved happenings and performances, actions and interventions in public space, concrete poetry and land art.
See: Branislav Dimitrije-vić, "Grupa KÔD", https://www.kontakt-collection.org/people/438/grupa-kod

"On the one hand, such a feast represents a privatisation of the totem animal, since everyone received a small, private piece of it; on the other, however, the justification for the feast was precisely a creation of the supra-individual identity of the tribe."[14]

However, there are those who were not invited or did not feel like going to this feast.[15] In order to connect this with the practice of ŠKART, one needs to underline that in the Yugoslav case what was privatised was not legally the property of the state, but *a property without a titular*[16], a property that conceptually belonged to the society and was delegated to producers and users. Socialist Yugoslavia was unique for this concept of *social property*, and this concept did create emancipatory effects in public sphere that in the 1990s, and later, were practically rejected, *škart-ed*. To somehow reassemble, remake and reshape some bits and pieces of this broken social apparatus, should be identified as one of the main goals of ŠKART throughout their work. Their reaction to the situation, and most importantly to their own living and working conditions, was not about critically *representing* these conditions, but about trying, and partly succeeding to induce situations in everyday life that are both poetic and directly engaged, that are about the immediacy of the poetic in some social reactions or propositions that acted as an alternative, a small, weak, and marginalised, but an *actual* alternative within the described circumstances.

Although practically working as a duo, ŠKART co-opted many occasional or steady collaborators. And these were not only artists or friends of their generation, like the photographer Vesna Pavlović who worked closely with them during the 1990s.[17] As opposed to the impression that artists from the former socialist countries wanted to break away with the previous generations working in the socialist context, for ŠKART, on the contrary, it was the relation with some protagonists of the local neo-avant garde that laid out a significant impact on their work. In Prota's hometown of Zrenjanin, such a figure was the poet Vujica Rešin Tucić, and also it was their connection with Miroslav Mandić, the founding member of the short-lived yet seminal group KÔD (1970-71), involved in visual poetry, land art, critical writing, public actions and political interventions.[18] In 1991 Mandić embarked upon a ten years durational activity entitled "The rose of wandering" during which he walked a total of 43,000 kilometres (which is the diameter of earth). Members of ŠKART took part at the launch of his activity and in 1994 they produced a poster.

The earliest systematic activity of ŠKART was to design, print and put up small-edition posters [19] in various locations in Belgrade, the actions that were accompanied by short announcements in the program of the independent radio station B-92. Essential for Belgrade of the 1990s, B92 mixed political program and daily news, alternative music with various cultural programs, including "Skitzenblock" presented by Darka Radosavljević. Other protagonists of the "underground" art scene had their broadcasts, like the legendary artist Saša Marković Microbe [20], or Radomir Grujić Fleka who, when prevented from painting due to progressive blindness, produced an anarchic night program that achieved a cult status. [21]

In 1993 the Faculty of Architecture in Belgrade became a location for one of their early happenings, an event entitled *Armature*. They commissioned a "love-technical anthem" from a young classical composer and the score was performed by a music school choir and the grindcore band URGH, and also recited by a ventriloquist and other participants. This was the moment they already gathered by a number of unlikely collaborators that include the famous elderly actor Stevo Žigon reciting: "If I would live in that house I would caress its facade through the open window all the time", with his recognisably dramatic voice. [22] The event was witnessed by the art critic Darka Radosavljević, their first critical supporter who saw in their work a shift from "the expressive, jaunty and easygoing 80s" to a "need to create new collectives uninterested in potential social or material recognition: a new possibility of contemporary art to become *self-responsible* when facing the current times and history", because "in the situation of isolation there is no reason for compromise". [23] The original idea of *Armature*, with its slogan "it is armature that connect us" was to try to organise it in all faculties of architecture in the war-torn country, which was of course proven impossible.

In December 1992, and throughout the next year, ŠKART set about their most widely known work of the 1990s. It consisted of short and simple poems about a certain type of *sadness*, that were printed on thick, hand-sized cardboards, each stamped as the "Product of ŠKART" in the edition named "Nothing required at the outset". [See p.65] These cards were distributed in a series of public actions in Belgrade to a certain "target group" and its particular type of sadness. The first action happened in front of a major department store where cardboards with The Sadness of Potential Consumers were handed out. The week after, the distribution of The Sadness of Potential Travellers was organised at

19
Throughout the early 1990s their posters also included a series dedicated to idiosyncratic individuals who have not adopted to their immediate or wider social environment. A friend who decided not to attend a school graduation and decided to "graduate alone", or similar personal stories about "small gestures" of rejecting dominant routines and discourses, and finding alternatives. They also produced posters informing the public about small heroes of civil society who found themselves under the pressure of authorities: radio presenters cut off from broadcasting, newspaper sellers accused of distributing independent journals, etc.

20
See: Darka Radosavljević et al., *Zbogom Undergound - Saša Marković Mikrob*, Beograd: Remont, 2013.

21
See: Darka Radosavljević et al, *Miomir Grujić Fleka - Javni ilegalac*, Beograd: Remont, 2021.

22
Žigon was a well-known stage actor, but for ŠKART it was decisive when they saw him in a documentary film by Želimir Žilnik about 1968 student protests in Belgrade when he performed a passionate speech of Robespierre from Büchner's *Danton's Death* in front of the protesting students.

23
Darka Radosavljević, "Armatura", an unpublished manuscript from 1993 broadcasted on her program "Skizzenblock" at Radio B92.

24
The film consists of three short segment. The first is a constructivist footage of the mechanics of an old elevator from which Prota exits to deliver a short statement and the third is a performance of a pensioners choir singing a well known children song. In the segment in between we see Prota and Žole quarrelling about whether there is any point in connecting these two footages in a single film.

25
Interestingly, these two works for Cetinje Biennial are rarely mentioned. I witnessed the one from 1996, and discussed it as their major relationist work in my first text on ŠKART (Branislav Dimitrijević, "The Aesthetic of Critical Modesty", Siksi - The Nordic Art Review, 3-4, 1998, p. 88-91.), and as for the one from 1994, I have heard of it only recently in a conversation with Žole and Prota. The photo-documentation of this work might be lost.

the railway station. The Sadness of Potential Vegetables were handed out at the green market, The Sadness of Potential Pan to children in a park, and The Sadness of Potential Return was mailed to friends who emigrated. The Sadness of Potential Rifles was put in packages with humanitarian aid sent to Bosnia and The Sadness of Potential Childbirth was distributed by their pregnant friend. The Sadness of Potential Tenants was practically self-distributed. Predicaments with finding any low-price lodging (in summer 1992 Prota was practically sleeping rough by the bank of the Danube) include bizarre anecdotes about their landladies that are described in a testimonial letter to Walter Benjamin printed on a long sheet of paper in April 1994. [See p. 229]

The Sadnesses emerged from an assessment of the situation and the need to find a way to approach disillusioned citizens. So it was about sharing – but it is too easy to interpret it merely in this numbly "positive" manner. It was also about laying out something conflictual, something suppressed, something colliding both with the aggressiveness of the warmongering project, and the passivity of the silent majority of the citizens. The working method of ŠKART is in fact based on conflictual relations between the two members that each work only partly resolves. This is nicely shown in an early video entitled Forrest sings, Forrest shines (1994), where we see two members quarrelling about the content of the very film this scene is a part of. [24] If Sadnesses were their first "relationist" work, and as such one of the very early examples of that practice, their first appearances at a major art exhibition occurred in 1994, when they were invited to the second edition of Cetinje Blennial, quite a unique art event that happened in a mountainous Montenegrin town. Their work consisted of two regular mail boxes mounted on two side walls of a residential building. The opening for inserting letters on one of the boxes was stuck, whereas on the other they took the bottom out so the inserted letters would instantly drop out.

Two years later they returned to the same art event, invited to assemble a shop for their printed work which has meanwhile become acknowledged for their modest appeal. Instead of opening the shop, they closed it down, boarded up the door and the windows, and behind the panels they played an audio tape with an endless and "contagious" laughter. [25] This laughter annoyed the inhabitants of a small town, so on the second night someone tore away the boards and slashed the speakers. The laughter was here located at the breaking point between the consensual and the dissensual. The usually unaffected and dormant coherence of the local community was here antagonised. This time not with

sadness but with laughter. Later, in 1998 they put up makeshift street desks in and around Belgrade and gave away a series of "Additional survival coupons". These were coupons for relaxation, revolution, faith, orgasm, fear, miracle, etc. [See p. 222]. The passers-by were offered to pick and take them "according to how they feel". The coupons were distributed also by mail, and the actions was repeated in different locations, including Brooklyn in collaboration with Franklin Furnace Archive.

In the second half of the 1990s, ŠKART extended their inquisitive and empathic proceedings to out-of-context instances they encountered on their first travels abroad. When they were in New York on an Arts Link grant in 1996, they encountered samples of everyday life and types of labour unimaginable for their own worldviews and their upbringing in socialism. For instance, they met Charlie, a 38-year-old elevator operator on the Lower East Side. They were perplexed when confronted with someone spending 8 hours a day in small cubicle continually going up and down: "up and down – that's my life!", Charlie told them. Unable to fully comprehend this, they produced a Fluxus-like parcel named "Hello Charlie" that was mailed to him from Serbia [See p. 213]. A few months later they found out that Charlie died.

Another work of theirs that can be situated in the 1990s, was presented at the third edition of the European Biennial of Contemporary Art "Manifesta", held in Ljubljana in 2000. This was their first participation at a high-profile international biennial. Their contribution, entitled *Your Shit Your Responsibility* consisted of a large edition of small paper flags that were distributed to be used to indicate dog shit in the streets, or to mark anything else as shit for that matter [See p. 42]. The slogan was rather ambivalent and could be extended to different usages and identifications, and ideological affiliations. In the catalogue of the show, as opposed to the wordiness of other artists' pages, their page consisted of a few "sentences" only in dashes, commas and dots. The sense of a withdrawal from the standards of contemporary art presentations is again manifested here.[26] Already in the 1993 they published their first "catalogue", that was actually a notebook with empty pages. Their early poster entitled "important" consisted only of one dot, and this and such reductions they called *The Songs that Ran Away*.

Their reservation towards the participation of their work in the art context resulted in a series of collaborations characteristic of their activities after 2000 [See p. 214]. Instead of exhibiting their work, they used every opportunity to bring different groups and collaborators along

26
*Manifesta 3. European Biennial of Contemporary Art*, Ljubljana, 2000, p. 165.

27
Marijana Cvetković,
"Affective alliances and
the arts. The case of the
Škart collective", in Lola
Joksimović and Tiago
Prata (eds.), *Borderline
Offensive: Laughing
in the face of fear*,
Belgrade: Centre for Cul-
tural Decontamination,
2021, pp. 57-70.

with them, short-term and long-term communities they had gathered with, starting with the amateur choir founded in 2000 (Horkeškart) or with different groups making poetic and humorous embroideries (resulting later in one of the ŠKART spin-offs, a group called NONpracti-cal Women). Although their post-2000 period is outside of the focus of this text, it can still be situated within their social and artistic worldview that they developed in the 1990s. As Marijana Cvetković put it in her recent article on the group, the form of artistic interaction (or rather an "intimate whisper") they developed is based on the working method where a space is created in which "everyone is in the main role and can use their own voice".[27] But, as this voice belongs both to an individual and the community in which this individual may or may not participate, it is always at the threshold, and needs to be reinvented, re-introduced and reassured. The context of their post-2000 work may no longer be the context of war (although it is doubtful whether the war in Yugoslavia ever actually ended) but it is the context of broken social relations, of pri-vatised public sphere, a context in constant need of a localized response.

# Škart as art for common use
Zdenka Badovinac

Škart Collective, founded by Dragan Protić-Prota and Đorđe Balma-zović-Žole in 1990, has constantly been both expanding and narrowing since its inception. Many branches have grown from Škart, some remaining attached to the trunk, others becoming their own tree. Škart means "trash" or "scrap" and in fact, scrapists are all who are touched in any way by the philosophy of škartizem/scrapism, or škart/scrap — in other words, by everything that is normally discarded and which says more than what is usually Included in the representative image of a given historical moment. We can call škart a kind of philosophy of pro-fanity (Agamben) that arose at a very specific historical moment and that in our case means above all the return of art to common use.

So how to profane art and return it to common use? This is one of the key questions of Škart. For some thirty years now, the members of Škart Collective have been trying to find ways for people to rec-ognize themselves in škart, to find ways for as many people as possible to co-create. The conditions for as many people as possible to take part in scrap, however, seem to be the following: common interest, economy of modesty, the not-yet-existing, care and play.

## Common interest

We could say that in the time of socialism, the common element was solidarity and the possibility for all people to decide on matters that concern everyone. Solidarity and participation in decision-making were the connective tissue of society, and this tissue began to disintegrate just when Škart was formed. It is precisely the struggle against such a disintegration of society that became the connective tissue of Škart and its community While the ideology of the common during socialist Yugoslavia was in the service of the monumental project of a self-man-aging society, Škart, after the disintegration of the state, came to seek connective tissue on the fringes of society, among artists, the unem-ployed, single mothers and other single women, the elderly, refugees, children and activists. The leaders of the newly formed states in the early 1990s declared such connective tissue, which would reunite peo-ple in solidarity, to be nothing more than scrap.

Škart started working when socialism and the common state of Yugoslavia were falling apart. At a time when the economic crisis into which Yugoslavia fell after Tito's death ended with a bloody war in the

Balkans, launched by Serbian aggressors. Being an artist in Serbia at that time meant above all having a moral obligation to adress all issues raised by the war. No one at the time was overly eager to collaborate with artists from the country that started the horrific war. At that time, international solidarity was directed at Bosnia and Herzegovina, where artists and intellectuals from everywhere went during the war to help the suffering people in besieged and isolated Sarajevo. Of course, there were also quite a few Serbian artists who resisted the war. Among them, Škart. In the 1990s, Škart cooperated with all of those who resisted the Milošević regime and condemned Serbian aggression in the Balkans. They went to demonstrations together with *Žene u crnom* (Women in Black), a women's feminist-anti-militarist group that was largely dedicated to separated families, education, economic independence, and visa assistance for those who wanted to study abroad. For them, Škart designed the publication *Sjećam se* (I remember) (1994-95), a collection of drawings and stories by women in refugee camps. They also made a logo for *Žene u crnom* that consisted of a depiction of an olive branch, a symbol of peace, and a symbol for woman [See p. 207].

Škart also worked on a graphic design for the only free-thinking radio station in Serbia – B92, which became internationally known when the Serbian government suspended it in late 1996 in connection with student protests against Slobodan Milošević; the station became dependent on the Internet for broadcasting its radio program. As for *Žene u crnom*, Škart did not limit themselves to working on a graphic design, because with Prota and Žole a graphic design is never just a design. It always has a performative role, that is, it works directly in the here and now. Designs and poems alike are performed directly in the public space. The poems Škart creates are sometimes made up of mere single letters – often it's the letter R, which we can only think of as possibly calling for a revolution [See p. 232]. But Škart is never so overt. For example, during the war in the Balkans, Radio B92 regularly broadcasted *Škart vesti* (Škart Reports), each time announced by the voice of the famous Serbian actress Rahela Ferarai (who died in 1994): "Now, something important!" Then followed a voice saying only the letter R. Škart thus opened up a space of nonsense, a parallel second space that distanced itself from the outraged debates about the war in the Balkans that led nowhere. Activist humor, which interrupts the normal flow of things, is constantly present in Škart. In the 1990s, at a time of various crises, Škart began to distribute *Pomoćni bonove za* (Survival Coupons) on the streets, with the aim of stimulating solidarity between people. They made 16 different coupons – a coupon for fear, power, an end, pain, revolution, relaxation... Especially witty is the coupon for

orgasm issued by Škart in 1997, in honor of the 100th anniversary of sexologist and psychologist Wilhelm Reich's birth. We can only imagine how patriarchal Serbian men reacted to this, since many could not admit that Serbian militarism had in fact symbolically castrated them.

In its works, Škart constantly tries to emphasize not only our rights, but also our responsibilities. The work *Tvoje govno, tvoja odgovornost* (Your shit, your responsibility) from the year 1999-2000, basically a small leaflet with a crossed-out sign depicting a little man crouching after having just defecated, was pasted around the streets of Belgrade. With this leaflet, Škart called for the responsibility of each individual. Of course, this particular shit needs to be understood in the context of a time when there was a lot of unfruitful talk about who should take responsibility for the wrongdoings that happened in those evil times.

Škart began to clean up the terrain so drastically smeared by Serbian leader Slobodan Milošević with a series of 23 poems called *Tuge* (The Sadness), which Prota and Žole tied with string, and shared on the streets for the first time in 1992. In a space contaminated by militarization, nationalism and machismo, Škart entered with an aesthetic of modesty, openness and gentleness. With such an aesthetic, Škart wanted to clean up the space where nationalism had become a new "common thing." With the series *Tuge*, our artists preferred to determine that what unites us is actually sadness.

The *Tuge* series occupies a central place in Škart's activist poetry, where the power of words, visuality and connectivity come to the fore. With these poems, Škart continues the tradition of the local post-war avant-garde, where, in view of this collective's kindness and openness, it connects more with the "poor" aesthetics of the 60s and 70s than with the leading (retro) avant-garde of the 80s, with such creators as Goran Djordjevič, Neue Slowenische Kunst, and Raša Todosijevič. Of these, the closest to them is Mladen Stilinović, a key representative of the aesthetics of modesty, an artist of individual words, who has written words such as "pain," "work," "red" or short slogans associated with official ideological slogans on small pieces of paper. On one occasion, Žole said, about Stilinović, "his works are visual poetry."[1] A large part of Škart's poetry could be related to signalist poetry from the 60s and 70s, which reduces verses and words to their constituent parts, by sign, letter and sound.

## Economy of modesty

1
Http://dizajn.hr/blog/
skart-svatko-ima-
svoj-ritam-budenja/

For Škart, poetry is the connective material of the community. Prota and Žole rip poetry out of its self-sufficiency and pass it along for others

to use. This use is also related to a different economy, one which is always at work with Škart. This poetry is always written on modest material, mostly recycled or found materials. The cards on which the *Tuge* poems are printed are made of cheap material. Their production was made possible through money collected by the artists' friends, which is entirely in keeping with Škart's ethos of advocating a non-profit economy of solidarity. Their earnings, such as they are, are intended for all those who urgently need money. From the very beginning until today, Škart has been working with various people in need and helping them by developing their creative potential. As early as the early 2000s, Škart invited women to create *Nove kuvarice* (New Cooks). The "cooks" are decorated tea towels or cloths that so long ago hung above the stove in every home. On them, the housewives embroidered short slogans expressing the wife's submission to her husband and concern for his stomach [See p. 226]. The most typical of these slogans is: "The way to a man's heart is through his stomach." Škart hired single women to embroider socially critical texts on cloths instead of such submissive expressions of love. At the same time, this is not only about raising awareness about these women; it is also a matter of helping them, or facilitating their survival. One of these embroiderers, Lenka Zelenović, became famous with her cookbooks, and her embroidered "tea towels," which read, for example, "Dust on the machine, silence in the factory", and are exhibited at various exhibitions in Serbia and abroad.

With their *Nove Kuvarice*, Škart has become a platform for everyone who wants to be a poet or try their hand at art in whatever way. Unlike *Tuge*, from the first period of Škart, where their economy follows the strategy of *Samizdat-samodat* (self-published-self-given), *Nove Kuvarice* belongs to the second period, when Škart initiated a series of new collectives and helped the women to become independent and stand on their own two feet – like Lenka Zelenović. The embroideries organized themselves in the group NEpraktične žeNE (NONpractical Women) – initiated and formed in 2000 (as the New Embroidery group, named NONpractical Women in 2016).

It is amazing how many new collectives and networks Škart initiated: the choir Horkeškart and Proba, the children's choir Moon Children and AprilZMAJun, the youth-retired choir HOR-RUK and the anti-fascist choir UHO (united choirs). Then there are the embroideries by NONpractical Women, of New Cooks, Poetrying – training of active poetry, Defiant Pensioners – gerontological poetry group, children's festivals, school and village events and educational workshops.

Škart's first period, with its economy of modesty from the first decade, is reminiscent of the anti-market philosophy of the Yugoslav

2
Miklavž Kmelj, Kao misliti
partizansko umetnost?,
založba cf., Ljubljana,
2009, p.8

avant-garde of the 60s and 70s – such as the OHO or Gorgona groups. However, its second period is more interesting from the point of view of examining the possibilities of modern alternative economies. At a time when dominant economies are based on different international networks, these can only be countered by different ways of different networks and no longer small, closed self-economies.

## Non-yet-existing

What Škart is interested in is the collective subject, the only subject capable of radical social transformations. Unlike its Yugoslav avant-garde artist predecessors, who were limited to their own communities, Škart is open to all, very different people and is thus close to the ideas of the early years of socialism. Its role models in this sense could be sought both in the collective resistance cultures of the National Liberation Struggle, which included and activated the masses, and in the post-war anti-elitist orientations of art for the people. About partisan art, Miklavž Komelj has said that it is constantly reflected in comparison to the not-yet-existing, in the dialectic of the existing and not-yet-existing.[2] And it is precisely this not-yet-existing that finally disappears with the end of the Cold War and the disintegration of self-managing Yugoslavia. Škart may feel this more painfully than many other artists in their environment. This pain and dilemma of how art should behave in circumstances when everything is falling apart and when the optimistic horizons of socialism have thus finally disappeared can be felt from the Tuge series. And even though the Tuge poems are the saddest of Škart's poems, they can also be understood as something that has transformational power and thus a future. The duo Škart distributed these poems at the market, the railway station, on the streets, each time adapting their poems' content to the site where they distributed them, so that people could identify with the poems even more easily. "The Sadness of a potential passenger" was shared at the train station, "The Sadness of a potential vegetable" at the green market, while "The Sadness of potential return" was sent to those who left the country for economic or political reasons. Each poem in this series begins with the same words "the sadness of potential" and then the subject of each followed –vegetables, travelers, potential, landscapes, a pan, friendship, genealogy, guns, re-momentum, a bird... And it is exactly the potentiality of those things that makes them sad and at the same time optimistic. The potential of each of these things actually speaks to the dialectic of the existing and the not-yet-existing. It is sad that every life, is, as a truly full life, yet to come, which is not the same as would be the case if it did

not exist at all. Since potentiality is the truth of all that exists, it is this fact that mitigates our sorrows, makes them less sad – that is, when Škart shares their small instances of sadness in the streets, markets, stations of Belgrade... as if they want to alleviate the great sadness that has covered the whole country and the wider region. But it is these little sadnesses that can be the most painful.

Let's look at how it hurts when Škart describes a situation (probably referring to the situation in Serbia), when something can't even sprout.

> *the sadness*
> *of potential vegetables*
>
> *fruit*
> *and vegetables*
>
> *sow them*
> *(grow them)*
>
> *it's sad*
> *being what is not allowed to sprout*

## Care

Škart is a poetic and at the same time socially critical collective that often takes an activist stance. However, its driving force is not anger, irony or exclusion, but connecting people. Connecting them through positive emotions such as love, play and humor. Looking back, I imagine that such an attitude of artists in the early 90s may have been even more unusual, almost too soft, especially when compared to the angry 80s. Škart deliberately left this dilemma unresolved. However, their position can be understood from their following statement: "When the regime in power is cruelly militant, it is brave to be sad."[3]

With each new historical situation, Škart's openness and gentleness towards everyone only gained additional dimensions. Prota and Žole dedicated themselves to war widows, children living in orphanages, the unemployed, pensioners and all other socially marginalized groups. In recent years their special attention go to refugees and all those who have remained isolated due to the pandemic [See p. 214].

Since 2012, Škart has occasionally worked with children from orphanages Vera Radivojević from Bela Crkva and Jovan Jovanović

3
Branko Dimitrijević,
The Aesthetic of Critical
Modesty, Siksi, The
Nordic art review, XIII,
No. 3-4, Autumn/Winter
1998, p. 19

4
Published on Kunsthalle
Wien's website: https://
kunsthallew-ien.at/en/
defiant-pen-sioners/

Zmaj from Belgrade. With their choirs Moon Children and AprilZMAJun they have participated in children's festivals and school and village events. In 2019 Škart also initiated the low budget *PPP–Paper Puppet Poetry*, which can be realized under the artists' guidelines on the streets, in classrooms, refugee camps and hospitals. The goal of this project has been to connect migrant children with native ones and to stimulate their creativity. The children choirs and Paper Puppet Poetry serve children as an alternative education in which they make puppets, write and perform songs with their own themes and connect with the outside world. Škart is always connecting people who are normally divided. For example, with the HOR-RUK Choir, this collective connects retirees with young people. In 2014, in Zrenjanin, Škart organized a poetry writing workshop Prkosni peznzioneri (Defiant Pensioners) to stimulate pensioners to write poetry. During the recent lockdown they wrote poetry in nursing homes and sent their pieces over the phone to Škart, who later illustrated their poems and made video animations.[4]

Škart develops long-term relationships with all of these people in need, within which they slowly build an atmosphere of trust. And it seems as if the main tool of this trust is poetry. When Škart trusts the participants in their workshops that they, as amateurs, can also be creative, the artists gains the same trust in return. Škart thus creates a referential field of different voices that becomes a third space, a space of poetry where everyone involved feels safe and cared for.

Today, sensitivity and care for other people have become almost daily mantras, while in the 1990s they became more apparent within the discourse of humanitarian aid. Today is a time of new morality, which in an atmosphere of a pandemic no longer knows nationality or any other affiliation. That this is not quite the case, however, is proven by Škart. Škart helps especially those who are no longer cared for by their country and who are treated by international organizations as passive objects of humanitarianism. These are mostly refugees, and they are rarely treated as subjects who have decided to seek a new life in the most difficult of ways. Škart worked with refugees in collaboration with Belgrade Group 484 and other artists. Being present in different refugees camps, Đorđe Balmazović-Žole documented their oral stories in his *Refugee Maps* (2013–2015). Those maps do not only document refugees' routes, long hours spent crossing forests or the sea, but also incorporate their answers to questions such as why they had undertaken their journeys, the hardships they faced, how they crossed borders, how much they paid smugglers, and their experience with the police and the inhabitants of the countries they traveled through [See p.208]. Žole's representations of the refugees' journeys are stripped

down to the bare facts in order to draw attention to the absence of humane asylum policies in Europe.

## Play

In 2010, Škart represented Serbia at the Venice Biennale of Architecture and for this occasion they made the installation *Klackalište – Poligon neravnoteže* (Swing - Polygon of Imbalance is SEA-SAW PLAY-GROW, Polygon of disbalance), intended for the pleasure of young and old [See p.221]. At the opening, one of the Škart choirs, the Proba choir, sang the song "Armatura" — with the titular armature meaning that which unites us all. And this is of course a combination of song, play and humor. At first glance, the Serbian pavilion was most similar to a children's playground, where there was playground equipment that allowed various combinations for riding — with two, three or even more people. The game also included plants moving on special pedestals. In this space, various human and non-human actors, sensitive to each other's movements, met. There were no technical aids there to guide them, no traffic lights telling them when and how to take the next step. The main method of play was based on responsibility to each other, which includes mutual consideration and tolerance. If such a *Polygon of Imbalance* were to emerge today, it could even be interpreted as a critique of the political situation in the Balkans, where balancing has become one of the central means of manipulation. The dominant right-wing parties are trying to erase left-wing traditions one way or another, and condemn those who are on the left as political extremists who have held key positions in society for too long, too overwhelmingly, and must now be balanced with their opponents.

However, such manipulative balancing is far from how Škart works; these artists create the conditions for mutual tolerance, which the participants in their projects recognize as the only option that can sustain their common interest, even if it is a game. This lesson of tolerance, respect and co-responsibility is especially useful for today's pandemic. However, such self-governing behavior needs trust from above. Trust and faith that things are possible are present in every Škart gesture. On the walls of the pavilion in Venice, where the Swings were exhibited, were written lines from Vasko Pope's "Velegradska pesma" ("Metropolitan Poem"), which read:

*My wife,*

*whom I'll do*
*everything for.*

*told me once:*
*I wish I have*

*a small green tree*
*that runs after me,*
*down the street.*

How to design a public space so that everyone has the feeling that one small tree is running behind him or her? First, people should believe that this is possible. Škart's ways of playing instill faith and optimism in people. Play is, as Giorgio Agamben says, one of the ways to profane things, to snatch them from the hands of the modern religion of capitalism and, last but not least, to return art to the people.[5]

Prota and Žole, as the heirs of the avant-garde, reflect on where the boundaries between art and life lie. As the heir to socialist culture and propaganda, however, Škart tests the power of the word and various slogans among the people. It is no coincidence that the first and most effective socialist propaganda was carried out by avant-garde artists. With their slogans and manifestos, as Alain Badiou writes, the avant-garde sought to achieve a moment of pure and unrepeatable present.[6] If we were once able to say something similar about the agitation slogans of early socialism, we can certainly no longer claim this for a time when socialism, with its slogans, has become an empty word. Over time, socialist slogans lost their profane use and became the domain of socialist religion. Agamben writes about capitalism as a religion that separates things from themselves, from their profane use. Something similar could be said of socialism in the years when it lost its innocence. In play, everything is accessible to everyone, even such separate fields of action as, say, economics or law, can become play. For Agamben, play is something that keeps the ritual of the sacred – that is, separated from people – and abandons its myth. Meant here by "sacred" is everything that, like capitalism today, separates power from people, that uses that power to separate things from common people. When play retains only the ritual and frees itself from the prescribed activities and obligatory relations and use of things, it opens up the different potentialities that lurk within them.

5
Giorgio Agamben, *Profa-nations*, Zone Books, New York, 2007

6
Alain Badiou, Dvajseto stoletje, Društvo za teoretsko psihoanalizo, Ljubljana, 2005

We could say that Škart and the avant-garde arts in general, with their ludicrous, provocative, anti-institutional and anti-art establishment, are working against the neutralization of profane power that enables a new experience of the world.

1
Škart's short bio in the
Poetrying pocket issue,
December 2013.

# Škart: it's us, an ordinary group....(hehehe)[1]
# Within Škart's extensive network of connections, relations and friendships

Milica Pekić

When I was invited to write about the work of Škart collective, founded by Dragan Protić-Prota and Đorđe Balmazović-Žole, instead of offering a single perspective of an art critic I decided to approach their work through conversations with collaborators, partners and participants of many initiatives, collectives, actions, platforms and workshops they initiated and conducted in the past twenty years. Soon after I ended up with a list of some thirty people and began an incredible journey of mostly digital encounters, exchanges, inspiring conversations and intense learning. I was introduced to an invisible network of connections and relations which I now understand is an integral and inseparable element of all the works Škart initiates and takes part in. My intention here is to share this research experience and try to navigate and guide you, curious reader, through the diverse thoughts, reflections, memories, feelings, impressions and ideas my interlocutors shared with me in our conversations. These conversations demonstrate how people's experiences and individual contributions transcend theories, testify to a possibility of alternatives and lead to a source of valuable collective knowledge.

My first impression approaching the task of interviewing the Škart collaborators was the ease of the process. Whether I called the director of primary school in small village in Serbia, the resident of an old people's home, a known feminist activist, a member of the Škart choir, the director of a small printing house in Beli Potok near Belgrade, a faculty professor, an artist, a curator or a young participant of Škart workshops from Vranje, the very moment I mentioned Škart and the reason of my call I was faced with a warm welcome and openness. Among all these diverse voices there was not only a strong feeling of pride to be part of something they considered an important experience but also a feeling of ownership of the results of their collaborative work:

"On my embroideries there is no kitchen, no stove, just socially and politically engaged lyrics"
— Pava Martinović, member of the Nonpractical Women collective initiated by Škart and an active poet within the poets' collective Defiant Pensioners, also initiated by Škart, Zrenjanin

"I am a shy person but working with Škart I've learned that we have never exaggerated, we have never been quiet or loud enough, and that we should do things for the community. Now I have the same way of thinking, of how to shift things, how to make things unusual, how to encourage stories. My work with children became Škart practice: striking, open, provocative and rebellious"
— Sanja Stamenković, alternative pedagogue, associate of Group 484, Vranje

"As a regular activity within the school program we have Poetrying manifestation where children are reading their literal works and poetry, this is a direct legacy of Škart and their activities in the school"
— Nina Petrov, director of primary school "Sava Žebeljan" in Crepaja village in Serbia

"Our collaboration is based on the culture of patience and perseverance in everything, building peace, building human relations. With Škart we developed both ethics and aesthetics of anti-war resistance. One cannot exhibit in galleries during the war, the street is more important. We searched for the rejected, marginalised, subjugated, for those whose voice is not heard, those whose lives are not important, misfits, deserters, those who violate the consensus, those who do not fit, victims of crime committed in our name. We developed everything together with them"
— Stanislava Staša Zajović, anti-war activist and co-founder of Women in Black, Belgrade

## What Maja[2] would call social choreography or what Žole[3] defined as architecture of social relations

From the experience of dynamic micro social interactions within street actions during the nineties they moved their practice after 2000 towards designing and constructing more complex artistic and social structures/collectives, involving greater numbers of participants. New collectives could provide a continuity of togetherness in creative work for the benefit of all involved[4]. Whether they were consciously

2
Maja Bekan, artist and member of Horkeškart choir

3
Đorđe Balmazović

4
In one of our conversations Žole remembers: "Somewhere around 1999, Prota and I were discussing delegated performances and so-called political video works which we were seeing in the galleries at the time, and we did not like them. I remember saying to Prota that if we were to work with people I would like it to be long term work, so that we could learn from them and they could learn from us, for the benefit of all ."

5
From the conversations with both Žole and Prota it is clear that their intention was to initiate greater collectives which could last but it is also evident that the structure, format and organisation within those collectives was not pre-designed but was developing and changing with time through experience of joint work.

constructing new collective formats or whether their architectural intuition and curiosity was leading them in this direction[5], Škart's choirs, Poetrying platform and Nonpractical Woman Collective demonstrated a self-organised logic of alternative art forms based on a particular set of values which confront established norms within the art system. Maja Bekan, one of the members of the HORKEŠKART choir, herself an artist, described some of the principles of the choir through her own experience:

"At the end of 2000, on B92 radio, I heard an announcement for an audition for the Škart choir. There were around 50 of us there and we were all accepted with no musical audition whatsoever. The voice was not the priority in the traditional sense but it was important in some other way. For me this experience was the first promise of something different. Now I think about it, it was like social choreography, there was a strong social element to it which was either choreography or architecture. Suddenly someone opens their practice for you to join in."

The strategy of using their symbolic influence to reject any kind of cultural domination and privilege and provide space for others was stubbornly exercised and implemented on every possible occasion. Whenever they would be invited to take part in an exhibition in a museum or gallery they would propose a choir performance, an exhibition from the Nonpractical Women Collective, a performance of the Defiant Pensioners Collective, some adapted Poetrying event, or a performance of the group they were currently working with. Displacing and travelling was one of the important strategies in construction of the Škart collectives and many of my interlocutors referred to this experience:

"For many people, travelling with HORKEŠKART was the first time they left the country. Our first visit was to Croatia in 2001 and I think this was the first cultural collaboration between Serbia and Croatia after the war. There were 50 of us, a full bus, with all the papers, permits, invitation letters and whatnot: it was an incredible experience. We performed across Istria and in Zagreb, we saw the sea for the first time in a long time."
— Tamara Milanović, architect, member of the HORKEŠKART and PROBA/Rehearsal choirs, Belgrade

A dedicated need to discover new and unexpected content, to empower and motivate everyone to express themselves, to share the stories of others and subvert the hierarchy between artist, artwork and audience is present in most of their work. Often they would promote voices which are structurally silenced and marginalised by the hegemony of the system in power. Their position becomes the one of a facilitator of situations and constructor of alternative forms of artistic participation that equally values the contribution of all participants. The result is collective work built by a diversity of multiple voices and mutual relations.

"Usually it is considered that individuality and collectivity do not go together, but this is not the case. We are all different universes, we all think differently but in our collective these diverse voices are precious. What we have in common is our capacity to respect the integrity of the other individuals and our desire to develop a dialogue"
— Brigita Međo, therapist, member of Nonpractical Women, Zrenjanin

"Škart is creating poetic and ideological communities within their projects, where the product is not merely the result of what would be called today the 'collective work'. Rather, the product is a result of a deep connection established between all participants in the process of production."
— Ana Miljanić, theatre director, Centre for Cultural Decontamination, Belgrade

Maybe the most intense and largest art initiative in terms of scale, number of participants, duration and material produced was Poetrying — Active Poetry Training, with a radically experimental structure of the programme which combined poetry reading, performance, video art, music, design, illustration and publishing. The platform created a unique eclectic harmony whose aesthetic had a profound influence on the Belgrade art scene.

"It is important to say that we wanted to democratise literature, to introduce people from the margins to the programme, to introduce performance, to play with media, to move from poetry as defined in

traditional circles. Poetrying was self-financed and self-organised".

— Vesna Bjedov, linguist, member of Poetrying editorial team, Belgrade

"People could take part on the spot, we called them accidental poets, and this was a complete lottery, sometimes brilliant, sometimes diary entries - but a moment of social dialogue was achieved. For me, the most important thing I've learned was patience working with people but also the feeling of trust and belief that if we open the space, people will be able to fill it in a meaningful way. Every part of the programme was working in cooperation with everything else. We achieved aesthetic eclecticism that was rich, where the whole transcends the individual contributions. Everything I have worked on since was based on direct democracy as a form of governance and still I haven't experienced more democratic space than Poetrying training, this agora where everyone can come up to the stage and in three or four minutes express their views."

— Marko Aksentijević, political scientist, member of Poetrying editorial team, one of the founders of Don't Let Belgrade Drown movement and the Ministry of Space collective, Belgrade

The claim that everyone has a say and that everybody can be an artist in itself contains a moral stance which is hard to approach from a critical perspective. However, exercising this criterion in practice can lead in various different directions from outstanding and inspiring experiences to complete failures. Dedicated commitment toward disruption of standardised regimes of behaviour founded in honest curiosity for people and a capacity to discover poetry in the excluded, rejected and abandoned is what distinguishes Škart's practice and motivates so many people to engage and take part.

"Through their practice they managed to position art as a social phenomenon. They used the production of art objects for social development, for communication and openness with other people. But they

always created an artwork, a material trace, an artwork in which social situations and people intersect."
— Darka Radosavljević, art historian and curator, one of the first to promote the work of Škart, founder of the Remont gallery, Belgrade

"They always take a risk and the outcome is uncertain but it always ends up in the best possible way"
— Dušica Parezanović, philologist, former director of Cultural Centre REX, Belgrade, program coordinator in Booksa, Zagreb

Poetrying events were organised once per month in front of packed audiences at the Cultural Centre Rex from 2009, for five years [6] [See p.200]. More than sixty pocket issues of poetry books were published and the economic logic behind the platform was based on a modest circular economy [7], mutual support and volunteer work of all people involved in the organisation and editing of the programme. We could easily misunderstand this logic as a promotion of unpaid labor, since it is obvious that organizing this frequency of events, for this many years, with this number of participants, involves a huge working investment and dedication. Still, keeping a non-commercial logic was a conscious decision by the team members and they all had different jobs to earn their livings. The enthusiasm they all expressed clearly testifies to the capacity of people to invest a huge amount of energy and time in activities which motivate and inspire them. Knowing this we could just wonder how the world would look like if people would actually invest their labor in things which motivate and inspire them and earn their living doing so.

The organisational structure of HORKEŠKART [8], for example, changed over time, from hierarchical toward a more horizontal and democratic logic. In 2006 following the introduction of self-management, Prota and Žole left the choir to its independent activity under the name of HORKESTAR; and it is still performing to this day. Their repertoire was subversive; preserving the memory of the cultural heritage of socialist Yugoslavia and Yugoslav avant-garde movements and was promoted in public spaces (streets, squares, markets, cafes) and carefully chosen locations such as schools, faculties, old people's homes, homes for children and youth, refugee centres etc.

There is also an evident intention to transform artistic forms which are stuck in old, traditional logics into the engines of playful engagement. Before Škart's initiatives, choirs were mostly linked to conservative music environments, poetry festivals were still very

6
After that, it was organised less frequently in Rex but it was also organised in schools, prisons, old people's homes and other institutions. It was often hosted by other manifestations and exhibitions both locally and internationally. Many regional tours were organised.

7
Tickets for the event were around one euro and all the income from the ticket sales was invested in printing of a small poetry book from one of the Poetree performers which would then be given back to the audiences with tickets for the next Poetree event.

8
HORKEŠKART/HORKESTAR conductors: Ljiljana Santovac, Ljiljana Danilović Cincarka, Zoran Petrović, Marija Balubdžić, Dragana Aleksić, Bojana Budimir, Marija Jocić...

9
It is important to add
that today both in Serbia
and across the region of
ex-Yugoslavia there are
numerous self-organised
choirs and even more
poetry festivals build on
the legacy of Poetree-Ac-
tive Poetry Training

10
The very begining was
the result of collabora-
tion of Škart, Women in
Black and Single Moth-
ers' Association, Zemun/
Belgrade.

11
Staša Zajović

12
Sanja Stamenković

traditional both in form and content [9] while embroidery was a forgotten trace of a patriarchal culture:

> "Embroideries reflected an old value system of tra-
> ditional patriarchal society. Then, one day, I saw in
> the paper new embroidery by Lenka Zelenović. For
> me it was an initiating experience, suddenly there
> was contemporary embroidery as a voice from this
> time. I finally heard a voice of the silent majority so I
> started searching for the author"
> — Brigita Međo, Nonpractical Women

Nonpractical Women Collective managed to transform a conservative folklore tradition into a medium of women's empowerment, emancipation and free expression. As opposed to the HORKEŠKART choir and the Poetrying platform this is a smaller collective with a flexible number of members, drawing women from a variety of different backgrounds. The initiative has existed for twenty years now [10], with the most active members in the past decade being Lenka Zelenović, Brigita Medjo and Pava Martinović.

> "I met Prota and Žole in 2000 through the Associa-
> tion of single mothers. Now I have made over 400
> embroideries and when Prota is preparing them for
> some exhibition I surprise myself with all the things
> I've done. Thanks to Škart I resolved my status and
> earned my retirement"
> — Lenka Zelenović, housewife, Nonpractical Woman

## What Staša [11] refers to as invisible practice and what Sanja [12] would define as different forms of presence

The workshop and its applications, implementations, realisations, variations, interventions and subversions is yet unexplored and still not an appropriately evaluated art format which constitutes a parallel, unbelievably productive line in Škart's practice. Workshops are often realised in collaboration with different organisations and collectives, among which are KC Rex, Center for Cultural Decontamination, Group 484 and Women in Black, Belgrade; village primary school "Sava Žebel-jan", Crepaja; Drugo more, Rijeka; WHW collective and Booksa, Zagreb; Bunker, Ljubljana; Točka, Skoplje; Rotor, Graz; Migrative Art, Brussels; Intercult, Stockholm; Akademie Schloss Solitude, Stuttgart; Franklin

Furnace Foundation, New York. I will briefly introduce just a few examples: three months of workshops with young addicts in Graz resulting in redesigned public bicycles with small flags carrying their stories across city [13]; six months of workshops with students of art faculties in Brussels resulting in the temporary collective FRONT' with numerous activists, anti-war and anti-violence public actions and designs during the NATO bombing of Yugoslavia [14]; two months of workshop with residents of a retirement home in London, in this case black immigrants from the West Indies, resulting in illustrated couplets of their stories [15], a series of workshops with children and youth in South Serbia resulting in various public performances, actions, published books, created objects, street theatre performances, and concerts [See pp.214-215]. The most recent one was conducted in 2021 and resulted in a temporary youth collective The Good News Drummers [16]; who, during the pandemic, announced optimistic news with drums on the streets of Bujanovac, Vranje and Belgrade and were also published in a pocket book.

13
In collaboration with Rotor, Graz, Austria

14
In collaboration with Ivana Momčilović and Migrative art collective, Brussels, Belgium.

15
In collaboration with curatorial duo B&B and organisation Space, Hackney, London.

16
In collaboration with Group 484, Serbia.

"Working with Škart was a totally new experience, nothing similar to school. We could do anything we wanted. All the things I did with them I never did before, public actions, public performances, creating objects, writing. They were like a driving force for us and nothing was taboo. I don't have a fear of public appearances any more, now I can go out on the street and say what I think. Honestly, I think what we did is performance art. Earlier, I thought that performance is only what Marina Abramović does."
— Andrej Stojanović, young The Good News drummer, Vranje

"Through collaboration we found out that the question of space and communication between people is the question of democracy"
— Robert Kozma, Group 484 and Don't Let Belgrade Drown political initiative, Belgrade

"They have generosity in relation to children and other collaborators which induce courage to step into the new with ease and spontaneity. Children feel this subversion and they feel proud to take part in something they feel is important."
— Zaga Aksentijević, philosopher, member of Group 484, Belgrade

17
For many years they
realised workshops in
Home for Children and
Youth in Bela Crkva in
coolaboration with
Ivana Bogićević Leko,
associate of Group 484.

More than fifteen years of continuous work with children from the Home for Children and Youth in Bela Crkva in Serbia should get a special chapter in the story of their workshops. Children from the Moon Choir, PPP paper puppet poetry formats, short videos, books of poems, numerous public performances are just some of the results of their work. [17]

"Others come once or twice and then they leave, but Škart is always here. For children every experience of the outside world is enormously important and with them they had adventures from learning ice-skating, running in the rain to swimming in the wild river."
— Zoran Stanković, Director of the Home for Children and Youth "Vera Radivojevic", Bela Crkva

Škart workshops, apart from the invisible relations created, the learning process and exchanges which take place among the participants, always result in extraordinary art forms in the media chosen to best communicate the results of the collective process with a secondary audience. This is why their workshop practice offers such rich material for research and will, hopefully in some future research, help reposition the workshop as an art form within the art system and secure its recognition and the consequent support it deserves. In Škart's practice sometimes the result of conversations with one community becomes the base for working with others.

"Žole had conversations with asylum seekers and created maps of their travel experience on the spot. Some maps would stay in the centres for asylum seekers and some would become the base for the work with other communities and schools. In their workshops participants are not receivers of the knowledge but are actively engaged in the production of knowledge."
— Tamara Cvetković, philologist, member of Group 484, Belgrade [See pp. 216-217]

## What Ana[18] defines as *thinking of the space and design as the condition and not the packaging of something*

18
Ana Miljanić

Škart's visual language and very distinctive *Do It Your Self* aesthetic is inscribed in the aesthetic of Woman in Black's anti-war resistance movement, the independent art scene emerging during the nineties in Belgrade (for example the Centre for Cultural Decontamination, Cultural Centre Rex, Remont gallery) and has influenced generations of artists and designers [See pp.206-208].

"It is certain that Škart has had a strong influence on design with their cheap, seemingly simple formats. They even managed to change the printing houses. What Standard printing house would do, no one else did."
— Darka Radosavljević

"Those were such fantasies which only I could produce. And we printed everything on recycled paper which is a disaster for my machine. The only thing I didn't print on for them was toilet paper."
— Rade Košničarević, printer and owner of Standard 2 printing house, Beli Potok

"I was surprised how we were moving from graphics towards performance."
— Branko Pavić, artists, professor of fine arts at the Faculty of Architecture, Belgrade

They used design as a way to connect people, like a "catalyst of exchange" as defined by Jean Baptiste Joly, founder of Akademie Schloss Solitude, where Škart articulated their first ideas on collectives.

"For one poetry book which I published, Škart gave the poems to several songwriters and one choir, Horkestar, so the reader can hear those performances through a QR code stickers, hidden where — in the cover-pocket."
— Ivan Čolović, anthropologist, publisher, founder of Edition 20th century, Belgrade

19
Lenka Zelenović

20
Text available on
http://www.skart.rs/
#announcement

21
*Rat, priča u crtežima*,
Đo & Dju, Fabrika knjiga,
Belgrade, 2018

22
Duga Resa/Fringe
Infringe, documentary
film, production Frak-
cija film revolutionary
action, Belgrade 2021/22

# What Lenka [19] teaches us from her embroidery: *We all have red blood type, not blue or green or any other shite* and a few more words on the politics of Škart

In one of their statements Škart articulated the politics inscribed in their work as "the politics of active self-governing non-alignment or the come-back (return) of the written off (the scrap)". [20]

Self-management and non-alliance are tightly linked to Škart's background and their direct experience of socialist Yugoslavia. The story of Yugoslavia and its dissolution is openly dealt with in their work. This is the topic of Žole's recent comic book made in collaboration with a school friend *A War, story in drawings* [21] and Škart's first documentary film *Fringe/Infringe*. [22]

"We gave the book to our eleven years old son to read since we thought it is educational. He was introduced to the topic and it is written in a way to cause no trauma"
— Ana Adamović, artists, KIOSK, Belgrade

"In a way, this is also a film about Yugoslavia and what is left and what is not left out of all those relationships and ties."
— Vladimir Šojat, artist, editor and producer of Fringe/Infringe film, Belgrade

Milica Pekić together
with Zaga Aksentijević,
Tamara Cvetković, Brigita
Međo, Sanja Stamenk-
ović, Pava Mar timović,
Robert Kozma, Dušica
Parezanović, Nina Petrov,
Lenka Zelenović, Milica
Mica Savić, Ljiljana Ilić,
Maja Bekan, Andrej
Stojanović, Vesna Bjedov,
Tamara Milanović, Staša
Zajović, Darka Radosavl-
jević, Branko Pavić, Zoran
Otankvić, Aleksandar
Veličković, Vladimir Šojat,
Ivana Momčilović, Marko
Aksentijević, Ana Miljanić,
Rade Košničarević, Ivan
Čolović, Ana Adamović,
Jean Baptiste Joly,
Dragan Protić (Prota)
and Đorđe Balmazović
(Žole), all of whom I had
conversations with and
who influenced the final
structure and content of
this text.

The legacy of socialist Yugoslavia, anti-war and anti-fascist politics, the politics of sharing, of friendships, of care; disturbing and shifting the aesthetic regimes of accepted bourgeois norms; demonstrating alternative modes of art production and self-organisation; all of these characteristics could be summarised in what Staša Zajović, Dušica Parezanović and Maja Bekan defined as the feminist politics of Škart, and I fully agree with them. Paradoxically the feminist politics is being nurtured by a collective whose only permanent members are both men: two men of different sensibilities and productive relationship of perma nent frictions, confrontations and mutual support. They remind us that social imaginary is dynamic, flexible and playful. Over thirty two years of ŠKART's immensely productive artistic output provides us with evidence-based arguments for a variety of different ideas. We just have to dive into it and open our minds and eyes for empowering alternatives.

# Visual glossary

# Applied poetry

### Poetrying (*Pesničenje*)

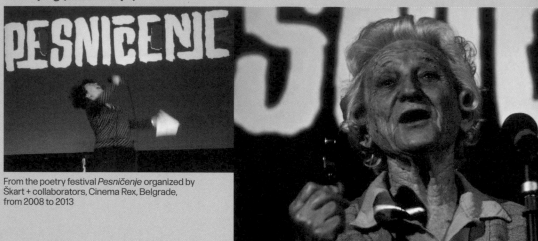

From the poetry festival *Pesničenje* organized by
Škart + collaborators, Cinema Rex, Belgrade,
from 2008 to 2013

## Exhibition views

Venice Architecture Biennial, 2010

Galerija Nova, 2015

Intervention at the public library Hauptbücherei am Gürtel, realized within the frame of "Wiener Festwochen: Into the City" together with the students from HGBLuVA, Wien, 2018

# City as a free ground

## Fron't - Art Against the Violence

Objects made at the workshop together with students from different universities in Brussels, 1999

Street action in Brussels, spring 1999. Photo by Wincent Meesens

## Horkeškart

*Horkeškart* at the tower of a mine in Labin, Croatia. Touring in Istria, summer of 2001

*Horkeškart* performing at the farmers market in Karlsruhe, Germany, 2005

## Seesaw Play-Grow

*Seesaw Play-Grow* replica in Bitola, North Macedonia, produced within the frame of Open City Festival, 2012

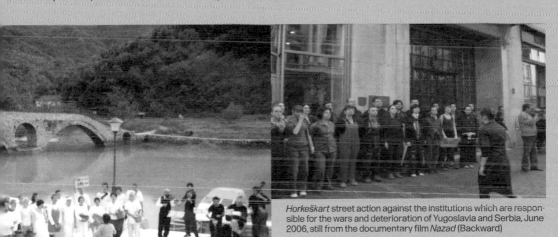

*Horkeškart* street action against the institutions which are responsible for the wars and deterioration of Yugoslavia and Serbia, June 2006, still from the documentary film *Nazad* (Backward)

*Horkeškart* performing at the village of Rijeka Crnojevići, as part of the Cetinje Biennial of Art, Montenegro, 2002

## NONpractical Women (*NEpraktične žeNE*)

Lenka Zelenović from NONpractical Women (*NEpraktične žeNE*), exhibiting her embroideries as part of Škart's solo show in the Museum of Applied Art in Belgrade, 2012

## Your Shit, Your Responsibility

Posters in the streets of Belgrade, placed in between political posters made by the ruling government, 2000

## Coupons

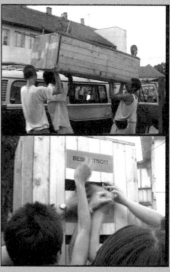

Stills from the video documentation of distributing *Coupons* for Survival in the village of Beli Potok, Serbia, August 1998. Photo by Miloš Tomić

# Singeroll, Skiroll, Penjalec

Open playground installation view from the Mladi levi Festival, Ljubljana, 2011

# Street actions

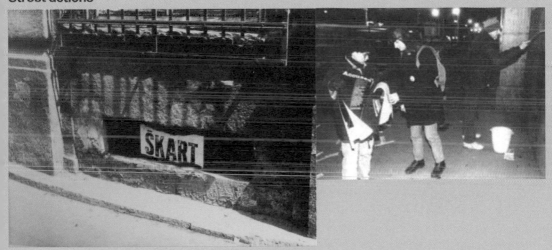

Škart in the streets of Belgrade, 1990-1994

# Collaboration

## The border is closed

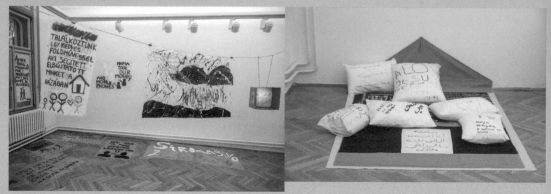

From the exhibition *The border is closed*, Loznica City Museum, Serbia, 2016. In collaboration with migrants, local artists and Group 484

## Graphic design by Škart

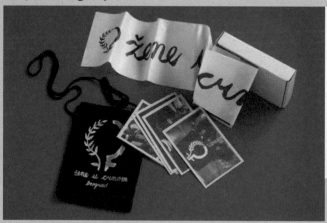

Women in Black

# I remember

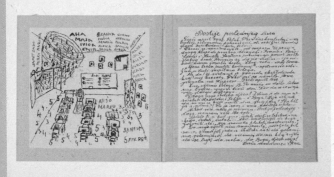

A book of documentary drawings and stories by women from refugee camps in Serbia, together with Women in Black. 16 × 16 cm, 200 pages, 1995

Literary magazine Reč, published by B92

# Migrant maps

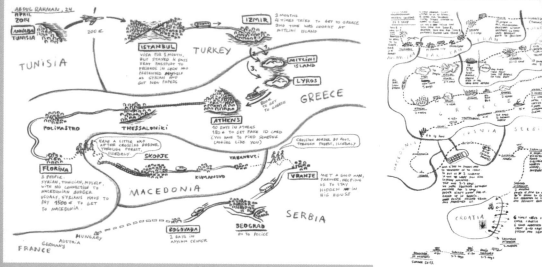

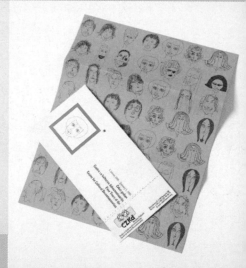

In collaboration with Group 484 (*Grupa 484*) and the migrants at Bogovadja asylum center, Belgrade, Serbia. 65 x 85 cm, digital print on canvas, 2013 – 2017

The Center for Cultural Decontamination (CZKD)

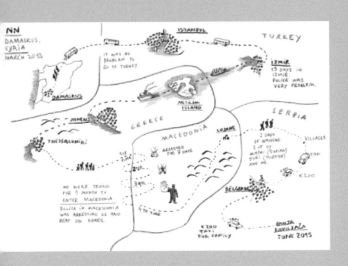

Radio B92

# Continuity

## Sadness

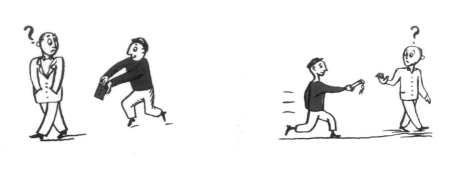

Drawing by Žole, Prota distributing Sadness cards on the streets of Belgrade, 1992-93

## NONpractical Women (*NEpraktične žeNE*)

We were introduced to the Association of Refugee Single Mothers in Zemun while we were working with the anti-war group Women in Black in 2000. We suggested that, instead of silently repeating the folklore embroidery, the women (all of whom were a part of the workshop therapy group) should actually say something about themselves using this skill which is familiar to them. Through conversation, and exchanges of exchanges, the first *New Kitchen Tapestry* was born. They also met women from other parts of the country and together formed NONpractical Women collective in 2016, which combines creative writing with social criticism. They have been creating their rhymed diptychs, "kitchen poetry", which they draw and embroider on wall tapestries. They display their work internationally both in public space and in cultural institutions, and some of them are included in museum collections too.

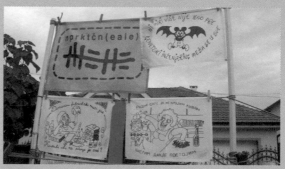

Members: Lenka Zelenović, Brigita Međo, Sanja Stamenković, Pava Martinović, Vesna Nenadov, Škart, Vladan Nikolić, and many others

# Women in Black

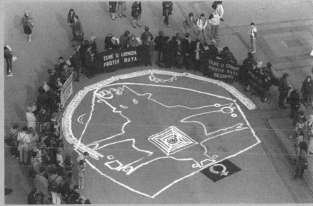

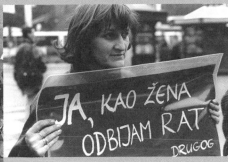

*Me, as a woman I reject the war of another.* Škart in collaboration with
Women in Black, anti-war demonstrations in Belgrade, 1991-2001
Photo by Vesna Pavlović

# Choirs

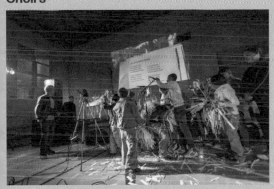

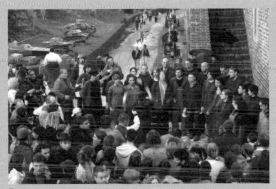

Škart in collaboration with Group 484 and children from the Vera
Radivojevic Foster Home in Bela Crkva. April Dragon June (*April
Maj Jun*), Moon Children (*Deca Sa Meseca*), from 2007 till present

Škart in collaboration with choir *Horkeškart*, from 2000 till present.
Street action at Kalemegdan Park, Belgrade, 2006. Photo by
Branka Nad

# Equal basis

## Choirs

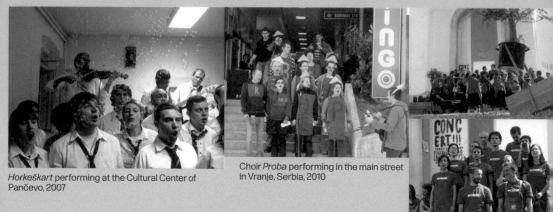

Horkeškart performing at the Cultural Center of Pančevo, 2007

Choir *Proba* performing in the main street in Vranje, Serbia, 2010

Choir *Proba* performing in Venice Architecture Biennale, 2010

## HORKEŠKART

We formed the choir and the orchestra *HORKEŠKART* in the year 2000 when we were presenting our work *Your Shit, Your Responsibility* at CZKD Belgrade. We had an open call for an audition which was advertised on Radio B92. Almost 70 interested parties applied and they were all immediately accepted... So unplanned, this first post-war alternative choir was formed and it continued working, performing, traveling and socializing till 2006, independently.

We left *HORKEŠKART* in 2006 but the choir continued working, changing its name to (what else could it be) *HORKESTAR*. The choir has been operating through self-organization strategies since more than 20 years.

## Hello Charlie

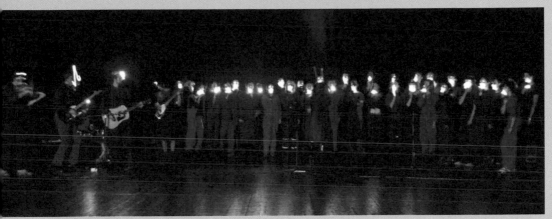

Choir *Horkeškart* performing at the 45th Mine, Yours, Ours Festival (Moje-Tvoje-Naše Festival), Rijeka 2006

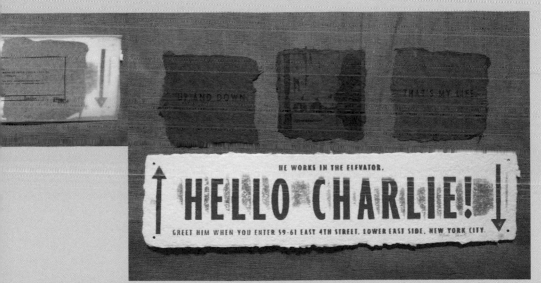

Parcel for Charlie, elevator operator in the Lower East Side, NYC. Silkscreen and relief prints on hand-made paper, 1998

# Invisible practice

Working in a team as well as with other teams is an everyday practice where we use different experiential tools. Each of these activities we have been engaged in during the last few years applies practical and (non-practical) poetry in its own way.

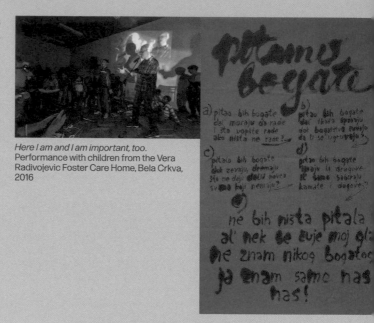

*Here I am and I am important, too.* Performance with children from the Vera Radivojevic Foster Care Home, Bela Crkva, 2016

From the workshop *How do we read images – Demystification of art* held with the elderly. In collaboration with The Museum of Modern and Contemporary Art Slovenj Gradec, 2015

Škart together with the residents of Pappie Close Elderly Care House, Hackney, 2009. Workshop recording and painting memories of the elderly, of their childhood, origins, life back in the Caribbean Islands, journey to UK and their impressions of a new country

Defiant Pensioners (*Prkosni Penzioneri*), poetry workshop with the pensioners in quarantine at the Zrenjanin Center of Gerontology, April 2020

Still from poetry clip Pobeda (Victory), Škart with *Moon Children* (Deca Sa Meseca), Belgrade, 2017

## Children from the Moon (*Deca Sa Meseca*)

We have been working with children from Vera Radivojević foster care house in Bela Crkva since 2007 in collaboration with Group 484 and Ivana Leko. Thus, the choir CHILDREN FROM THE MOON was born. The aim was – as a socio artistic collective – to enable them to get out, travel, see other surroundings, other realities and other children.

All young and some older (15 children) + the orphanage dog Medo + the educator + us = go for an afternoon walk. While walking, Kristijan asked: WHAT DO THE RICH DO WHEN THEY DON'T DO ANYTHING? We decided to save that question for the afternoon workshop. Then we sit in a circle answering the previously asked question. First we take the answers from the volunteers, later we ask the shyer ones. We write down the answers. The last one to give the answer is Ljilja, and by accident, used a rhyme:

*I WOULDN'T ASK THEM ANYTHING, BUT YOU SHOULD HEAR MY VOICE.*
*I DON'T KNOW ANYONE RICH.*
*ALL I KNOW IS US.*

## Defiant Pensioners (*Prkosni Penzioneri*)

Because of the Covid-19 pandemic *Defiant Pensioners* have been isolated since the 9th of March 2020. Almost two years from now. And in spite of it – they don't stop writing. They send their poems by Facebook, or SMS, then we publish and share the audience response with them. Their existence in everyday life outside the gate, even through the poetry, means a lot to them.

At the moment, the most active and the most optimistic one is Dušan Todić, who recently experienced a brain stroke, recuperated and started walking again. He sent poems from the hospital the whole time, and now, after coming back home, he restlessly waits for the gate to open again and go to the opposite cafeteria and pay the waitress 200 dinars and order Coca Cola. (He doesn't drink alcohol anymore).

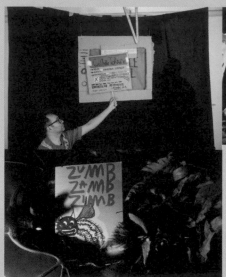

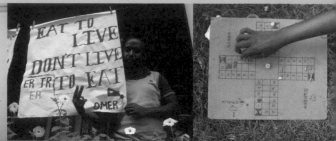

Workshop with migrants in Bogovadja asylum center, Serbia, 2013-2017. In collaboration with Group 484

*Paper Puppet Poetry* workshop at Belgrade and Plovdiv Asylum Centers, 2019

Poetry workshop with the pensioners, Zagreb, 2016. In collaboration with the Museum of Contemporary Art Zagreb

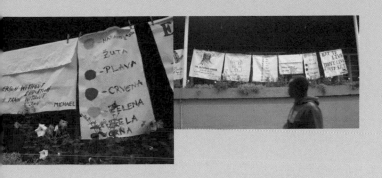

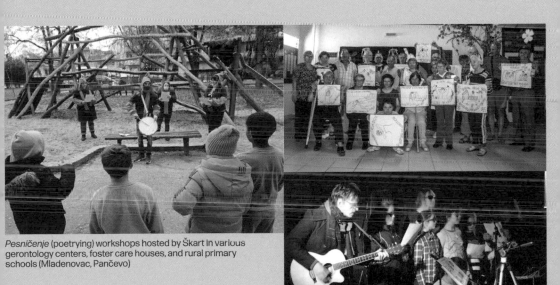

*Pesničenje* (poetrying) workshops hosted by Škart in various gerontology centers, foster care houses, and rural primary schools (Mladenovac, Pančevo)

# Exhibition making

The Nineties: A Glossary of Migrations, Museum of Yugoslavia, Belgrade, 2019

Fiery Greetings, Museum of Yugoslavia, Belgrade, 2015

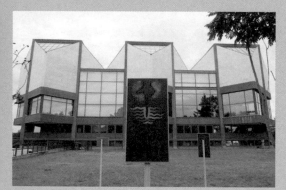

Water Remembers, from the exhibition "Overview Effect", Museum of Contemporary Art Belgrade, 2020

Mini-Retrospective, Aichi Triennale, 2013

*Aesthetic of resistance – Škart*, Galerija Nova, Zagreb, 2015

The Flint Public Art Project, Michigan, 2012. In collaboration with Stephen Zacks and Čedomir Kovačev

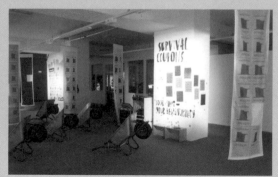

ŠKART – NAPAD! REJECTS – ATTACK! AUSSCHUSS – ANGRIFF!,
Platform München, 2016

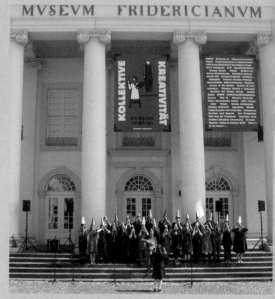

Collective Creativity, Museum
Fridericianum, Kassel, 2005

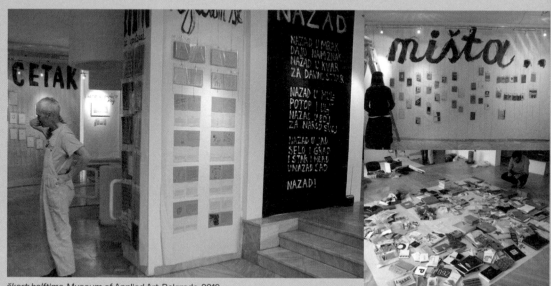

škart: halftime, Museum of Applied Art, Belgrade, 2012

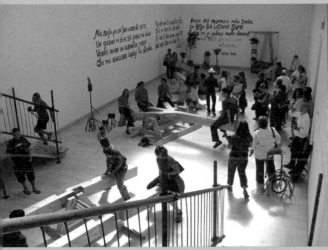

*Seesaw Play-Grow*, Venice Architecture
Biennial, 2010

*Migrant Maps*, Slovenj Gradec, Slovenia, 2017

Workshop with the residents of Tabor retirement cen-
tre, realised in the frame of Mladi Levi Festival, 2021,
Ljubljana, Slovenia

# Self-distribution

## Walk permissions in any direction

Škart and friends making Free Walking PASS, to support protesters during demonstrations against fixed-term elections, Belgrade, 1996/97

## Coupons

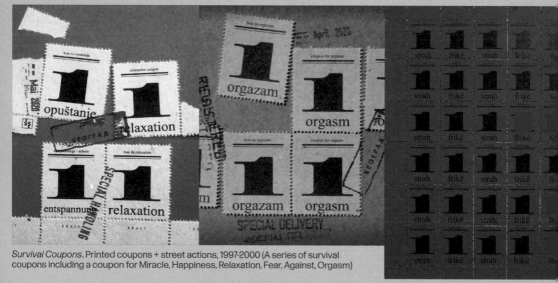

*Survival Coupons*. Printed coupons + street actions, 1997-2000 (A series of survival coupons including a coupon for Miracle, Happiness, Relaxation, Fear, Against, Orgasm)

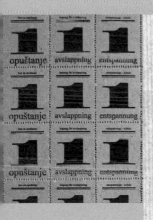

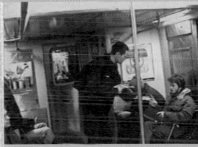

Škart distributing *Coupons* in the NYC metro, November/December 2000

Envelope designed by Škart to send *Coupons*, 1998

## Sadness

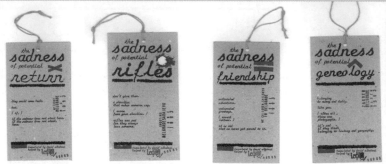

*Sadness*. A set of poems printed on cardboards. 15 × 8,5cm, screen print, 1991-93

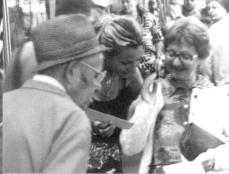

Distributing additional Coupons for survival at the Boulevard of the Revolution in Belgrade, 2001. Photo: Zoran Drekalović

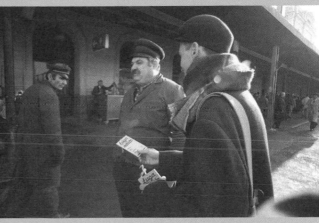

Distributing *Sadness of Potential Travellers* in the main railway station In Belgrade, 1992. Photo: Vesna Pavlović

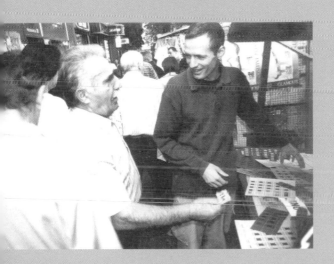

# Self-empowerment

### NONpractical Women (*NEpraktične žeNE*)

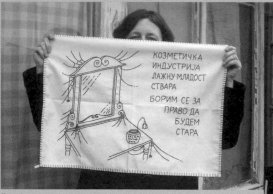

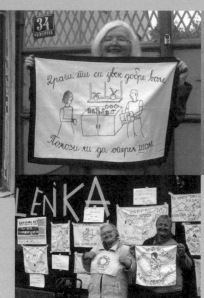

Škart in collaboration with NONpractical Women
(*NEpraktične žeNskE*) embroidery group; Lenka Zelenović,
Brigita Medjo, Pava Martinović

### Paper Puppet Poetry

Storytelling workshop with the children, Škart in
collaboration with Borderline Offensive: laughing
in the face of fear, Košice, Stockholm, Plovdiv, Belgrade

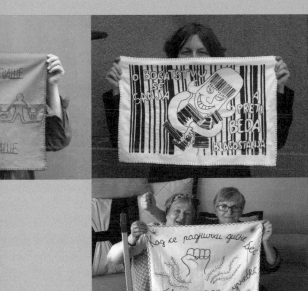

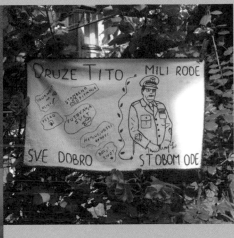

# Subversion

## Fron't – art against the violence

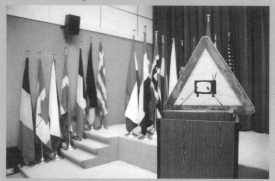

Warnings signs against war. Action in NATO headquarters, before the daily press conference. In collaboration with ENSAV, Brussels, 1999. People involved with Fron't: Raquel Alves, Davide Otero Y Alonso, Frederic Rousseau, Lisa Boxus, Phillipe Hullet, Charlie Case, Axel Pleeck, Martin Van den Beelen, Bruno Hardt, Vincent Meesens, Jelena Matić, Selena Matić, Ei-migrative Art, Škart

Warnings signs against war. Sticker designed by Lisa Boxus, Škart and David Otero Y Alonso, 1999

## Armatura

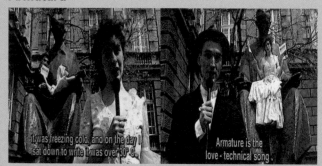

Still from the video *ARMATURA (love-technical song)*, Ana Kara Pešić and Dragan Protić, Belgrade, 1994

Album cover designed by Škart + Branko Pavić, 1993/94. Music composed by Ana Kara Pešić

## Your shit, Your responsibility

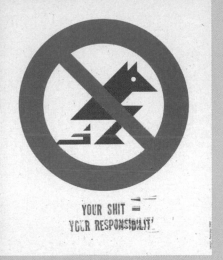

*Your shit, Your responsibility*, posters, flags, stickers, 2000

## Homemuseum

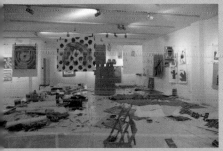

Action, *Homemuseum*, hold during the conference "Designer: Author or universal soldier" at the Museum of Contemporary Art Belgrade, 2012

## A Letter to Walter Benjamin

Letter to Walter Benjamin, Belgrade-Berlin, 1994

## Men embroidery actions

Belgrade, Tirana, Skopje, Seoul, Gdansk, 2003-2009
Photo by Goranka Matić

## Katalog

The first Škart "catalogue" (a notebook with empty pages), published in 1993

## Feed, Warm, Dress Yourself

Warm Yourself, poster + street action, 68 × 44 cm, offset, Belgrade, 1999

Dress Yourself, poster + street action, 68 × 44 cm, offset, Belgrade, 1999

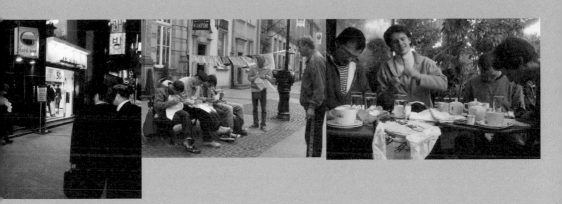

Feed Yourself, poster + street
action, 68 × 44 cm, offset,
Belgrade, 1999

# Visual poetry

## Posters

*Kuca* (House), poster, 50 × 70 cm, screen print, 1991

*Q Retko Slovo* (Q Rare Letter), poster, 50 × 70 cm, screen print, 1991

*And Yet Another This*, poster, 50 × 70 cm, rubber stamp and red ink on paper, 1990

*And Perhaps This*, poster, 50 × 70 cm, rubber stamp and re[d] ink on paper, 1990

## Pocketbooks

Pocketbook for ART-KINO, 8 × 12 cm, Rijeka, 2016

*The Bus*, Pocketbook, 8 × 12 cm, Kaliningrad, 2003. Produced by SEAS, Intercult, Stockholm. Translated by Darja Bekan

R for letter R, poster, 50 × 70 cm, screen print, 1989/1990

This By No Means, poster, 50 × 70 cm, rubber stamp and red ink on paper, 1990

Sve, Da Li Je To Dovoljno? (Everything, Is That Enough?), poster, 50 × 70 cm, rubber stamp and red ink on paper, 1990

Sve, Samo Sve (Everything, Just Everything), poster, 50 × 70 cm, rubber stamp and red ink on paper, 1990

Fog, Pocketbook, 8 × 12 cm, 2004. Produced by Secession, Vienna, 2004

Sve, Sve Ima Svoju Cenu
(Everything, Everything Has
A Price), poster, 50 × 70 cm,
rubber stamp and red ink on
paper, 1990

Sve Na Prodaju (Everything
For Sale), poster, 50 × 70 cm,
rubber stamp and red ink on
paper, 1990

Mi smo krenuli
ka kapiji.

*We were heading
towards the main gate
of the courtyard.*

A ona...

*And she...*

The Fence, Pocketbook, 8 × 12 cm, 2013.
Produced by the Museum of Applied Arts
in Belgrade, translated by Wayne Kehoe

In Rijeka the river Riječina is down
and a high mountain is above the
town, Pocketbook, 8 × 12 cm, 2013.
Produced by Drugo more, Rijeka,
translated by Svetlana Rakočević

# Workshopping: traces & tools

## Printing & Poster Making

From the printing workshop *Developing a Visual Voice*. Realized within the frame of the 4th Athens Biennale AGORA, 2013. Together with Cactus Network and Tzortzis Rallis

## How do we read images

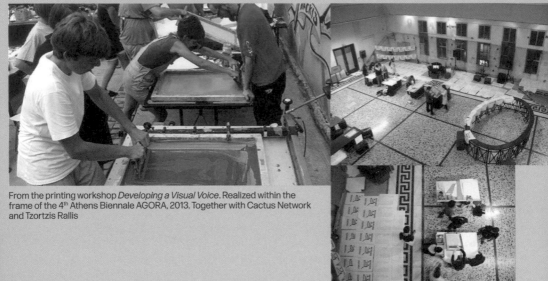

From the workshop *How do we read images – Demystification of art* held with the elderly. In collaboration with The Museum of Modern and Contemporary Art Slovenj Gradec, 2015

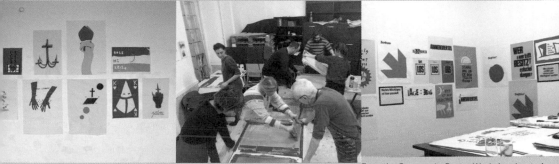

From screen printing workshop *Bishop's Love Letter*, Rijeka, 2016

From the Community Poster Workshop hosted by < rotor > association for contemporary art, with Cactus Network (Tony Credland and Glenn Orton), 2010

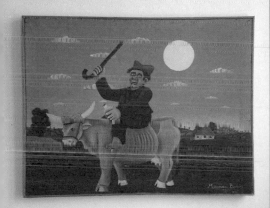

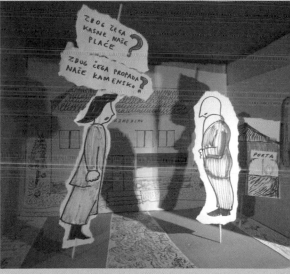

From the workshop *How do we read images – Demystification of art* held with pensioners at St.Ana, Zagreb, 2016. In collaboration with the Museum of Contemporary Art Zagreb

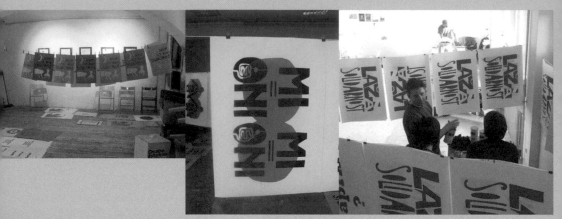

From the workshop *Political Poster*, Rijeka, 2009. Together with Cactus Network

# Epilogue[*]: Presence and togetherness as forms of (re)presentation

Merve Ünsal & Seda Yıldız

**Merve**   How would you interpret the utilitarian value of Škart's practice, if we are to think about Rancière's "ethical regime of of art"? It is obvious that their practice stems from an inherent need that they feel as practitioners: I would like to consider how their work's societal/utilitarian values could be articulated in aesthetic terms?

**Seda**   Yes, there is an integral relation to politics in Škart's practice. As you said, it has been developed in line with the social world, and it stems from a need to respond to socio-political upheavals in their immediate surroundings. I think, as they are committed as individuals, their art practice reflects their commitment too. This way, their practice and everyday life simultaneously transform into each other. Yet Škart would not label their practice as political art, or social art but instead as "building human relations through art." I love this poetic definition because if we summarise how Škart operates in a sentence it could be that it is about looking for everyday things that can be embodied into a new poetics. *Sadness* project is a beautiful example of this; it is a commentary on the loss of the social bond during the dissolution of Yugoslavia, but at the same time, the artistic imagination in the work is so strong. It talks about war through the perspective of, let's say, vegetables, it reads "It is sad being not what is not allowed to sprout." Or this strong humour, "In war I read more books than ever before, oh I need another war so I could read a bit more." It is important to highlight this poetic and artistic imagination, which I think Škart is really good at, especially because in a socially engaged practice there tends to be a prioritisation of the social content over the artistic, only reliant on its "usefulness." When examining local cultural dynamics in the early 90s, Škart clearly left an impression on the understanding what art is. Their approach to form, beyond social engagement, was radical as they were not interested in the standard way of artistic presentation. An example of this are the self-promotion radio jingles or newspaper ads they created. Also, one can clearly see the strong affiliation with the avant-garde and conceptualism in their early work, the posters from the 1990s for example, which carry half-abstract, slightly Dadaist statements like, "R for the Letter W". Fluxus inspirations are visible too, for example anonymous mail art interventions.

[*]
I posed some of the questions that I wrote in the margins while reading and editing the book with Seda, embracing the dialogic form that she had embraced while in conversation with Škart. This epilogue is meant to make tangible for the reader our numerous conversations while working on the text together.
– Merve Ünsal

And how does Škart's motivation to contribute to a more just society translate into aesthetics? The ways of production and distribution? I think their choice of form as well as material is telling. Here, we could talk about a democratic approach to form; their practice is slightly modest in scale and sometimes – if I may so – not visually striking. Often they work with cheap and easily accessible materials like printing poetry on cupboards, or creating pocket-books, fanzines (these forms also bear a certain connotation of low status) which is linked to self-distribution strategies too. The strategy of free-distribution: artworks for anyone and everyone. As printed material offers limitless and affordable reproduction, it has been preferable for reaching a broader audience. In such a way, we could talk about political equality taking form. Another example is the choir projects and embroidery making workshops in which equality and multi-vocality become basic principles of operation. These are less representative, more accessible and self-empowering forms and thus a very strong aesthetic decision in terms of producing forms of visibility.

On the other hand, there is a strong level of "openness" in Škart's practice dealing with making art in terms of participation. Workshops they have been working on since the early 2000s are process-oriented encounters in which presence and unexpectedness become central. As authors, Škart is offering the infrastructure but still their end is uncertain; uncertainty as a tool for creativity. This I find interesting, especially discussing utilitarian values, because in the Škart case we can talk about a broader understanding of the notion. Returning to your reference of Rancière, he indicates something refreshing – whereas activism, based on action, has clear ends, let's say to transform the world, aesthetics are not destined for action; it is only an inner split of action without programming its end. This does not mean doing nothing, but it could focus on immediate needs, for example.[1] Maybe these projects are not "useful" in changing social reality directly, but they offer another pragmatic utility like working with a choir, which allows participants to travel, meet an international audience etc. Or in the case of children's choirs, which allows them to exit from gated doors, to travel to other villages and cities to perform, so there are different degrees of being open-ended within artistic activities that can be adjusted, re-worked, responding to needs of circumstances/collaborators.

Merve    The shifting relationships between representation-presentation-poetics offer pluralistic ways of interpreting Škart's practices. From your position of articulating/being in dialogue with their practice, how do

1
"The Aesthetic Today"
Jacques Rancière in
Conversation with Mark
Foster Gage, 2016
https://www.youtube.
com/watch?v=w4RP87
XN-dI

you position yourself within these dynamic relationships? In other words, as Škart's practice defies linear interpretations, what kinds of challenges does that pose for your practice of being with their practice?

Seda    There are two sides to this notion of nonlinearity; in Škart's case we can interpret it as an asset for navigability. It is a practice which is not defined by accumulation. On the other hand within this nonlinearity there are often cracks, gaps and things that remain missing, or invisible. This becomes more clear considering the change of their operational modes from the 1990s to the 2000s, leaving the streets to develop community projects which mainly happen behind closed doors with a specific audience. We see a big shift in making art here; whereas in the former Škart is the maker, it is the participants who create the work in the latter. So we should differentiate between presentation and representation too. I think Škart is not interested in showing the problem, or representing a certain group of people, but facilitating presence and togetherness as forms of presentation. It is also interesting how Škart handles collaborative art production; when invited to join the exhibition at the Fridericianum in Kassel instead of documenting the collective work, they insisted on travelling with the choir to the venue. So what this small gesture means, again in utilitarian terms, is to meet immediate needs; a group of people getting a chance to travel outside of the region, with per-diems, to meet with other people etc. Some might find this tricky but to me it totally sounds legitimate. And this is also the role I take on, being in dialogue with their practice, to make these exchanges more visible either by documenting, archiving, sharing with multiple audiences, both through institutional and non-institutional means.

And what kind of challenge does that pose? Škart designs, organises, collaborates, motivates individuals, or groups but less often they activate the resulting objects (embroidery, song, playground, poem etc.) as art. This shared experience needs to be mediated. However they have never been interested in the idea of documentation, most of their barely documented encounters do not convey the contextual frame of the work, or the multilayered relations behind it. I don't think Škart conceives of documentation as "a betrayal of an authentic event"[2] in Peggy Phelan's terms. It only happened to be secondary. And this is the moment when I (and other practitioners as curators, writers, art historians, critics) have difficulty approaching their fluid practice. A "fear of approach" in lack of discourse and documentation as art historian Branislav Dimitrijević named it in a conversation we had on this topic. How do we discuss these projects then? Do I need to experience

2
Peggy Phelan. *Unmarked: The Politics of Performance.* Routledge, 1993

them firsthand in order to speak about them? I have this "outsider" position right, I'm not a part of Škart, I never had a chance to join their community projects. Plus, I am a foreigner to the region and its geo-politics, which strongly shaped their practice. Still, as you said, my role here is to articulate this, which is challenging. It might sound naive but one advantage of being an outsider is that it allows another mapping possibility, a certain ease to embrace the "fear of approach". Also it is valuable to develop a different criticality, to identify things which work or things that do not, and this becomes particularly clear when we discuss workshop projects that Škart initiated outside of the region, for example.

Merve    There are multiple agencies at work within Škart's practice. What are the challenges of interpreting and talking about a practice that was so alive? How did you deal with these challenges?

Seda    The main challenge for me was to navigate through 'trace-lessness', being physically distant from each other (which we couldn't avoid) and to reflect on plurivocality while not being in contact with the individuals, or groups that Škart has been collaborating with. It was only during my stay in Belgrade that I had the chance to meet a few of them, including Lenka, Mirko, Filip, Reza, and to listen to what this exchange means for them. But in time this certain absence led to another col-laboration. To reflect plurivocality in the book we invited Milica Pekić, a friend and long term collaborator of Škart, to conduct field research by visiting village schools and foster homes frequented by Škart from 2010 up till now, to talk to individuals they had collaborated with includ-ing members of NONpractical Women, Group 484, or people involved in the Pesničenje poetry festival. I think Milica's contribution is extremely valuable, through her local eye we had the opportunity to capture those diverse engagements and experiences.

In addition to that the lack of documentation, we were talking about a scattered practice from the pre-Internet era to the digital era. We lack a proper existing archive; most of the artworks are located in different places, in personal boxes. Some of the analog documentation of street actions from the 1990s have not been digitised yet. To get a full understanding of thirty-years long active practice under these circum-stances almost becomes impossible, at least in the time-frame of this book. So I decided to embrace this fragmentary nature, making this fact visible in the book too. "Continuity of discontinuities" as Zdenka Badovinac puts it beautifully. I have not met any other artist for whom the material existence of their work is so neglected – and this again

3
Claire Bishop, *Artificial Hells: Participatory Art and the Politics of Spectatorship*, Verso, 2012

goes back to Škart's idea that what matters most is creating a commonality, a common space for social betterment. Claire Bishop also mentions this motivation of contributing to a more just society as a goal in the long term which is almost unrepresentable.[3] I find this interesting to reflect on: how do we work with the unrepresentable? I have a difference of opinion with Škart on this: for them these engagements are self-sufficient and require no extensive documentation. However it obviously causes a visibility problem for the work and the artists themselves, as it results in reaching a small audience. Therefore it has been challenging to decide on "what" to include in this book. A selection process was needed so I decided to focus on what I personally found more meaningful and relevant today. That was the way to deal with the weight of decision-making. I must also add that my selection is based on a level of openness and playfulness too. I proposed to discuss works which are more open in comparison to others with a straightforward commentary on the political situation, as in the case of *Your Shit, Your Responsibility* (many call this project indeed not an artistic work but a political campaign). Now that I think about the book only as a starting point, instead of a retrospective project, I approach this decision-making challenge with ease too.

Merve How did editing and writing in this book shift your practice as an interdependent curator? What is next for you?

Seda What I learned from being in dialogue with Škart's practice is the pure beauty of collaborative work, and working with joy, which is the most important aspect! It is beautiful how this encounter creates many others, opening up new possibilities of collaborations and friendships. Our dialogue continues, and I guess when the book is published it will be another beginning for us as we want to explore ways to share this book in rather unusual ways, both in terms of presentation and documentation. We would love to imagine this book making friendships too, so we consider creating different structures of togetherness, through and around the book. At the same time I would love to continue working on archiving Škart's work and exploring potential ways to share it, which is a long-term process.

Also these last two years have been self-transformative for myself; I'm becoming aware of my needs and wishes, what kind of projects I want to work with, how and with whom to collaborate, and under which conditions. I've been reflecting on the ethical responsibility in curating too, and I think it is not a coincidence that it developed during this process. To name things that one is not satisfied with and act

accordingly, this is another motivation for Škart, and I'm still working on this. Until now, what works best for me is to build a way of working which is rooted in a deeper understanding of local contexts, creating collaborations & reciprocal relationships, and long-term engagement.

For the upcoming work, again, my personal interest and research focus is on the former Eastern Europe; particularly art practices from the 90s (breakpoint) to the first decade of the 2000s. In this period we see an alternative stance to mainstream art and progressive ideas in terms of making and displaying art, along with its definition. An example of this are also artists -particularly who were not affiliated with the art academy- proposing subversive activities to operate within the lack of functional art and cultural institutions. In relation to that, I find the idea of collectivism and practical skills such as self-organisation highly encouraging. But also on a personal and emotional level, it feels right to be working in the region thanks to the hospitality, sincerity, generosity, and intimacy that I encountered, and even, if I may say so, a certain level of imperfection in a broader understanding of the word. These are the values that matter to me and which organically give direction to my work too.

Recently I was a resident at the Igor Zabel Association for Culture and Theory in Ljubljana to more deeply explore the work of Slovene art historian, curator and writer Igor Zabel, who extensively wrote/worked on the dialogue between the West and the East. I'm intrigued by Zabel's idea to approach dialogue as the initiation for collaboration, to work closely with artists. He also focused on creating an active space for works of art and their interaction, the possibility of reaching a more personal and attentive relationship with art. This creates a thrilling opening and I would like to explore these ideas further, and I will see what will come out.

## Selected engagements of Škart

### 2021
- Bigger than yourself – Heroes from ex-Yugoslavia, MAXXI, Rome
- REALISE! RESIST! REACT! Performance and Politics in the 1990s in the Post-Yugoslav context, MG MSUM, Ljubljana
- South Constellations: Politics of Non-aligned, Rijeka, organised by Drugo more
- 90s: Scars, MMSU, Rijeka, Croatia
- Beyond the Border, The Museum of Modern and Contemporary Art Koroška (KGLU)
- Documentary "Duga resa" (Fringe Infringe) directed by Škart

### 2020
- Viral Self-Portraits, MG+MSUM, Ljubljana

### 2019
- Solidarity—now more than ever; ACC Galerie Weimar, Germany
- The Nineties: A Glossary of Migration, Museum of Yugoslavia, Belgrade, Serbia

### 2018
- The Industrial Art Biennial (IAM), Pula – Labin – Vodnjan – Rijeka, Croatia
- Sequences. Art of Yugoslavia and Serbia from the Collection of the Museum of Contemporary Art
- It is obvious from the map – REDCAT gallery, Zagreb and Istanbul
- Story Time – Vetrinjski Dvor Maribor, Berlin Metro Station Kleistpark, Grazer Landhaus, Graz

- Graphic novel "Rat – priča u crtežima" (A War Story in Drawings), published by Fabrika knjiga, Belgrade

### 2017
- Disappearance at Sea, Mare Nostrum, BALTIC art gallery, Gateshead, UK
- It is obvious from the map – REDCAT gallery, Los Angeles, USA
- Story Time, Trg svobode in Park herojev, Slovenj Gradec
- Exhibition design for the retrospective exhibition of Tomislav Gotovac, Museum of Modern and Contemporary Art, Rijeka, Croatia

### 2016
- Re-construction of Painting, MSU Zagreb
- Cold Wall 2, MSUV, Museum of Contemporary Art Vojvodina, Serbia
- NEW GRAZ / Part 1 NARRATIVES FROM THE ARRIVAL CITY, Steirischer Herbst, Austria
- INDIGO – Festival of Contemporary Ideas Ljubljana
- Low Budget Utopias, Museum of Modern Art, Ljubljana, Slovenia
- PLATFORM, Munich, Germany (solo exhibition)
- Border is closed, City Museum of Loznica, Serbia

### 2015
- Border is closed – Museum of African Art, Belgrade
- Aesthetic of resistance – Škart kvart", Galerija Nova, Zagreb (solo exhibition)
- Performing the museum – KGLU Slovenj Gradec

- CONTEMPORANEITY, AWARENESS, ETHICS, PSYCHOTHERAPY – Interdisciplinary Congress 2015, Kino Europa, Zagreb, Croatia
- Fiery Greetings, A representative portrayal of childhood in socialist Yugoslavia, Museum of Yugoslav History, Belgrade, Serbia

## 2014
- Politicisation of Friendship – Museum of Modern Art, Ljubljana, Slovenia

## 2013
- The Subversive Stitch Revisited, Victoria & Albert Museum London, Conference
- Aichi Triennial: Awakening – Where Are We Standing, Nagoya, Japan (solo exhibition)
- PESNICENJE (POETRYING), Cross-disciplinary monthly poetry festival, Cultural Centre REX, Belgrade, 2008-2013

## 2012
- Halftime – retrospective Škart exhibition at Museum of Applied Arts, Belgrade (solo exhibition)
- Creative Time Summit, New York (Focus: Art for Social Change)
- Flint Public Art Project 2012, Michigan, US

## 2011
- Time Machine – No network!, D0 ARK Underground – 1st Konjic Biennale of Contemporary Art, Bosnia and Herzegovina

## 2010
- Seesaw Play-Grow, Venice Biennial of Architecture, Serbian Pavilion (solo exhibition)
- Sur le Fil (déviances textiles) Maison Folie Wazemmes, Lille, France

## 2009
- The Origin of Wishes, ŠKART retrospective, Space gallery, London (solo exhibition)
- Selected: 10 years of Rotor, Rotor Gallery, Graz, Austria

## 2008
- ŠKART retrospective, Kortil Gallery, Rijeka, Croatia (solo exhibition)
- Design Biennale, Saint Etienne, France (solo exhibition as part of biennial)
- Design Biennale, Seoul, South Korea

## 2007
- October Salon, Belgrade, Serbia (1st prize)

## 2006
- Neo-Sincerity:..., Apexart, New York, US
- Fever, 6th Gwangju Biennial, South Korea

## 2005
- Operation: City, Former Factory Josip Kraš, Zagreb, Croatia
- About Normality (90s art scene), Museum of Contemporary Art, Belgrade, Yugoslavia
- Arbeit, Galerie im Taxispalais, Innsbruck, Austria
- Collective Creativity, Kunsthalle Fridericianum, Kassel, Germany

## 2004

- Exciting Europe, Galerie für Zeit-genössische Kunst, Leipzig, Germany
- New Past, Marronnier Art Centre of the Korean Culture, Seoul, South Korea
- Flipside, Artists Space, New York, US

## 2003

- Real Utopia, Graz 2003, European Cultural Capital, Austria
- Seas, Baltic-Adriatic work in progress (2003/4/5), Sweden, Poland, Russia, Lithuania, Latvia
- 2nd Biennale of Contemporary Art, Tirana, Albania
- Fog, Bikini Gallery, Berlin, Germany
- Graphic Biennale MGLC, Ljubljana, Slovenia

## 2002

- Red Elephants, New Gallery, Oslo, Norway
- Music in Me, Gesellschaft für Aktuelle Kunst GAK, Bremen, Germany
- Biennial of Contemporary Arts, Cetinje, Montenegro
- October Salon, Belgrade, Yugoslavia
- A Need of Realism, Ujazdowski Castle Centre for Contemporary Art, Warsaw, Poland
- Design Biennale, St. Etienne, France
- Evolutionäre zellen, Neue Gesellschaft für bildende Kunst, Berlin, Germany

## 2001

- Steirische Herbst, Rotor Gallery, Graz, Austria
- Collective Distribution 01, Akademie Schloss Solitude, Stuttgart, Germany
- Wedding, Oberwelt e.V, Stuttgart, Germany

## 2000

- Selection, Remont Gallery, Belgrade, Yugoslavia
- Golden Bee, Moscow Global Biennale of Graphic Design
- Manifesta 3, Ljubljana, Slovenia
- Your Shit Your Responsibility, street actions of civil disobedience, Belgrade

## 1999

- OFF Biennale di Venezia (Belgium pavilion)
- Typografica gallery, Brussels (solo exhibition)

## 1998

- The Political Poster Triennial, Mons, Belgium
- Steirische Herbst, Graz, Austria
- Dieu Donne Papermill, New York (solo exhibition)
- Coupons, street actions in the village of Beli Potok, streets of Belgrade, Stockholm, Graz and New York City

## 1997

- 3rd Biennial in Cetinje, Montenegro, Yugoslavia
- I Kissed Your Daughter (Together with Lili Marlon & Certain Gears), micro-opera performance at the laboratory of the Faculty of Chemistry, Belgrade

## 1996

- International Biennial of Graphic Design, Brno, Czech Republic
- PostOlympia, Olympic Games, Atlanta, US

## 1994

- 2nd Biennial in Cetinje, Montenegro, Yugoslavia
- Dibidon, ŠKUC, Ljubljana, Slovenia
- Accused, street action at the City Court, Zrenjanin, Serbia

## 1993

- ARMATURE (love-technical-musical together with the choir and orchestra "Stankovic"), Faculty of Architecture, Belgrade

## 1992

- The 16th Kanagawa International Print Art Triennial, Japan
- The Book in All Forms, Paris, France
- Sadness (together with the photographer Vesna Pavlovic), street actions + radio performances, Belgrade and the village of Lukicevo (1992/94)

## 1991

- ZGRAF (The International Exhibition of Graphic Design and Visual Communications) Zagreb, Croatia
- MONDAY, TUESDAY, WEDNESDAY, Performance, Triennial of Drawings Sombor, Serbia

## 1990

- Salon of Architecture, Belgrade, Yugoslavia
- ŠKART NEWS, poster + radio jingle, "Sketch-book" program, Belgrade, Radio B92

## Groups Škart initiated

### 2001
New Embroideries, NONpractical Women (women embroidery group) together with Lenka Zelenović, Brigita Međo and Pava Martinović

### 2008-2013
PROBA (choir)

### 2008-2013
Pesničenje (poetry festival)

### 2000-2006
Horkeškart (choir)
(As of 2007 till now Horkeškart exists as Horkestar)

## Residencies

### 2017
- NTU CCA Singapore Residencies Program

### 2011
- The Kamov Residency Programme, Rijeka, Croatia

### 2009
- Artists Residency Program, Space, Hackney, London

### 2007
- Reunion Project, B+B and Space, Hackney, London

### 2001
- Akademie Schloss Solitude Stipendium Stuttgart, Germany

**2000**
– Akademie Schloss Solitude
 Stipendium Stuttgart, Germany

**2000**
– The Franklin Furnace Fund, New York,
 USA

**1998**
– ArtsLink International Fellowship,
 New York, USA

**1996**
– Olympic Art Festival Residency,
 Atlanta, USA

## Workshops organized by Škart

– "How to make and illustrate a book",
 Booksa, Zagreb, 2019.
– Workshop with children and elderly
 in The Museum of Modern and
 Contemporary Art Koroška (KGLU),
 Slovenia, 2017.
– Workshop in Sveta Ana retirement
 home in collaboration with Museum
 of Contemporary Art Zagreb, 2016
– "Bishops secret love letter", screen
 printing poster workshop, Rijeka 2016
– Workshop with children and elderly
 people in The Museum of Modern
 and Contemporary Art Koroška
 (KGLU), Slovenia, 2015.
– Workshops with children at the
 foster care centre Vera Radivojević
 in Bela Crkva, Serbia, 2005-2014
– "Protest Poster" with Cactus group
 and Occupy London – London, in
 Athens, Greece, 2013.
– "Protest Poster" with Cactus group,
 Novi Sad, Serbia, 2011
– "Protest Poster" with Cactus group,
 Graz 2010

– "Domino Dancing" with pensioners,
 in collaboration with Peppie Close
 Housing, London, 2009
– "Riskiko Riskieren!" with teenage
 group in Youth Center in Fürstenfeld,
 in collaboration with Rotor Gallery,
 Graz, Austria 2009
– "Protest Poster" with Cactus group,
 Mine-yours-ours conference, Rijeka,
 Croatia 2009
– Škart Choir" with citizens of Seoul,
 Design Olympics, Seoul, South Korea
– "My First Book" with children,
 Srebrenica Library, 2007
– "Škart Choir" with Gwangju citizens,
 Gwangju Biennale, South Korea,
 2006
– "Mekanika Popular" with children,
 SEAS project, Baltic/Adriatic tour
 (Sweden, Finland, Croatia, Montene-
 gro, Italy) 2005
– "What Do I Do" with children, Kraljevo
 library, Serbia 2005
– "Mekanika Popular" with children,
 SEAS project, Baltic tour (Russia,
 Lithuania, Latvia, Poland) 2004
– "Collective/Individual" with graphic
 designers, Skopje/Bitola 2004
– "Rent A Bility" with teenagers (drug
 addicted therapy), Pilot Project/Rotor
 Gallery, Graz 2003
– "Who Wants?" with hyperactive
 children, Foundation Powiśle/Zamek
 Ujazdowski, Warsaw, 2002
– L'atelier des (in)visibles (with Collec-
 tive Distribution) – workshop with
 graphic design students, Les Halles,
 Brussels, 2001
– "Survival Coupons" with postgrad-
 uate students, Parsons School of
 Design, New York, 2000

- "Submissive" with postgraduate students, Jan Van Eyck Akademie, Maastricht, 2000
- "FRON't" (with collective Migrative Art and graphic designers, activists and students, Typografica gallery, Brussels, 1999

## Collections

- Kontakt collection, Wien, Austria
- IAS (Insa Arts Space), Seoul, South Korea
- Nexus Press, Atlanta, USA
- MoMA (Study collection), New York, USA
- New York Public Library (Graphic collection), New York, USA
- Connecticut Graphic Arts Centre, Norwalk Connecticut, USA
- Walter Koning, Cologne, Germany
- Galerie für Zeitgenössische Kunst, Leipzig, Germany
- Museum of Contemporary Art Belgrade, Serbia
- Telenor company, Belgrade, Serbia
- Verlag: Atelier collection, Graz, Austria
- MG+MSUM, Ljubljana, Slovenia
- Royal Museums Greenwich, National Maritime Museum, UK
- FRAC, Poitou-Charentes, Angoulême, France
- KGLU (The Museum of Modern and Contemporary Art Koroška), Slovenia

## Selected awards

- Best solo exhibition of the year 2012, Association of Independent Curators, Serbia, 2012
- Commission Award of Museum for Applied Art, Belgrade, 2007
- First Award at October Salon, Belgrade, 2007
- Golden Pen Award on Golden Pen Biennale of Illustrations, Belgrade, 2005
- First Award (1/4) on Evolutionäre Zellen, Neue Gesellschaft für bildende Kunst, Berlin, 2002
- Special Award for "Development of graphic design", Grifon, Belgrade, 2002
- Special Award for "Development of graphic design", Book Fair, Belgrade, 2001
- First Award at October Salon, Belgrade, 2000
- Special Award for "Development of graphic design", Grifon, Belgrade, 1998
- First Prize on Independent Publishing Fair, Belgrade, 1997
- Award for the Life-Work from the Rhythm of the Heart program, B92, Belgrad, 1997
- First Prize for theatre poster, YUSTAT (Ist Biennial of Theatre Arts), Belgrad, 1996
- Silver Medal for "Toy design idea", World Exhibition of Innovation, Eureka, Brussels, 1993
- Third Award, Poetry festival "Shake hands in May", Podgorica, 1992

# Contributors

**Zdenka Badovinac** is a curator and writer, who has served between 1993 and 2021 as director of Moderna galerija (Museum of Modern Art) and MSUM (Museum of Contemporary Art) in Ljubljana. Badovinac is known internationally for her curatorial work and theoretical contributions as a writer in the international discourses on the geopolitics of contemporary art in Eastern Europe and global art history. In 2020, she was awarded the Igor Zabel award. Badovinac initiated the first Eastern European art collection, Arteast 2000+. Her most recent exhibition is *Bigger Than Myself: Heroic Voices from Ex-Yugoslavia*, MAXXI, Rome. Her most recent book is *Comradeship: Curating, Art, and Politics in Post-Socialist Europe* (Independent Curators International (ICI), New York, 2019. She is a founding member of L'Internationale and president of CIMAM, 2010–13. In 2022, Badovinac has been appointed director of the Museum of Contemporary Art in Zagreb.

**Dr Branislav Dimitrijević** is Professor of History and Theory of Art at the College of Art and Design in Belgrade. He teaches and writes internationally on art and culture of socialist Yugoslavia; avant-garde art, contemporary art and exhibition histories. His books include: *Consumed Socialism – Culture, Consumerism and Social Imagination in Yugoslavia, 1950-1974* (Fabrika knjiga, Belgrade 2016), *Dušan Makavejev's Sweet Movie* (MOCA, Belgrade, 2017), *Against Art – Goran Djordjević, 1979-1985* (MOCA, Belgrade, 2014, w. J. Vesić, D. Sretenović), *On Normality: Art in Serbia 1989-2001* (MOCA, Belgrade, 2005, w. B. Andjelković, D. Sretenović) and most recently Yugoslavia: *How and Why?* (Museum of Yugoslavia, Belgrade, 2019, w. I. Erdei, T. Toroman). His curatorial projects include *Good Life* (Geozavod, Belgrade, 2012, w. M. Hannula) and *No Network* (2011), the first edition of the Time Machine Biennial in the nuclear bunker in Konjic, Bosnia and Herzegovina.
https://independent.academia.edu/BranislavDimitrijevic

**Milica Pekić**, PhD, art historian and curator from Belgrade. Her research focuses on avant-garde artistic practice, alternative forms of collective authorship, institutional transformation and potential of interdisciplinary approach both in research and production. Being actively engaged in the civil sector in culture for more than a decade, she is also part of many initiatives both on national and regional level focusing on sustainable frame for development of independent cultural scene and its regional collaboration. She is co-founder of KIOSK platform for contemporary art, Association of the Independent Cultural Scene of Serbia and KOOPERATIVA – regional platform for culture.

**Škart** collective was founded in 1990 in Belgrade, Yugoslavia. Between 1990 and 2000 their work focused on self-publishing (poetry books and printed matter) that were distributed in self-organised street actions (*Survival Coupons, Sadness*). From 2000 to 2010, the group founded other collectives; Choir Horkeškart and Proba, children's choirs Children from the Moon and AprilZMAJun, and a female embroidery group together with the single mothers association of Belgrade. Škart ran the monthly festival of experimental poetry Poetrying (*Pesničenje*) at the cinema Rex in Belgrade between 2008 and 2013. In 2010 Škart represented Serbia at the Venice Biennale of Architecture (*Seesaw Play-Grow*). Since 2012, the collective has been working occasionally with the pensioners and the children in the foster care center in Bela Crkva, Serbia. In collaboration with Group 484, they conducted several workshops with migrants in asylum centres in Bogovadja and Banja Koviljača between 2013 and 2017. Škart is involved in poetry and graphic design, often cooperates with others, helps activist groups, and earns wages mainly working as graphic designers and illustrators.
http://www.skart.rs

**Seda Yıldız** is an independent curator and writer based in Hamburg. Her socially engaged practice is inspired by thinking across disciplines including visual arts, design, music, literature and activism. She is interested in taking part in process-oriented projects that foster collaboration and exchange with a wider audlence. Her recent curatorial projects include the performative exhibition of the visual artist and musician Vigan Nimani, *Unfixed Place, Ambiguous Time* (2022) at Kino Armata, The Grand Hotel Prishtina and the artist's studio in Prishtina; the archive exhibition *Memory of Kundura: The World Within a Factory* (2021) at Beykoz Kundura in İstanbul, a roller disco weekend *We Live Together, We Dance Together* (2019) at Kunstverein Harburger Bahnhof in Hamburg. A member of AICA Turkey, she writes on art and design. She was the art critic in residence at the Igor Zabel Association for Culture and Theory (2021), joined What could/should curating do? program in Belgrade (2019) and Shanghai Curators Lab led by Carolyn-Christov Bakarglev and Yongwoo Lee (2018).
http://yildizseda.com

# Building Human Relations Through Art
## Škart collective (Belgrade)
## > from 1990 to present

Onomatopee 224

Author: Seda Yıldız
Editor: Seda Yıldız
Contributing authors:
Zdenka Badovinac, Branislav Dimitrijević, Milica Pekić
Contributing artists: Škart
Graphic design: Rob van Leijsen
Copy editor: Merve Ünsal
Proofreader: Matt Hanson
Printer: KOPA, Lithuania
Fonts: Forma (DJR), Sectra (Grilly Type)

ISBN 978-94-93148-82-6

This book is made possible thanks to the support
of Kontakt – ERSTE Stiftung and Hamburg Future
Scholarships for Visual Arts of the Ministry of Culture
and Media, Group 484, Jelena Šantić Foundation,
Eglo Lighting doo, Suzana Jovanović, Gordana Olbina
+ Park family, Sanya Samac.

»Gefördert durch ein Hamburger Zukunftsstipendium
der Behörde für Kultur und Medien in Zusammenarbeit
mit der Hamburgischen Kulturstiftung und dem
Berufsverband bildender Künstler*innen Hamburg.«

Kontakt Collection is an independent non-profit asso-
ciation based in Vienna. Its purpose is the support
and promotion of Central, Eastern, and Southeastern
European Art.

k    takt
  on

www.kontakt-collection.org

First edition, 2022
Onomatopee Projects
www.onomatopee.net